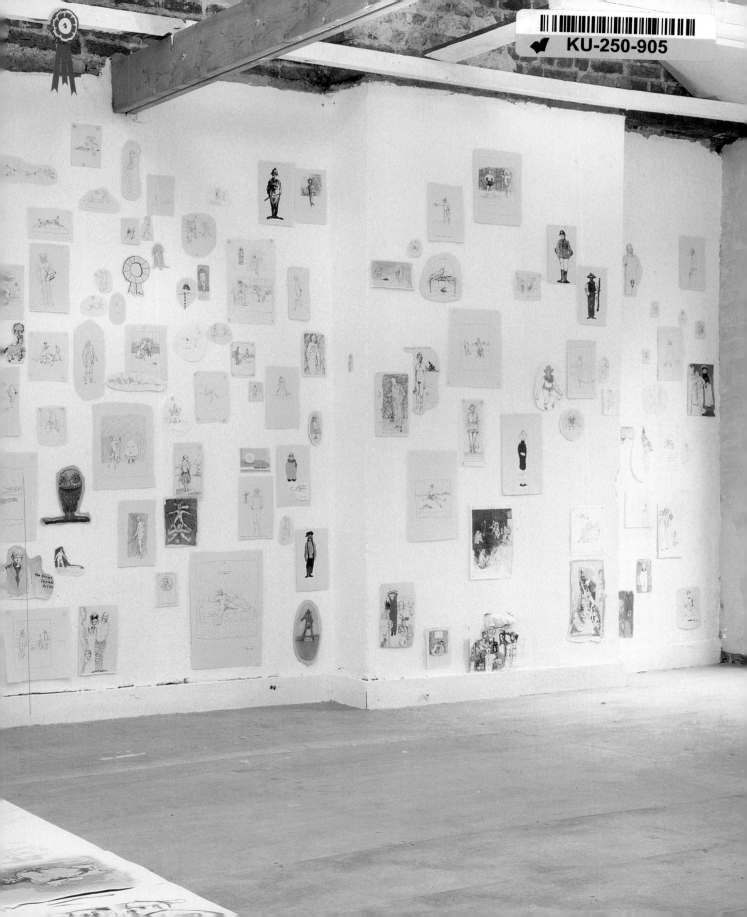

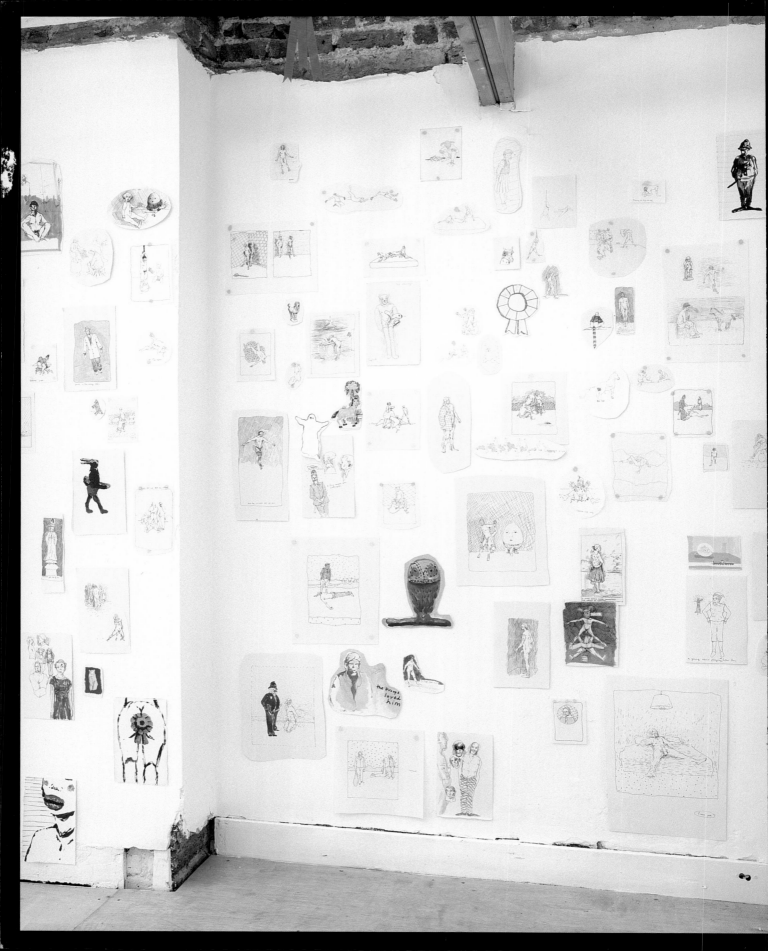

Dedicated to Angela Lucas

Simon English & the Army Pink Snowman

Simon
English &
the Army
Pink
Snowman

Contents

Once Upon a Time by Fred Mann —— page 7

Drawing Pincta by Stella Santacatterina —— page 17

Simon English by Bill Arning —— page 31

 Rosette Head & Bunny Bride —— page 46

 4 Doors—Agnès b. —— page 53

 Ansuya Blum —— page 58

 Bride —— page 64

 Drawings for The Breeder No. 5 —— page 67

 El Greco's Knees —— page 74

 Drawing with Blu-Tack —— page 79

 Haddock —— page 88

 Nobody Loves Me —— page 91

 Nurse Rackham —— page 100

 Keith Vaughn's Stable —— page 108

 Drawing Installation —— page 115

 Jean Plaidy —— page 120

 Julie Christie —— page 127

 Performance —— page 131

 Army Pink Snowman —— page 138

 Mrs Brown —— page 146

 Double & Twist —— page 151

 Real Rosette —— page 160

 Artist's Gaze —— page 163

 Lawrence Gober-Munch —— page 172

 R & W Series —— page 178

 The 7.42 from Worthing —— page 184

 Farmer Humpty —— page 194

 Walls —— page 197

 List of Illustrations —— page 204

 Artist's Biography —— page 205

 Artist's Bibliography —— page 205

 Acknowledgements —— page 206

Once Upon a Time
by Fred Mann

English family photo,
courtesy of the artist

I often find myself in the woods with the fairy princess and I am never quite sure why I am there...

Quote taken from a conversation with Simon English in regard to drawing

1
ENGLISH, SIMON
Notes on Childhood,
2005 [Unpublished]

Once upon a time there was an English boy called Simon English... It is important to mention that, apart from his name, Simon English is English, as in many ways it would simply not be possible for him to make the work that he does if he were from anywhere else. There is a particularity to an English childhood, and all the things that English saw and did as a boy have informed his adult artistic practice. He directly incorporates childhood memories into his works and has married these recollections to the storybooks of his youth.

The biggest influence of all on English is stories, and in England there are particular stories that stem from a European tradition of writing for children. Very importantly for English many of the stories of his childhood were illustrated, and the characters he loved as a boy have grown with him and been transformed and carried into adult life.

When English was two, his father died when his Land Rover skidded on black ice. The subsequent time the small boy spent growing up with his mother, two older sisters and grandparents, was key to the development of his imagination. Like the characters in his favourite Beatrix Potter books, he was surrounded by a lawn and hedges, a kitchen garden and countryside, and a gardener (although English's gardener was not as frightening as Peter Rabbit's Mr McGregor). English remembers learning to draw from his elder sister, Sarah, who was very good at doing pictures of beautiful women and ponies. He recalls, "I still have these drawings. Big houses, cars, powerboat babes, seventeenth century heroines with big earrings, jewellery, ringlets and sweeping busty dresses and very long eyelashes and evening gloves. Men in tweeds (possible suitors for my mother, they must be rich, and handsome and wear tweeds). I drew markets and town streets, I never stopped."[1]

During this time English created a complex fantasy world, which in many ways he still inhabits. In his most recent works, elements of multiple biographies appear, and English uses these fragments to evoke and suggest the relationship between the stories of his youth and the complexities of his adult life. Some of these memories and fantasies evoke his days at home, the holidays and his escapes into his childhood dreams, but, simultaneously, new and more complex elements are brought in. The contemporary and modern art world and more recent autobiographical events feature heavily, all contained on the same picture plane as a panoply of more youthful characters, as well as literary and art historical quotations and characterisations.

Figures have featured very centrally in English's work, both in his boyhood and adult drawings. They appear throughout his works as combinations of complex references, some diaristic and some imaginary. Both men and women appear as beautiful and extraordinary creatures, like characters in passages from stories that we only half know and half remember, and from stories that we can only guess at or imagine. However, like all great fantasies, the narratives that emerge from English's drawings defy both categorisation and closure. His finished works confound straightforward reading, subtly suggesting the full depth of their meanings, insisting that we apply the codes of conceptual art to unravel them:

We have taken the fairy tales of our childhood with us into maturity, chewed but still in the stomach, as real identity. Between Snow White and her heroic prince, our two great fictions, we never did have much of a chance… Despite ourselves, sometimes knowing, unwilling, unable to do otherwise, we act out the roles we were taught.[2]

Aged 11, Simon, his mother and two sisters moved to Dorset to live in a big empty house, with a disused railway at the end of the valley. English recalls feeling like he was a character in E Nesbit's *The Railway Children*: "When they first went to live at Three Chimneys, the children had talked a great deal about their Father, and had asked a great many questions about him, and what he was doing and where he was and when he would come home."[3] As in *The Railway Children*, the sense of memory, escape, growing up and rebellion combined happily with Peter Rabbit, the 'coloured' Fairy Books of Andrew Lang, illustrations by Arthur Rackham, Margaret W Tarrant, and all the other tales of Beatrix Potter.

In some way the Victorian writers for children had transcended the age-old debate concerning the purposes of 'literature' (instruction versus delight) as well as the equivalent moral tract versus fairy story argument regarding children's literature… Children's literature of this period almost always had a moral or religious basis, but it was often just this conflict between morality and invention (or morality and eroticism in Christina Rossetti's *Goblin Market*) that created some of the era's greatest works.[4]

2
DWORKIN, ANDREA
Woman Hating,
New York: Dutton,
1974

3
NESBIT, E
The Railway Children,
London: Wells
Gardner, Darton and
Co., 1906, p. 204

4
COTT, JONATHAN
Extraordinary Works of Fairy Tale and Fantasy,
New York: Stonehill,
1973

Then sucked their fruit globes fair or red:
Sweeter than honey from the rock,
Stronger than man-rejoicing wine,
Clearer than water flowed that juice;
She never tasted such before,
How should it cloy with length of use?
She sucked and sucked and sucked the more
Fruits which that unknown orchard bore,
She sucked until her lips were sore;
Then flung the emptied rinds away,
But gathered up one kernel stone,
And knew not was it night or day
As she turned home alone.[5]

For English it is exactly this conflict between tradition (Englishness), moral instruction and childhood history versus modern art, sexuality and creative freedom that informs the visual structure and the intense eroticism and depth in his adult work.

As an adolescent in Exeter he continued to draw and his work developed while he was studying Art and English A levels, on a course attached to Dartington. His tutors had a radical and

playful way of teaching and to learn about Wilfred Owen and the War Poets English played war games in the local woods, went to abattoirs, dug big trenches and built installations. All these things help us to form a picture of his quintessentially English upbringing. It may seem indulgent to talk at such length about children's books and the world of the imagination; however, the fantasy worlds that we develop as children become morally, sexually and visually integrated into our adult life and works.

Children's turning to the tale is no casual recreation or pleasant diversion; instead, it is an instant search for an ordered world more satisfying than the real one, a sober striving to deal with the crisis of experience they are undergoing... it is even possible... to see the child's turning to the tale as a salutary utilisation of an implicit device of the culture. It would appear, moreover, that after reading a fairy tale, the reader invests the real world with the constructs of the tale.[6]

ARTHUR
RACKHAM
*She clipped a
precious golden lock,*
Frontispiece for
Goblin Market by
Christina Rossetti,
1933

However, in a parallel way to Robert Gober, English utilises a seemingly ordinary world in his work, through the security of his fantasy images and stories of childhood. This fairy tale world exists alongside and in denial of the difficult adult world, where the "litany of abuse and discrimination against gays, neglect of children, of untimely death, of official incompetence and ignorance of Aids. These in turn are set against a background of everyday ordinariness which itself harbours the sexual stereotyping and cultural conformism that underpins society's passive response to injustice and discrimination."[7]

5
ROSSETTI, CHRISTINA
"Goblin Market",
*Goblin Market and
Other Poems,*
London: Macmillan,
1862

6
Urbana: National
Council of Teachers of
English, 1977

7
MORRIS, FRANCES
*Robert Gober,
Rites of Passage,*
London: Tate Gallery
Publications, 1995

Architecture Art
Design Fashion
History

Black Dog Publishing Limited
Unit 4.04 Tea Building
56 Shoreditch High Street

London E1 6JJ

Photography
Theory and Things

Black Dog Publishing

Architecture Art Design Fashion History
Photography Theory and Things

If you would like to be kept informed of forthcoming Black Dog publications, please fill in
and return this postcard, and we will add your name to our mailing list.

☐ Architecture ☐ Design ☐ Photography ☐ Film

☐ Art ☐ Fashion ☐ Music ☐ Please send me
 a catalogue

Name

Address

City

Post Code Country

E-mail

Therefore, the fear and lies (or cautious half truths) of childhood, and the fear and lies subsequently generated by the stereotyping of society in adult life have played a large part in Simon English's world. Characteristically, it is again a children's story that he uses as a metaphor to explain, debunk and demystify these complex fears and to confront his biggest fear with his art work, the fear of painting.

8, 9, 10
TOMLINSON, JILL
The Owl Who Was Afraid of the Dark,
London and
New York:
Methuen, 1968

Sketched across many sheets are images of an owl and the words "Dark is Splendid, Dark is Exciting, Dark is Fun". This is a reference to Jill Tomlinson's novel *The Owl Who Was Afraid of the Dark*.[8] In this children's story, Plop, the young owl, learns to fly by falling off branches and English equates the owl's journey of self-discovery with his personal journey of learning to paint and draw. The parallels between creative process, the owl's journey and Simon English run deep. English is discovering a way in which he can make his art and freely, outside of a prescriptive norm. This is not simply a way to rebel against an overly conservative or uncreative world, but in a more complex way it is about demanding acceptance for how you actually are from a conservative world, without compromise.

JOANNE COLE
Illustration for
The Owl Who Was Afraid of the Dark
by Jill Tomlinson,
1968

Plop forgot about being afraid of the dark, he had to know what was going on.
So he shut his eyes, took a deep breath, and fell off his branch.[9]

Simon English (as with many artists) used to believe that painting as a thing in itself and proficiency in painting form the simulacrum of visual and creative achievement. He has often put himself in a position where it is painting that he must deal with, confront and pursue. However, the area in which he becomes creatively free is drawing, and subsequently it is drawings that form the bulk of the works reproduced in this book. It is important to understand how English has reached this point of relative freedom as during the last ten years he has had many battles with allocating a comfortable medium for his expression. Painting and these trials and tribulations have now become a subject within the work and no longer form a burden or block to his creative processes.

The ground was closer than he expected it to be and he landed with an enormous thud.[10]

Looking back as far as his inclusion in The Saatchi Gallery's exhibition, Young British Artists III in 1994, it was clear that the heroic stance of picture making across such large canvasses left English both exposed and under pressure. This pressure continued some way into his career, when the market forces associated with a fêted young artist placed him in a space where more paintings were expected—but this was not the direction that English took.

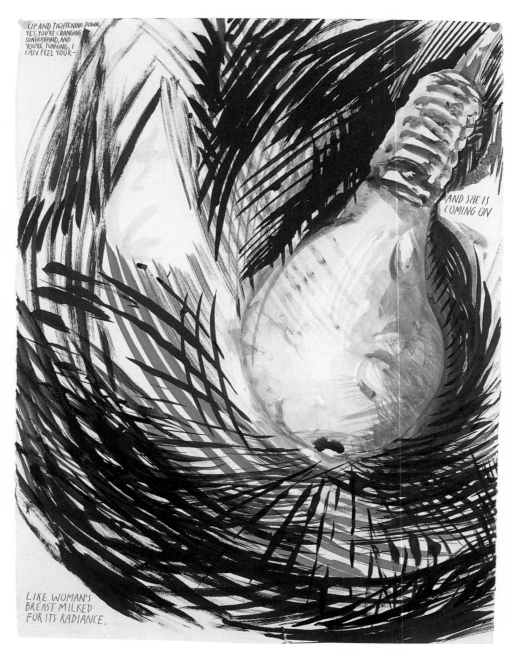

RAYMOND
PETTIBON
*No Title (Up and
tightening)*, 2003,
pen and ink on paper,
76.2 x 56.5 cm
© Raymond
Pettibon, courtesy
Sadie Coles HQ,
London and Regen
Projects, Los Angeles

Following this period English comments "Started drawing again. Release. Enter Lewis Carroll, bunny rabbits, and Dennis Potter's *Blue Remembered Hills*."[11] His new drawings refer to this period of moving away from painting and all its trappings and are peppered with self-criticism: 'Failed painter' or 'Good ', as if marking a school exercise book. Raymond Pettibon uses writing in a similar way in his drawings, as a sort of parallel running commentary that is either a counterpoint to or in tandem with his drawings; he comments: "I don't think my work stands on its draftsmanship or its qualities of drawing or painting. I never saw myself as an artist primarily. On the other hand, I think I need the combination of both [text and drawing]".[12]

During this period, English began to work more directly and openly to combine his childhood memories and his sexuality. References in his drawings become like memory notebooks of remembered pleasures, fears, triumphs and failures. Overcoming fear, as the owl in Tomlinson's story does; whereas before darkness was fear, it now becomes the natural habitat in which to live and appears as a symbol of an alternative way of life and a better, more fulfilled and open mode of living.

So Plop shut his eyes, took a deep breath, and fell off his branch. He floated down on his little white wings and landed like a feather. Feeling very pleased with himself, he looked around.[13]

The way that English began to make these new, freer works again had much in common with Raymond Pettibon. English's studio became awash with filled sheet after sheet of creamy pink paper covered with cyclical and often familiar references: pink ponies, football fans, rosettes (both real and drawn), owls, bunny rabbits and heaps and piles of naked wrestling men. As the sheets became filled from edge to edge, English began to join them together, by pinning them in great blocks around the walls of his studio.

Various characters appear, often over again, and many of them seem to be magical, but some of them represent actual events, things that have really happened to English. He recalls: "I saw my first naked man in Bovington Army Camp when I was eight in the showers and my first naked woman who was aged 70 playing Eve within a garden of Eden tableaux staged in a small tent at a Dorset steam engine rally alongside lots of horny farmers when I was 13."[14]

Farmers, gardeners, and naked men certainly appear in these recent works, in varying guises and situations. These characters, such as the 'Tall American' or Tomlinson's owl reappear, as do texts and quotations from his heroes and champions: Julie Christie, Lawrence, Gober, Munch or even the novelist Jean Plaidy. In a similar way, so do repetitions and changes in particular drawing styles, different brush marks or uses of the pen or pencil. Areas of dense black cross-hatching, broad areas of thin colour washes or finely curling pencil tendrils define different blocks or spaces across differing sheets.

11
ENGLISH, SIMON
Notes on Childhood,
2005 [Unpublished]

12
Raymond Pettibon in conversation with Ulrich Loock,
Kunstalle Bern, 1995

13
TOMLINSON, JILL
The Owl Who Was Afraid of the Dark,
London and New York: Methuen, 1968

14
ENGLISH, SIMON
Notes on Childhood,
2005 [Unpublished]

Raymond Pettibon has used repetitive marks and textures in a similar way. Pettibon comments that:

> ... a lot of the figures I tend to go back to with consistency and constancy are the figures that are drawn that way like you can see: these cross-hatches... if there is any completion... it'll be a parenthesis that stretches in infinity as far as the clouds can reach, and it closes somewhere deep in space or as far as one can look, and ultimately is empty.[15]

Over a period of two or three years English worked over his sheets again and again, drawing with paint and applying collage as well as areas of cross-hatching employed to resemble engravings by Rembrandt and Dürer, whilst other wistfully brushed and washed areas began to recall the empty voids of Luc Tuymans. Perhaps unconsciously, English had inadvertently returned to the great heroic tradition of painting as rebellion, but almost by accident. In a similar way to how Pettibon picks up his multiple sheets of surfers and comic heroes from the studio floor and groups them together ranged around gallery walls, English now pasted together his stories, passions and multiple references to form the large and dramatic framed works reproduced here.

It is an interesting process to see how English, freed from commercial constraints and the expectations of an almost hypothetical audience or society, has reached such a plateau of new found freedoms: the freedom to blast apart the expected structures of the painterly heroic gesture, only to rebuild them anew. However, the fundamental difference and great innovation that English has brought to bear is his rediscovered love of drawing. And it is drawing that has become his chief means of expressing his passions, victories, desires, erotic fantasies, pleasure and intense skill and application to his chosen medium. However within all of this expression are meanings and tales that seek out both acceptance and understanding.

In the work of Robert Gober, the artist uses the repeat appearance of particular domestic objects that become imbued with meaning. The drain, wall paper, a dog basket, rat poison and cat litter hold keys to layers of commentary about relationships, devotion and society, often dealing with absolutes as well as a layer of anger at a society that the artist feels outside of or opposed to, often in the context of the fight against AIDS:

> ... the cat litter was to a large degree a metaphor for a couple's intimacy—that when you make a commitment to an intimate relationship, that involves taking care of that other person's body in sickness and in health.[16]

In the work of Simon English, repeat depictions of objects such as his rosette at first sight also seem normal, domestic or innocent, like a trophy from a horse race or dog show. However through further reading of his drawings, the rosette reappears pinned in the male anus and ultimately becomes the anus itself. Thus, as with Gober, an ordinary or domestic image becomes a symbol for

15
Raymond Pettibon in conversation with Ulrich Loock, Kunstalle Bern, 1995

16
Robert Gober in interview with Richard Flood, Trustees of the Tate Gallery and Serpentine Gallery, London, 1993

ROBERT GOBER
Drain, 1989,
cast pewter,
11 x 8 cm,
photography:
Geoffrey Clements,
courtesy the artist
and Matthew Marks
Gallery, New York

a group of outsiders, gay men and gay desire, and confronts a taboo in society, that of anal sex, through a conscious and playful juxtaposition (1st prize, 2nd prize, runner up).

This device is similarly repeated with English's use of an image of a button. For English, buttons are a symbol of adolescent desire and sexuality; the desire to explore and experiment is to undo the buttons. A button itself holds two things together, but for English, the act of undressing, looking and the possibility of touch become a tantalising striptease within his drawings, and the separation an act of defiance, but ultimately celebrating a joyful pleasure in sex and sexuality. It is one of life's charming ironies that Simon English's recent studio where much of the work in this book was made was formerly the premises of a tailors, and while working on his drawings he collected a great many discarded buttons from between the gaps in the floor.

Drawing Pincta
by Stella Santacatterina

Drawing & Desire

The artistic vision of Simon English finds its concept in the pursuit of drawing rather than in the stuff of painting, a principle echoed by many other important artists in history. The word painting comes from the Latin *exempla pincta*, meaning the structure of vision: something beyond the merely visual, more concerned with the imagination, which was how it was also used to create the language of poetry. Even more so than painting or sculpture, however, drawing is an *exempla pincta*, a process of realisaton, as Degas said, not of form itself but of the way to see form.

With the act of drawing, the artist is released from the material blackmail of painting and free to draw on the sheet of paper the image as a reverse of an internal image. This image exists in a space that is not two-dimensional like the sheet of paper. Rather, it is a system of spatial relations where the hierarchies of high and low, inside and outside, before and after do not exist. External space becomes a specular surface, a magnetic field that captures and organizes the image. But the image always corresponds to a pulsion, an obsession, to a desire to expand its own flux beyond the assigned body. In this sense drawing becomes the mechanism that tends to give order to the only dimensions in which desire moves: space and time. Desire, when it encounters the materiality of painting or sculpture, always finds a kind of resistance, which gratifies it and directs it inside the layers of reality. The pulsion is erotic in so far as it seeks and finds a vector that puts it in communion with tactile and visual sensation. The material of art is what imprisons and makes definitive desire; it is what defines the split between the imaginary and the subject. Material keeps desire on the inclined plane of appearances, surrounding it with a gravity where desire condenses and infiltrates the oppressive grid of language. Drawing, however, rather than going along with desire's masquerade, exposes its rarefaction. It suspends the movement of desire in a place of projection and reversibility. It is at the threshold where desire moves, but is not yet available to confront the obscurity of language.

In painting, in the sense of its materiality, desire works through *mise-en-scène*; it finds a way to conceal itself in the grid of the visual language that expresses it but does not represent it directly. Language tends to host desire inside itself without accusing it of being a tautological presence. Desire never directly corresponds to the desiring subject because language itself is the subject. In this way is born the antagonism between artist and language, between imagination and image, which resolves itself in a deferred place where specularity is lost. Gratified by this battle, desire becomes impersonal.

Simon English encountered this problematic in the making of *R & W*, 1994–1996, an assembly of hard and soft wood panels,

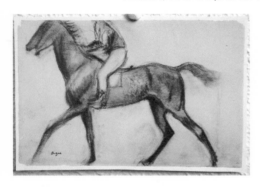

EDGAR DEGAS
Racehorse and Jockey,
print tacked to
English's studio wall

each of which is divided into two zones: in one, the geometric form, derived from urban parks or tennis courts, refers to space and location, height and depth; in the other, clusters of human figures, some reminiscent of Muybridge's chronophotographic series, are articulated in a minimally delineated space that is more or less perspectival. However, the artist felt constricted by the material process and compositional rules, and ultimately felt too detached from the freer play of the imagination.

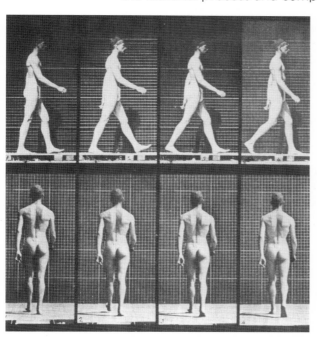

EADWEARD
MUYBRIDGE
*Man walking at
ordinary speed*,
1884–1887

The work, therefore, undergoes a more profound shift towards immateriality, towards the lightness and speed of paper and line. It is not the case, however, that the artist avoids paint—his is a practice that still comes from the painting tradition—but it is used with reticence. Figures are often delineated by, isolated in, or occasionally emerge from a roughly rectangular ground of colour. The colour too covers a modest range of chromatic hues that eschew the more strident primaries in favour of tertiary blues and violets, and the elusive tints of the earth reds. But the point here is that in Simon English's art it is the drawing-sign that is privileged over the material work of painting and sculpture which is more or less an elaboration of it, over what in painting gives the imaginary the status of objectivity. In drawing, the elaboration of work is preceded by that of the labyrinth (meaning, 'work inside'). The labyrinth allows desire to reveal and set itself in motion. Here the split between subject and object, between the desiring subject and the subject of language, becomes one body.

The labyrinth confines the errancy of desire, the contemporary stasis and dynamic of the imaginary, according to a structure that continuously retraces a line that is both descendent and ascendant. The descendent line traces the entire body of the artist and ends with the gesture that transfers mark to drawing surface. The ascendant line ensures that the mark or sign cannot be inscribed definitively in the external space, but brings back the pulsion of the originary place where the imaginary is in harmony with desire. Harmony determines transparency; it maintains the metonymic character of desire, because it temporarily annuls the distinction between imaginary and image, between the labyrinth and elaboration. The movement that determines imaginary flux remains subtended above the mark, ready to return to its temporal circuit. To draw becomes to embody; and it makes manifest movement, which is neither the rhetoric of motion nor a parody of Eros, but rather what keeps the imaginary in a state of potentiality and allows it to be both diachronic and synchronic.

The experience of Simon English's work reveals to us that with drawing, in contrast to painting, it is as if the pulsion remains frozen in its own tension, as if Eros is held back in his own space rather than that of the other. It is autoerotic because, according to Lacan, desire moves its object continuously along the chain of metonymic substitutions until it destroys it. The mark or sign encounters only the materialization of its own evidence, subtly visual. Hence, for English, drawing is the artistic form that more than any other concretises itself as a continuous variation and, in its materialisation, dissolves the distance between concept and object. Thus, drawing, in its inconsistency, tends to give itself as mark, trace, as a visual suspicion of a larger and more concrete image, one that chooses to remain in a state of uncertainty that is its inner nature. It seeks always to reveal the gesture of the artist, to capture the moment that precedes the birth of the sign.

The Artistic Gaze

The artist's vision possesses an almost magical capacity to capture and give form to what we might otherwise pass by. For Degas, "Drawing is the most obsessive temptation of the intellect… but is it correct to speak about intellect? Things around us look at us. The visible world is a continuous excitation: everything alerts and nourishes the impulse to possess the figure that the gaze constructs." That "things around us look at us", may perfectly describe the experience that gave rise to a series of photographs by Simon English during the early 1990s entitled *The Artist's Gaze*. The artist recounts how he would casually encounter certain things in the street that so captured his attention that he was immediately compelled to take photographs of them. This was a rare deviation from a practice that is otherwise articulated wholly around drawing; but it serves to illustrate that the artist draws less with the hand than with the gaze.

The gaze of art is always oblivious. It is enough to recall the Orphic myth in which the gaze turns to look at Eurydice but loses her in the very instant it catches her as image. For Orpheus there is no third possibility that would allow him to capture both the image and Eurydice. The exclusion of the eye in Orpheus, like the cut of the eye in Buñuel's *Un Chien Andalou*, is the metaphor of a blindness, or better, a shift away from the scopic field, from the eye to the gaze, from the visible to the invisible, to a place where desire takes itself by surprise. Here, the act of drawing itself becomes the authentic pulsional scene; it substitutes and abolishes the subject, becoming more than the real body, exactly a narcissistic body. It is precisely this sense of a self consumed that is splendidly conveyed by Degas:

Furthermore, the desire to give a closer form to the image in our mind compels us to take up the pencil. And here we are, completely involved in a strange play that we often conduct with passion, in which desire, chance, recollection, signs and the imprecision of the hand, idea and tools combine and exchange, and of which signs, shadows, forms, appearances

of being and place, in other words, the work itself, are the effect, more or less happy, more or less predictable.
It happens that inventive drawing inebriates the artist, it becomes a frantic action that devours itself, nourishes itself, exhilarates itself, exasperates itself, a movement of passion that rushes towards its own *jouissance*, towards the possession of everything we want to see.

English's work becomes almost the machine that, according to Deleuze and Guattari, needs desire to function but without being able to produce desire. This is only the process that activates the intention and act of drawing. Hence the tautology of desire that confirms a kind of persistent biological aspect of art, a need that moves the gesture of the artist. English's language moves along a spatiotemporal dimension in a strategy that can be compared to filmic montage, determined by a space that is bi-dimensional and fluid. Like the sequential photogram of film, it creates a temporal dimension until the last moment, an end that is only apparent because the film loop itself can be reactivated and returned to the beginning; it is both horizontal and circular. The act of drawing here corresponds to the urgency of expressive enquiry but at the same time to an immediacy that enables English to avoid the filter of a more pictorial language. The fascination of his drawings lies also in the close relation between trace, line and scripture. We perceive the physical and concrete presence of his hand. In drawing, Calvino writes, "we can feel the corporeal gesture, the vibrant circulation of an autography… The substance revealed by the drawing is the true substance of the world."
The relationship between memory and oblivion is a crucial aspect of the creative experience. For example, for Baudelaire memory aligns itself more naturally to the present than to a past that always acts as a phantasm. The instant, in Baudelaire, is the cat's eye, the frozen hour that the clock cannot follow. The authenticity of artistic experience lies above the veiled horizon of voluntary and rational memory and thus can never coincide with it. The artist must come out of time as successive flow in order to exit the flux of ordinary experience, to go beyond the gap between subject and object. To come out of time is therefore to create an "immobility". Benjamin uses precisely this word in *Passagenwerk* to describe this spatiotemporal condition of the image: "It is not the past that throws its light on the present, or the present that throws its light on the past, but the image is everything that has already happened and what has been unified in a flash with the hour (*Jetzt*) as a constellation." In other words, the image is the dialectic in immobility, a "discontinuous and jerky movement", and the place where we can encounter its language. The relation between past and present is purely temporal; by contrast, the relation between what has been and the hour (*Jetzt*) is dialectical, not of a temporal but of an imaginary nature.
Art is always a journey, a circumnavigation towards an unexplorable continent, a journey, as Rilke would say, towards a space of freedom, a utopic space that is simultaneously paradoxical, erotic and contemplative, ambiguous but not limitless. For this

reason Simone Weil in *Cahiers* writes that to capture the length, breadth, height and depth it is paradoxically necessary to be rooted in the absence of place, in other words, in utopia. Novalis pointed out that utopic space is a world in-between. Inside this destabilising space we can sense the invisible suspended behind the visible. Here we can potentially activate relations and configurations hitherto concealed from us. This limit, which previously functioned as an exterior barrier, according to Novalis, is also an aim. It is an interior limit, the fertile zone of the margin, the in-between space of the not-any-longer and the not-yet. It is in this very place that there emerges a new meaning, one that carries the power of the image. In this sense we can say that Simon English's work is founded in this zone of the margin.

HUMPHREY MILFORD
Down the rabbit hole,
Illustration for
A Little Book of Alice in Wonderland
by Lewis Carroll,
1932

We may say that his work is a thinking through images driven by sensibility, imagination, viscerality. A rhetoric of desire founded on free association and the free flow of impulses that leaves behind images as an oneiric writing articulated through displacement and condensation, between a dormant metaphoricity and metonymy, the enigmatic instance of an 'inner world'. His figuration, without hierarchy, is drawn from the archives of biographical memory, popular mythology and art history, from El Greco to Picasso, from Lewis Carroll to Hergé, the language of art and the language of the vernacular; it is profoundly inside a contemporary sensibility. Complex and hybrid, the poetics of his work is characterised by a duality in which the low of the popular and the sublime of high culture are mutually implicated and justified by a quotidian experience lived both as reality and as feelings. The figures carry the trace of a twilight world, from the unstable and metamorphic universe of *Alice in Wonderland* or *Through the Looking Glass* to the shadowy and brittle glamour of the nightclub, traversing and disturbing the tectonic equilibrium of artistic language. The ambiguity attributed to this thinking through images means, as Freud would say, to remain always between consciousness and the unconscious, which, in the end, is also the ambiguity of the 'real' as simply an absence of meaning to life itself.

Between Word & Image

In Simon English's art pencilled notations are scattered throughout the clusters of images, typical of an artist's notebook as 'work in process'—the thought hurriedly caught before it flees. Sometimes, phrases, like "My/First Big/Lie Series", "Plaidy" and "Julie Christie" in *El Greco's Knees*, are given the heavier emphasis of a black marker pen. Above all, there is the enigmatic presence of the title. What, then, is the relationship here between word and image? The question is a delicate one, as Michel Butor reminds us, since, "if the

title has such great importance for the plastic organisation of the work, it is also true that the work of art can receive enormous damage by an inappropriate name. The artist who does not pay attention or care can, with a simple unconsidered title, impede the viewer's ability to see the work." Many titles and words in English's work form a poetic or fairytale nucleus, not limited to providing verbal or aural colour to the work. They acquire an almost primary importance, in some ways parallel to the Surrealists, in so far as—they paid so much attention to the choice of title that they would often let a poet choose for them—it is enough to think of Miro's *Constellations*, 1940–1941, in conjunction with Breton's *poèmes parallèles*.

In any case, in Simon English's work titles or phrases are never extraneous elements that create a total disjunction with the image typical of the deferral of meaning between word and title in Magritte's work that Foucault describes as *trompe l'esprit*. Rather, title and image are poetically explosive, they proclaim and declaim themselves. They may be strongly metaphoric like *Real Rosette*; evocative like *El Greco's Knees*, or *Army Pink Snowman*, a synthesis of several references drawn from both inside and outside the collective drawing that entrap us in a paradox of violence and saccharine nostalgia; or, as in the case of *Ansuya Blum*, chosen, among other things, for the beauty of its sound. Other titles are a simple peripatetic of the word itself, like *Haddock*, which alludes to

The Shadow of the Pomegranate by Jean Plaidy

Hergé's cartoon *Tintin* (English admits he is smitten with Haddock). The symbiotic relationship between image, words and drawing give substance to and are in tune with the image itself. The titles never constitute a catalogue or classification, they are never illustrative or explanatory like a caption, but are a continuous invention of meanings, uncanny and powerful, that irradiate like the ripples produced by stones thrown in the still water of a pond. They create a web of possible relations.

Throughout Simon English's drawings, the symbolic is never consigned to a figure, never a substitution for it but, on the contrary, it produces an interactive union of image and word, an intriguing synchrony capable of suggesting an endless analogical association. The semantic fragment, the lexical chain, is altered by the grouping of figures, functioning as a note scribbled on a piece of paper, an intermittent pulse. Each title holds a humorously poetic tune, able to establish an arcane and fragile rapport between image and world. The rhythm in his drawings as a form of narration is impregnated by figures *in* suspension and figures *of* suspension in an extraordinary poetic metaphor that creates a

RENEE MAGRITTE
*The Magic Mirror/
le miroir magique*,
1929, oil on canvas,
73 x 54 cm,
courtesy Scottish
National Gallery
of Modern Art,
Edinburgh / Gabrielle
Keiller Bequest, 1995
© ADAGP, Paris and
DACS, London 2005

fairy tale universe. One might say that his work is constituted by two texts: one that is purely visual, of the image, which is a kind of 'body', and another, the title, which is the 'soul', often a pure subjectivity, an enigma, a proper name, a 'void' without reference. Between figure and title is established an electric circuit of meaning. The title transforms the work and its context, influencing the entire structural organisation. As Roland Barthes reminds us, when we juxtapose image and text they reinforce each other's radiant value, and participate in a simultaneous perception that belongs to 'pure vision'. In its involvement of word and image, the artist's work goes against the grain of contemporary culture whose consumer has an increasingly weak relationship with words, writing and reading.

Thought as Image

The image in Simon's work traces a serpentine movement: the serpentine temptation of the soul that becomes flesh. From this movement is born the figure of bodies, sometimes solitary, sometimes coupling. These scenarios find parallels with Flaubert's idea of art, where he writes that this transitional movement makes one slip without realising it from the height of the sky to the depth of the anus. English's work is constituted by a particular, aesthetic universe that draws on his own biographic memory and the imaginary of art. His images are always conjugated by a complex and ambiguous narrational structure, following a rhythmic cross-contamination of many styles. But the principal poetic of the work is the encounter with the image as a moment of revelation, when the line empties and loses itself in an image, only to find itself in the fiction where any difference becomes a resemblance by surprise. It is a play taken to the point where what is generated is a tumultuous mirroring of projections, of reflecting images, of an image of an image: pure figuration.

The interweaving of these various levels produces a visual sequence that plays on lightness and the stratification of images, reminiscent of the accumulation of TV images as well as the atmosphere of Plato's cave. This allows the artist a freer contamination among

SIMON ENGLISH
detail from
Real Rosette,
2002–2004

parts, enabling his figures the possibility of mutual slippages. Such contamination enriches the possibility of representation and puts it under the sign of a dramatic, sometimes cruel, sometimes comic, fragmentation, where, as we see, there is no discernable distinction between the fantastic world of the child and that of the adult. With the end of ideology, the contemporary artist now finds a vast repertoire of linguistic remnants that can become

the raw material of the work. But in Simon English's drawings the use of quotation is never an attempt to rescue old values; rather, these remnants of the past become a kind of readymade displaced from their original context and resemanticised into another figurative reality. One senses the need of the artist to recreate both his own subjectivity and a collective one, each now no longer unified but fragmented and ambivalent, where different feelings, from cynicism to cruelty, tragedy to comedy and irony, are put into vital and conflictual play.

Figures

Figures is the title of an installation of 2004 comprising 12 panels of drawings on paper collaged together without any apparent narrative sequence. The strategy expresses a minimal adjustment from the generative space of the studio to the gallery display. Certain figures are recurrent, revealing an intensely personal lexicon of imagery—the winged man, men suspended by their ankles, dressed as furry bunnies, disporting a bear's head, engaged in sexual couplings—that combine and recombine in encounters reminiscent of a quasi-mythic world between the sacred and the profane that is also that of classical animation where anything may happen, anything may shape-shift into something else. Thus, the lightness of touch of the drawing, the luminosity of the paper ground is placed in counterpoint to a mood that is nocturnal in its tonality.

Two figures in particular emerge from the deep psychic shadows of the drawings: the winged man and the orgy. The winged man, perhaps an angel, carries significance here as one of the most important imaginary figures in modernity in so far as it directly addresses the position of the subject. Hybrid and therefore in some sense monstrous, it once occupied the intermediate space between heaven and earth, symbolic of the fracture but also the mediating possibility between the divine and the human, and on an unconscious level a fascinating but fearful androgyny. But already in Rilke there is the sense that the angel has abandoned the modern world; it is now a sign of irremediable loss. Henceforth, the artist can only seek the redemption of the subject in fraility, in the metamorphosis of things, to express through the figure the precarious world of appearances. We can now grasp the significance of Simon's use of hybrid forms, because they are the very condition of the subject in a contemporary metropolitan world devoid of metaphysics, subject only to the endless play of order and disorder. Such a world is a place of insecurity, now segregated from the thought of the absolute. Like the 'angel', the figure of the orgy is rooted in mystical experience, in what lies outside the linguistic framework of the everyday as an impossible excess; the orgy, as Bataille describes it in *Story of the Eye*, is an indefinable but regenerative space in which the dissolution of the boundary between self and other leads to a new recognition of the other.

'Figure' etymologically correlates with fiction and reconfiguration. The figure is the focal point of art; it sustains the

centrality of language because it conveys both the desire and the intention of the power of the imagination. Desire is a transvestite that transforms itself through various clothes linked to the expressive urgency of circumstance. Therefore the figure in art is multiple and chameleon-like; it can wear a variety of materials and techniques to display itself to the gaze of the viewer—a theatre of seduction, because art can never descend to the level of ordinary communication, it never speaks through the mask of the everyday. But rather, it acquires a level of form that is unpredictable and original. Seduction is necessary to create a flash, an opening in that pragmatic inertia of the everyday that Blanchot called the "kingdom of *déjà-vu*", of the already known, the grey comedy of habit, a stupor that breaks horizontal impenetrability, capable of crossing the barriers of social exchange. The foundation of English's eroticism as desire is precisely the figure as a particular and ex-centric modality capable of holding the impulse of art. In the moment of creation the artist suspends any relation with the outside, cultivating a distance supported by his 'anti-social' attitude. He begins to feel all the internal turbulence of the creative act—by definition, catastrophic—and reaches that strange condition of dynamic calm, which is the very sensation produced by the drawings themselves.

The body here becomes hybrid, a mixture of human and beast, evidence of the obsession of the artist with his own image. This emerges through various details of an imaginary that is impeded from making any totalising relationship with the world by a tormented biography and a historical context in profound crisis. Hence, Simon English's figure acquires a multifaceted body, it assumes many masks that allows the imaginary to express the desire to carry in its turbulent movement the root of life which is death. Living for English means exactly to expand the iconographic field of the everyday towards an overcoming death. That is, his art discloses the impossibility of life to articulate itself as it is. For this reason, to overcome is also to assume the destructive impulse. As Nietzsche commented in *Twilight of the Idols*, "In art there is a joy that brings with it the pleasure of destruction." The artist, in order to construct, must always depart from a landscape of ruins; only from here can there be any attempt at reconstruction. Simon English's work is exemplary of this condition: the creative process cannot invent something from nothing; it is nonetheless from the fragmental residues of a prior and catastrophic cultural or biographical memory that work can be realised. In the artist's drawings the image is also the uncanny; it is what donates its unquiet atmosphere, underlining the solitary violence of the imagination. At the same time it is supported by a systematic discipline that allows the artist to overcome this threatening solitude and move towards a relation with the world.

Figures are suspended, isolated in a state removed from external gravity, so that they acquire the character of a flux or movement. It is the sign of an interior mobility and disorder that precludes the articulation of narrative as such. The world presented is a precarious and turbulent field in which the figures rely only on a momentary stability. This places the image outside

the tradition of naturalistic perspective—the element that was so discomforting in *R & W*. What prevails is a language of expression with its own traces and *lapsus*, completely devoid of any narcissistic abandonment to the pure pleasure of the sign. The consequence is that our attention is drawn to the sphere of the unsayable—that complexity ever more silent, ever more hidden from contemporary existence. This is what constitutes Simon English's artistic maturity; it believes in art as a deep experience, but rejects any simplistic notion of the integration of art and life. Rather, it holds to the possibility of invention that can operate in the fluctuating interstices between the complex forms of art and the pre-existing forms of life.

Context

In summarising Simon English's work, the question of where to place his iconographic universe arises. On a closer look, we can say that, even though the artist shows a certain fascination with the past, his practice needs to be understood above all as rooted in the present. From the more recent past he introduces strategies that belong to the historical avant-garde—a projectual intentionality and therefore also the construction of the 'new' familiar from Surrealism and Dada. But in contrast to the avant-garde, still secure in its subjective unity, the drive towards constructiveness in Simon's work takes place inside a catastrophic subjectivity, decentred and dispersed through the complex web of relations that constitutes the contemporary field of the social. His merit is to have understood that the intentionality of project and the construction of the 'new' are neither merely the result of a simple flow of time, nor of a nomadic dissemination. His drawings delineate another place of the aesthetic experience, vast but defined, that can still find a meaningful position in the contemporary artistic landscape.

In his work, the constructive intention of the new certainly re-vindicates the importance of the project; but this is a palimpsest whose potential is not yet exhausted, it is still capable of being free of 'avant-gardist' encumbrances, free of their mission to reinvent the world in its totality. The artist is fully aware that he operates in a cultural context that renders art peripheral, if not completely marginal, in the face of recent trends in the system of art, which almost entirely coincide with the demands of the market itself and mass entertainment. But he does not relinquish the necessity of giving form to those things that have value for himself rather than those that satisfy the expectation of the consumer and the taste of the marketplace. He chooses to develop according to an internal visual coherence that escapes any form of rigidity and allows him to be involved with the complexity of the act of making, in the construction of montages open to the unpredictability of manual engagement rather than the strictures of technological means. It is a portrait of an artist who travels light, dependent only on his own resources.

Under these conditions it is clear that his work is also free of the recycling aesthetic—by now an international style—which

appears perverse and insubstantial, no more than a function of the spectacle, because the vital tension of art cannot be replicated through a purely iconographic index. Simon English's work is antithetical to that imperturbable repetitiveness with which many artists feel compelled to show us their own viscera and misery collapsed into marketplace kitsch.

Against this perspective, Simon English's work resonates with doubt; it oscillates in the sphere of the not-any-longer and not-yet, in that place uninhabited but endlessly criss-crossed where he may yet enact a productive dialogue between the dimensions of abstraction and figuration. In this way he presents a challenge that stands out from the current situation. As we have argued, his work incorporates the concept of construction as a manifestation of a projectuality, minimal and probabilistic, capable through intuition and invention of capturing the mythologies of our culture and therefore of transcending the impoverished reality of the present and its apology. It looks to a future, one not framed by a distant ideological utopia, but by the modest sensibility of the intimate. As Hugo von Hofmannsthal suggested in his aphoristic *Book of Friends*: "Inside the narrow limit, the more particular task, there is more freedom than in the vast kingdom of Utopia imagined by modernity."

Simon English
by Bill Arning

Bill Arning—Simon English

What does one do with an artist like Simon English? In his works he delivers images to the eyes and brain in a blizzard like way. His images, dark, sexy and troubling, swirl around our psyches like sparks, ready to immolate our sense of the real. For picture addicts like myself English is the equivalent of a crack dealer.

His works are evidence of and analytic tools for considering the visual turn our culture has undergone. But while the common wisdom is that new technologies have changed the cultural hierarchy and placed images on top, English shows that this is a much older phenomenon, and might even have claims to some trans-historical veracity.

Fretting over the so-called visual turn our culture has taken over the last couple of decades is pointless. Nothing has changed. Since human culture began pictures have held power over us. Perhaps we have a few more images surrounding us today, or more likely they are turning up in unexpected places. The distributed technologies of ubiquitous wired flat-screens have made a vast picture universe omnipresent, but the same technologies have made everything perpetually available, words, music, shopping and sex, so pictures are no different.

Recently the process of figuring out the meanings of the guano left behind by culture, puzzling through the pictorial poo seems more rewarding than the semiotics of linguistic leftovers. That might be the result of academic policies requiring scholars to publish as often as normal folks piss. The only way to keep the interest of academic presses is to find virgin turf, something that hasn't been analysed a thousand times. Poof, the visual turn is discovered, and replaces the earlier linguistic turn. As Richard Rorty proposed, the subject of philosophical investigation was once things, then ideas, then words. Other theoreticians, such as WJT Mitchell, continued Rorty's progression to the present and found that we are now concerned primarily with pictures. It is an elegant construction but I find it difficult to look back at a world history that includes Baroque art, the obsessive private world of Henry Darger, Japanese tattooing, baseball cards and heavy metal album covers without thinking that pictures have always ruled our world.

The truth of the matter is that since that primal magical moment when depiction began pictures have had inordinate power over human minds. The earliest manifestation of conjuring through making pictures may have been the cave man filling his mouth with a coloured material and then spewing it over his hand to leave a proto-signature of his barely conceptualised self on a cave wall, or his more imaginative buddy in the next cave sketching with burnt wood four lines, a head and a trunk indicating a game animal; in others words, the power of pictures to conjure either self or others.

Pictures have had a tremendous, intoxicating power over human imagination and that power has had certain uses: to make us more devout, to arouse our libidos, to offer aesthetic pleasures, to sway our opinions; but the central effect is that of transporting us out of the hum-drum continuum of our daily lives, to let us forget who we are.

The salient quality of anything that humans can become addicted to, is the ability to offer an immediate change in how one is feeling. It doesn't matter whether the substance or activity will make you feel better or worse, as long as it makes you feel different. The only unbearable option is to stay exactly the same. As Noel Coward said in a long ago lyric, "The invitation said come as we were, and we stayed as we were—which was hell."

The most effective mood-altering substances are booze, drugs and cigarettes; they do their jobs so well that they have saved many lives, offering an option to self-annihilation when nothing else could help. They serve to remove inhibitions and allow those who are stuck in the ruthless web of normalcy to act differently and find a hint of happiness. But in their efficacy they are destructively addictive, since the liberating and comforting

SIMON ENGLISH
Studio shots,
London Lane, 2003,
photography:
Goswin
Schwendinger

effect soon goes away. Other addictive mood-altering behaviors such as having sex, falling repeatedly in love, expressing rage, eating sweets, over-tanning and indulgent shopping can either be good or bad. As they rarely kill the host body quickly they can continue for a very long time and seem less like a destructive pathology than a troublesome quirk and hence go untreated. There is also a full range of positive addictions—exercise is the most common, but self-sacrifice and charitable works are others. No one will stop those suffering from these addictions as to do so might only result in another more destructive addiction taking its place. So we let those suffering from positive addictions take one spin class after another with no more than a raised eyebrow.

Picture addiction exists too. While it may not occur to anyone to stage an intervention when someone refuses to leave the Prado at closing time, that feeling of "Let me just see one more gallery" is, more than likely, familiar to anyone who cares enough about pictures to be reading this volume. And it is nothing new; as long as man has made pictures there have been those among us who felt the right quantity of pictures was always more, and there could never be enough.

Those of us with this affliction have reported the strange sensation of missing the experience of the picture before us, because we are already glancing at the next one. Andy Warhol once described his experience of eating chocolates the same way. When he would have one in his mouth he would be wondering what the next one would taste like. He continued this way until the

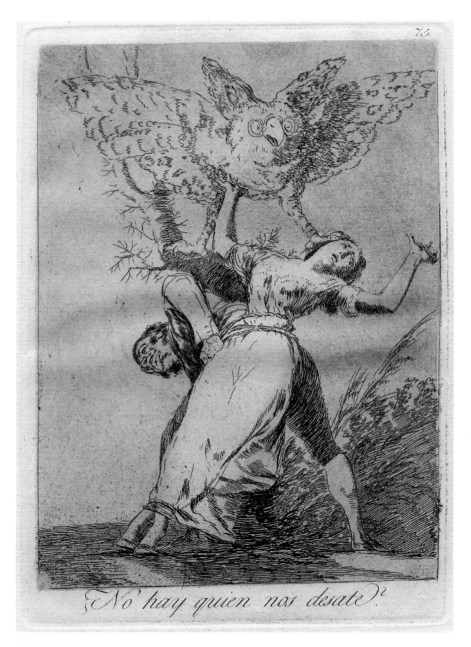

¿No hay quien nos desate?

FRANCISCO
GOYA
Will No One Untie Us?
Capricho No. 75,
c. 1799, etching

whole box was gone, and was left with the sad feeling of having missed that joy of tasting any of them. 20 minutes before closing time at any of the great museums of the world is pure torture for those of us with picture addiction: what to see? And is it better to stand still and look harder at the one before us?

I have felt the power of picture addiction and it is probably the reason why I became a critic and curator in the first place. This was the one field that offered nearly unlimited opportunities to indulge in this vice. I have talked with other curators about this. As a people we do not know when or how to stop consuming images.

I can obsessively look at old master paintings for hours, then move to a fashion magazine, then a couple of hours of internet pornography, then onto a visually rich film. A dose of pictures that big would kill a beginner. The loss of a sense of hierarchy in culture has caused the academic disciplinary crisis in which art historians morph into visual culture theorists, who can publish on fashion photography or the ontology of leather-themed pornography. If

in previous eras serious thinkers did not write in public about vernacular photography or porn, it was likely due to the shame of how self-indulgently fun it is, as there is certainly plenty to say of interest.

Simon English art exists as both a manifestation of and a royal indulgence in picture addictions. His way with pictures is self-aware but nonetheless compulsive. In other words, for English to make and for anyone to visually, mentally and physically consume these works one needs a hint of the malady.

The experience of encountering one of his accumulations of drawings—whether framed in the way the finished pieces are, or in the rough and tumble working mode as I first encountered them in his studio—will tell you quickly whether you have the picture addict gene. If you can stop after a normal dose of English's visual emissions—say the 15 to 20 pictures that are ganged in a typical work—you are probably normal. As I can get addicted to almost anything, like some genetically primed laboratory rat, I found stopping impossible. After a few hours in the

SIMON ENGLISH
Childhood doodling over Beatrix Potter, *The Tale of Samuel Whiskers or the Roly Poly Pudding*

ANONYMOUS
c. 1960, courtesy Michael Petry

studio when we were both exhausted from having discussed so many pictures and needing to get on with our days, I was ready to rifle through the trash bin outside to extend the picture buzz by a few moments.

English lets us consider magic, aesthetics and the erotic simultaneously, managing that grand slam of visual intoxicants, art, sex and God. With that combination his works will trigger compulsive viewing in nearly everyone. His amalgams of images are queer in

the less political sense. Acknowledging the different ways the word is used in the English-speaking world, they are 'queer' as an Irish grandmother might describe the introspective youth reading poetry in the corner; they are also 'queer' in the OutRage!/ACT UP activist mode that demands that our sexual drives be respected as fundamental components of human happiness, and the language intended to disempower its objects be reversed in a big phallic-power-grab.

English's image world is also 'queer' in the pejorative way that makes kids cry when the word is lobbed at them—strange, and different from the others—for the scenes depicted are conspicuously wrong. There are fantasies here that one should never share or speak of, to which shame is the appropriate response. Even on the psychiatrist's couch, to share one's sadomasochistic fantasies, replete with animal costumes, populated by the elderly, androgynous adolescent youths, and a few mythic characters, might well horrify even the most jaded therapist.

That they are in this conspicuously drawn form grants them their particular power. To stage and photograph such scenes would be overly literal. Even the best actors when placed in such scenarios would reveal too much in their facial expression. Either they are safe from the psychic and physical dangers these scenes suggest, in which case the naughtiness becomes trivial and comic, or they appear severely at risk, in which our role as passive viewers because morally unbearable.

To describe these extreme actions in language would be worse. As drawn images swiftly rendered, they are more the things we accidentally reveal with our shrinks rather than the entertaining scenarios that we prepare in the waiting room. At a certain point we would have to do what the divine Marquis de Sade did in the *120 Days of Sodom* to give the reader the sense of one atrocity following on the heals of another. Descriptive language failed and passions were spent, so he resorted to the database style of a scan-able list.

English did experiment in the late 90s with a series of performances and orgiastic choreographies using real human bodies to enact certain similar scenarios. Human flesh is both specific—this mole, this hair—and general. We do not see a dancer's body and wonder what they had for breakfast. Nonetheless, when seeing the documentation of his performance works, I immediately wondered about whether the performers felt comfortable doing the things they were called on to do. Seeing them in conjunction with the drawings we must be grateful that he did not push his living collaborators as far as he takes his drawn creations. If he had, this text would likely be accompanying an art-from-prison catalogue. But English luckily used drawing to explore his dark side.

In drawn form they can flower into their full resonance as mental constructions, conjured from the subconscious and drawn out to be better transmitted to a sympathetic fellow traveler, as a virus might be shared during a soul kiss.

English's image world is uniquely his, yet it is reminiscent of many touchstones from the history of art, and its less respected

siblings, illustration and cartooning. Goya, Leonardo and William Blake rub up against children's book illustrator Beatrix Potter and gay erotic cartoonist Blade (Neel Bate). These unlikely bedfellows seem a less strange match when one considers them as a catalogue of the obsessions of a particular, compulsive collector. In which case it is not hard to imagine and describe the holder of this particular sensibility.

It is only in the false realities of archaic legal systems and architectures of hell that proud perverts are sequestered away. In real life one's darkest desires rub elbows against odd cute babies and collections of Victoriana. When the token gay character on *Sex in the City* starts seeing a cute guy, it is almost ruined by the ritual of clearing away the trick's collection of expensive porcelain dolls before sex. The affair ends tragically when passion leads them to carelessly fuck without clearing them away to safety, and one doll breaks. A close up of her shattered face on the ground made it clear that the actor would not be a returning character.

Such juxtapositions abound when one explores the limit realms of sex out of pure necessity or simple curiosity. Attending an established orgy group in the Boston neighborhood of Dorchester on a snowy night, I learned that the old band of brothers in arms who staged the sex event were also great fans of science fiction movies, and the room where one waited with other naked sweaty post-orgasmic men waiting to recharge for round two always featured a sci-fi movie on a big screen TV. The night I went it was *The Fifth Element*, starring Bruce Willis. That surreal, comic scene would not be out of place in English's image world.

The images themselves are hard to describe as from even a normal viewing distance they tumble together and verge on incoherence. One never loses the sense that his markings will resolve into bodies, human, animal, and some humans disguised as animals, but coherence in a classical sense is fugitive here. As when one walks into an ornately painted cathedral most of the figures will have no chance at imprinting themselves on our memory, we might look upward to try and grasp the figures hovering around painted in the cupola but, unless we are prepared to find a way to maintain that uncomfortable pose for a very long time, the bulk of the figures will just give us a sense of an unspecific haze of gestures.

English's works cohere as pictures from a distance primarily because they are fiercely delimited as discrete art works by the overbuilt frames. We are conditioned so thoroughly that even empty frames can nudge us into an aesthetic swoon; these structures make the accumulations that once sprawled across English's studio wall and floor into a permanent form. This is true not only in the very practical way of allowing them to be bought and preserved together, but also as a conceptually limiting mode, a type of visual punctuation. In our awareness of the function of the frame as a preserving mechanism against the normal effects of time on arrangements of works on paper, which tend toward dispersal and decay, we also attempt to read the works together as intended narratives or essays. Each group is titled independently, with evocative and non-specific titles, referring most often to English's chosen highpoints in the web of culture. We might get

a hope—perhaps false—that the frozen, titled accumulations will somehow stop for a second to allow for fuller visual apprehension. The puzzle of why these pictures are deployed together will eventually be cracked.

That is not the case. It is the business of art historians to puzzle out every figure in a Renaissance mural cycle. They may, after centuries, and given a thorough reading of the intended narrative, the patrons' identities and interests, and other cultural factors of the region and period, come to a possible name and function for every one of the painted multitudes. So we might leap into English's multifigured-visions and assume that the same Panofsky-Magic Decoder Ring is potentially accessible.

Yet English's choices have no similar program to allow decoding. As we progress from optic to haptic viewing distance each sheet within the whole starts its own little interior discussion, the figures struggling with one another for psychological primacy. Which one wins will have a lot to do with our own psychosexual and imaginative hard wiring. The Humpty Dumpty competing with the animal-headed swingers. The Renaissance lady versus the naked prophet. All contend to star in my little stories.

These names for English's characters are ones I made up, as it helps to have a name when one is trying to shift a scenario into long-term memory. When we have given a figure a name that sticks and resonates in our psyche, we can find our place in English's visual sequence again, like dog-earing the page of a book. If I have named a 'sadist with wings' or an 'overall boy', I can return to them, remember them, cruise them again. This is just like the names we give the men in bars, parks and other places where men meet as bodies with no jobs, families, histories or proper names. We are free to call them 'the manic-jacker' or 'nipple-master', since there and then that is their only referent in reality. It is the only quality they have that matters in that place.

Walking though a cruising park or the endless cubicles at a bath-house the urge to walk through quickly, scanning each body once, seems the correct way to begin the process of committing to someone, but it never works. On the next lap, the bath doors that were closed are now open. The promising candidates have all paired up with each other and one must start again. The most attractive silhouettes have dissolved into the shadows of the trees. When one has done enough laps that the faces are all familiar, a depressing self-awareness creeps in, how the lust to touch a few more bodies has compelled another night of walking in circles, like the characters in a Samuel Beckett play. It is easy to identify with *Happy Days*' static protagonist Winnie when buried to the waist with unfulfilled lust in a cruise park at 3am. Unable to move, Winnie has "So little to say, so little to do, and the fear so great." I have too often felt the same.

That is startlingly similar to scanning the characters in a large English work. We search for the clue to crack the code that brings the stories together, and in that we know we shall be frustrated. We also want the smaller scenarios to bring satisfactions of their own. They do and they don't, because each scene is suffused with a desire that has begun to curdle into

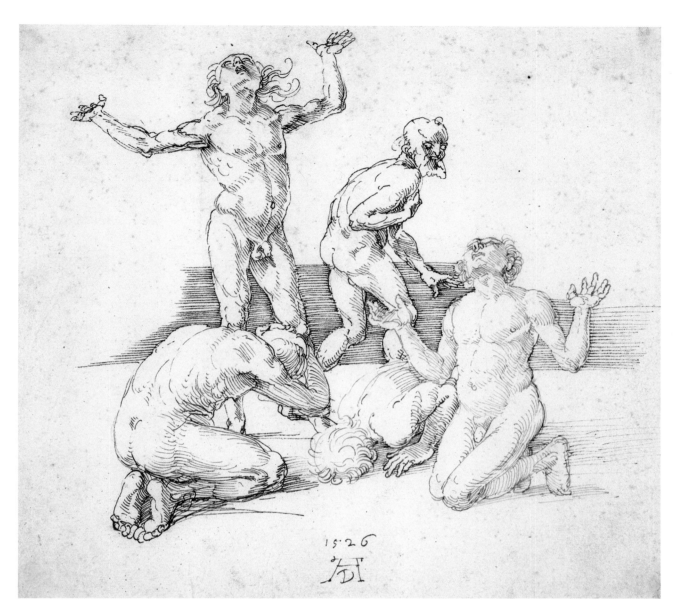

ALBRECHT
DÜRER
Five Male Nudes,
1526,
black and grey ink,
18.8 x 20.6 cm,
courtesy bpk Berlin/
Kupferstichkabinett,
Staatliche Museen
zu Berlin,
photography:
Jörg P Anders

something else, something that has started to go bad. But like the evolved taste one gains as an adult for the lingering taste of particularly stinky cheeses, that type of bad image imprints itself fully on our cerebral cortexes.

In attempting to know each of English's sheets my first response is erotic. My visual scanning mechanism turns on. I want to find the one image among the sea before me that will absolutely do the trick, that will reach down into my psychosexual core and transport me. Like reading through *120 Days of Sodom*'s endless list or following the cruiser's repeated encounters in John Rechy's *Numbers*, the numbing effort of scanning takes on an aesthetic of its own. I have been trying to avoid cyber metaphors, because English's language is clearly not grounded in that culture, but the most common real-world manifestation of the erotic scan is in fact cruising on the Internet, the best known being *Gaydar* in the UK and *Manhunt* in the States. The seemingly endless stream of faces and genitals is addictive in its own right. It is very easy to lose sleep by being unable to stop staring at pictures.

And the entrancing cyber posts are more pictures than flesh. Most people who start looking will keep looking long after any interest in actually meeting any of the men is gone. And it is not because this is a free or cheap version of pornography. One could masturbate to the pictures but it is hardly the point of the enterprise. Some that have the least effect on the libido can be the most fascinating.

English's mode of serial picture-making has much the same type of non-erotic eroticism. We look through scene after scene aware that we are in the realm of the sexual, and that provokes a certain type of hungry looking, but each and every image subverts a standard erotic response. English's Sadean amusement park is an existential agility test, requiring that we stand squarely and reveal our own secret desires in relation to English's visions.

Drawings that are not strictly studies are always missives. They are fragile speaking things always aimed at someone and their reception or lack of reception is a part of how we understand the work. What types of creations can function as love notes is very specific. Most sculptures don't work at all, and it would be hard to comprehend a suitor dedicating a video installation to you in hopes of getting you into bed. Mix tapes and photographic prints could work, but art historically, it was only drawing that could function perfectly as love notes. Paintings are too hard to produce, too costly in terms of materials and the time they take to make. In early Modern times paintings and sculptures were commissions owed to a client for their fee, so going back to Michelangelo—who gave his much-younger beloved a Ganymede drawing, which seems to have worked for him—the drawing had to be the mode of artistic seductions.

It is within this discourse of seduction that English's finely calibrated degree of finish and specificity of image needs to be understood. The level of finish is precisely chosen, in a way that invites the audience to entertain fantasies of narratives.

Much earlier in his work, English tried different ways to create ambiguity. He first rose to fame for paintings of nocturnal

visions, from which appeared multiple figures. In those works, the deliberate ambiguity was between torture scenes and death-camps on one hand, and SM/leather playgrounds on the other.

It has been often commentated on that there is an ironic contradiction in the desire of many men to speak of their loves in the bright light of common culture, when in fact they prefer to remain in the shadows. The eroticisation of the costumes of social control and power within often illegal play spaces is another irony. Another link between actual torture and sex play is that both require conspicuously theatrical presentation. This quality allowed English to show off his Caravaggesque techniques and degree of finish in order to maintain the right amount of ambiguity.

After a detour through sequential painting and installation, which let English practice the conceptual distance from his highly charged subject matters so expertly displayed in his current work, English tried using actual bodies. It is here that the reserve shown in his earlier groupings of work seems to break free, and the fun of the new work appears. Each of those qualities, ambiguity, experience, fun and conceptual distance, are in the current work. This requires the artist to finely modulate his ambiguities. He does so by keeping the sheets that make up his works in a way 'unfinished'. The lack of finish is breathed through with an intense desire to get the image onto the page. As if, if the image did not get down, the lover would leave, so like a Scheherazade he keeps spinning tales on paper in rapidly drawn form, the compilations mini Arabian Nights.

Perhaps the lover whose attention he is trying to get is not yet known and has appeared to this drawing maker—who we might consider English or his double—only in vision. He could have had a vision of the future, a vision of an alternative life that might have been his that he can make real in drawing. Perhaps these drawings are bait, each to try to make the lover come to him and soon. Or perhaps they are dream notations. When one is trying to remember one's dreams—to present to a psychiatrist or mystic—one is advised to keep a pad by the side of the bed, and to set the alarm for odd hours during the night. Without thinking, one is supposed to reach for the pad while still functionally asleep and get as much of the fugitive visions down as possible. If we take these to be missives from the artist's sleeping mind, he must awake with fevered sweats, a terrified gurgle and an erection all at once.

These images might have transited from English's unconscious to the paper only so that he may see them and make them real. One thinks of the precocious child who discovers a drawing talent and realises they can remake the world with pen and ink. Their teachers are rendered as their chained slaves, their parents as jackasses and their chosen objects of sexual desire become instead their horny suitors.

In coercing the world into the shape of their secret whims with the same hand used to masturbate and with a similarly nuanced quality of touch the youth gets to feel power over the world. This is a wonderful power of the drawn and painted world that Photoshop manipulations of photographs can only serve as a poor substitute for.

English's quivering line and multiple images reveal the presence of someone rapidly imagining a wealth of arousing and disturbing images to bring into view all at once. The line shakes and changes directions as new visions take hold of his imagination. And while the desire to see the world in this way is strong, the ability to show it to others is more powerful still; to find allies and lovers in the flesh through seductions. Each sheet is epistolary.

He also explores the dark side of visual imagination in a way that makes his pictures dangerous and therefore alluring. Some of the pictures could be outtakes from Goya, or illustrations for some of the Marquis de Sade's queerer passages. In fact the reason for ushering such fantasies into view may verge on the therapeutic. To put these scenes down on paper may be to rob them of their power to control the fantasiser's actions; since many of the operations we see would be punishable offences were they acted upon in the real world. To draw something in certain cases could be antithetical to living it out.

Like de Sade, Simon English structures his accumulated pictures in a way that mirrors the picture addict's looking patterns: one image leads directly, breathlessly directly to the next. One has not been absorbed, before one is actively taking the next in. By choosing to display these drawings in their accumulated form, English becomes his own collector. Collecting is a form of trying to organise the world. In a queer version of art history articulated best by Aaron Betsky, the origin of the museum is in queer collecting. Put simply, the queer leaves the closet to explore the outside world, and perhaps get laid. But the outside world is scary, sex is harder to find than anticipated, so instead the queer shops, bringing the exquisitely tasteful treasures of his travels back to the closet. Soon the closet becomes more of a trophy case that continues to expand over time until it turns into a private museum, then public. English has worked though these steps, with the exception of leaving the closet; English's journey may have been to the SM club or the cruise-park but the trophies are all generated from within.

The one thing they are not is conspicuously contemporary. There are no hints that the players in his stories are the same guys who cruise the Internet nightly. No one instant messages for help. If the space is a cruising space it is the gay beaches and forests that cruisers have colonised forever. It takes a queer sensibility to find romance in a dark, rat-filled urban park, cruising by the light of the moon and an office block. But in those parks, there is the hint that we are communing with an ancient dark force that drives human behaviour, that we glimpse when we let ourselves go beyond our limits.

Pictures are not lovers, even when the pictures are of lovers. There are some pornographic magazines that I have owned since my teenage years, and have moved from place to place over time. The stars of their pages have, from the amount of hours spent with them one-on-one, become real in a way. The importance of lover's photographs is in no way proportionate to their importance in one's biography—tricks can overshadow semi-long-term relations. What is this thing that happens with pictures in our lives that they

become so crucial? Are they based on the quality of the pictures? Are we rarefied aesthetes when considering the visual record of our desires? Will Roland Barthes help us here?

Is it picture addiction that makes us guard pictures with our lives? In answer to the perpetual question, what does one save from a burning house?, pictures are always third, after people and pets.

I should be careful here not to suggest that English is stuck on photographic images, which is very false. It is the dreamed worlds that he is most invested in, and it is clear that he does not find these images anywhere but in his mind. As a culture we might be overfull of photographic images. Even in our picture addicted souls we have reached a limit on photographic images.

But English's world can trigger out of control picture craving because it springs from a universal dark and creative place in his psyche. As our craving gets worse we want to be near to the Ur-source of English's font of images, as a junkie wishes to be near the dealer. We have confidence that the dry spells will be rare here.

Like all addictions there is no end until one is sated. That may have happened for me with Internet pornography. After years of filling hard drives with pictures in case there was a crack down one day, I realised there would always be more, and I was suddenly released from its spell.

But that has never happened with English's art. He works through so many unexpected psychological margins that I am forever wowed by the generative capacity of his brain. And that will lead to happy consumption of English's pictures for the foreseeable future.

Simon English & the Army Pink Snowman

Rosette Head & Bunny Bride
Oil, ink, crayon and print on paper
2002–2004, 210 x 130 cm

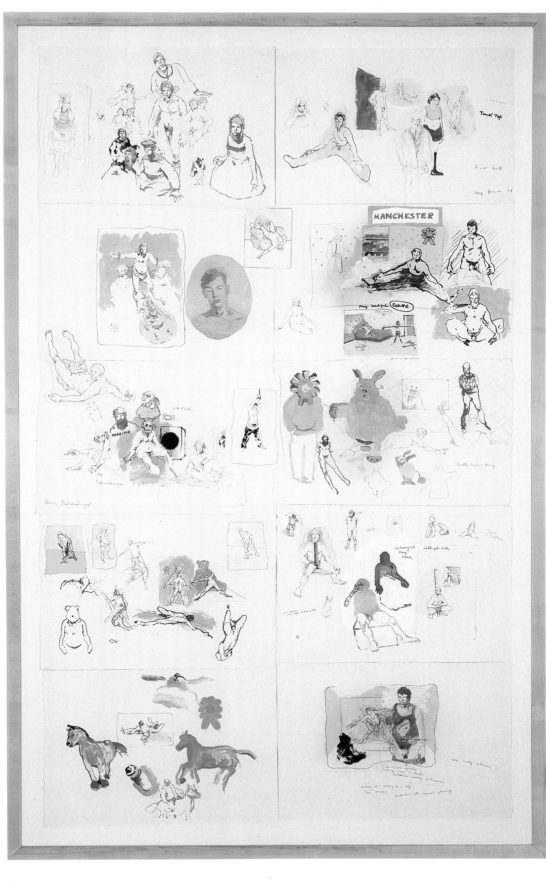

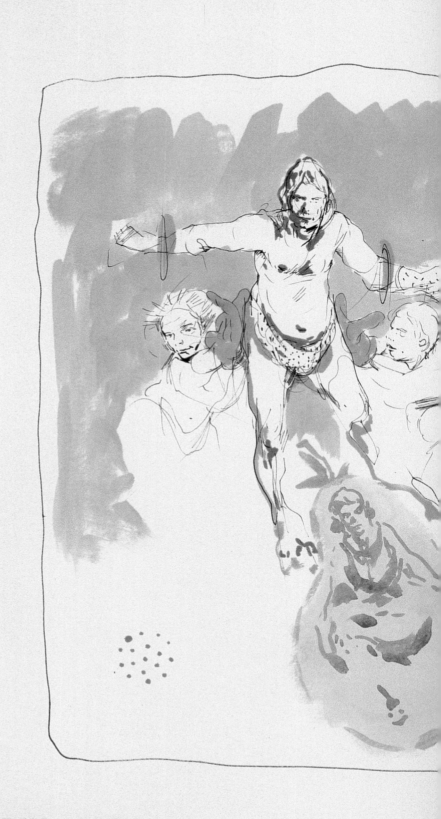

Rosette Head & Bunny Bride—detail
48 & 49

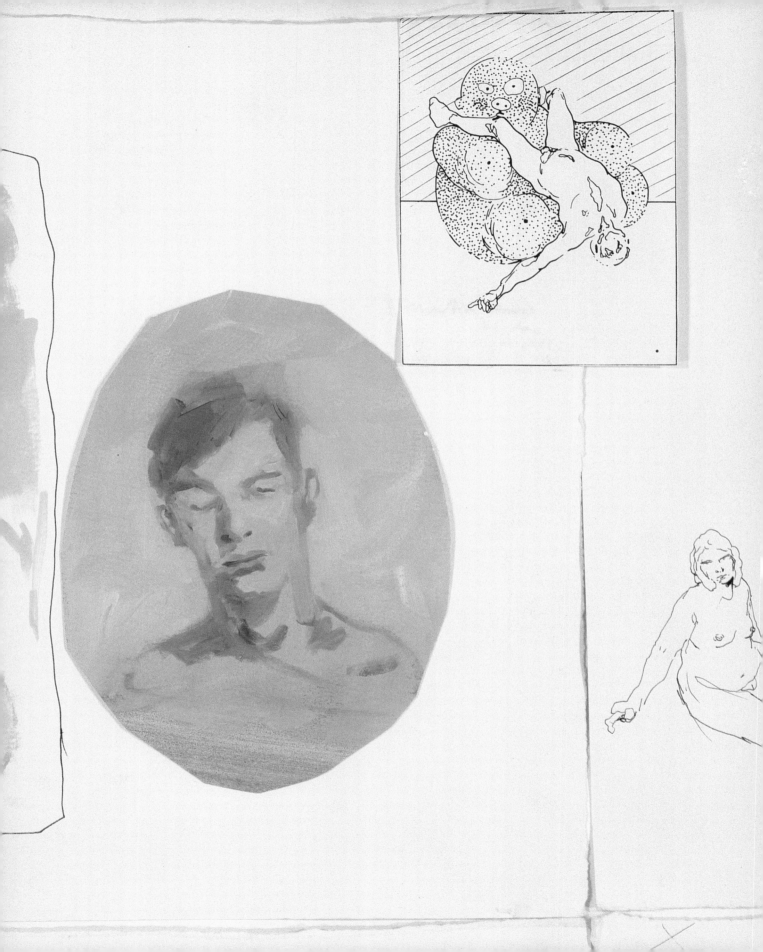

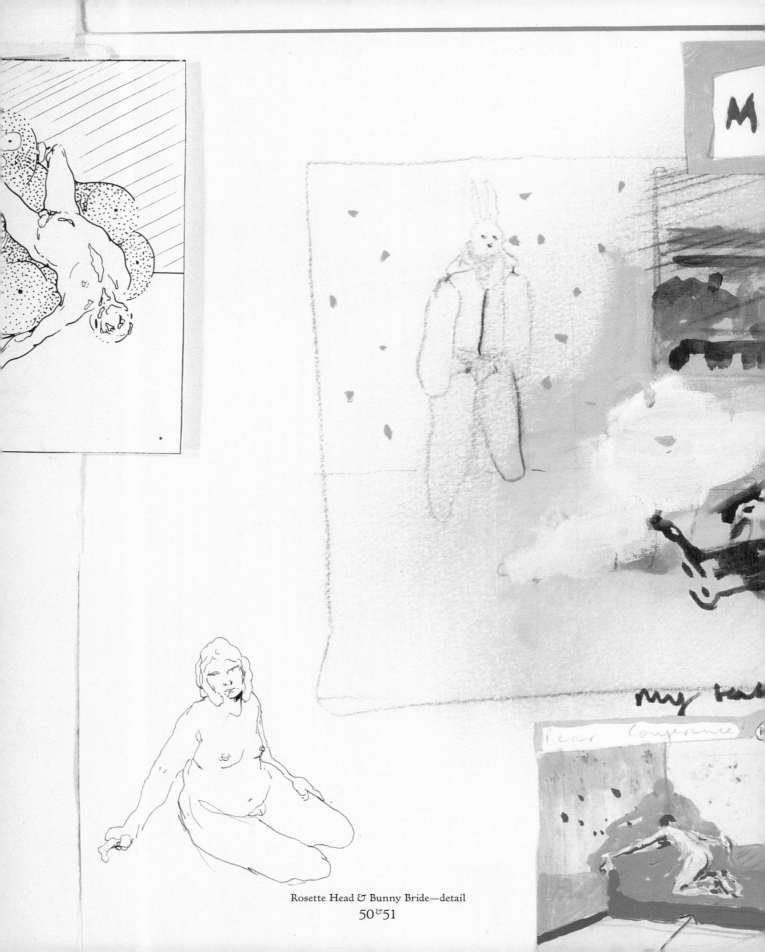

Rosette Head & Bunny Bride—detail

50&51

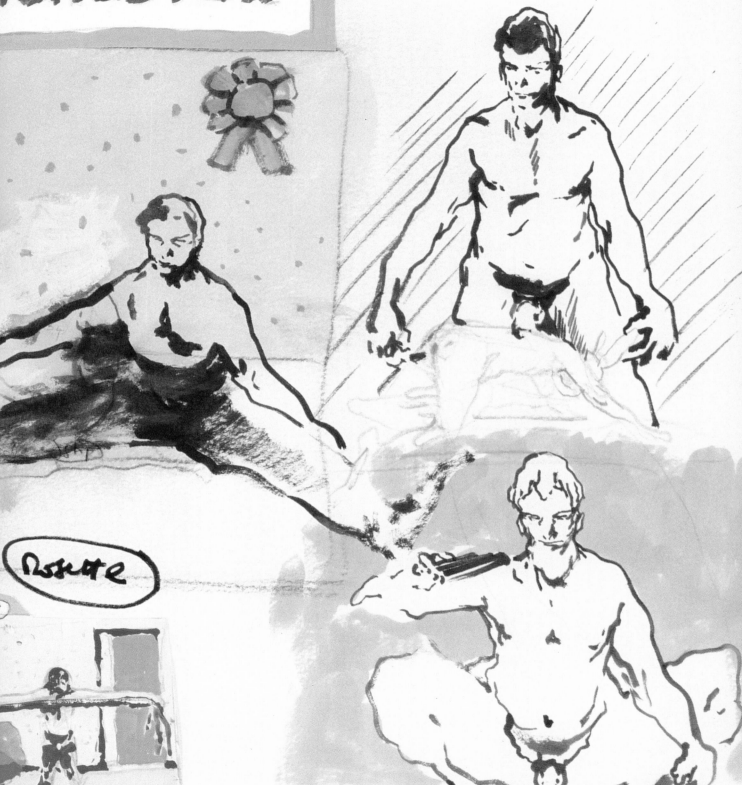

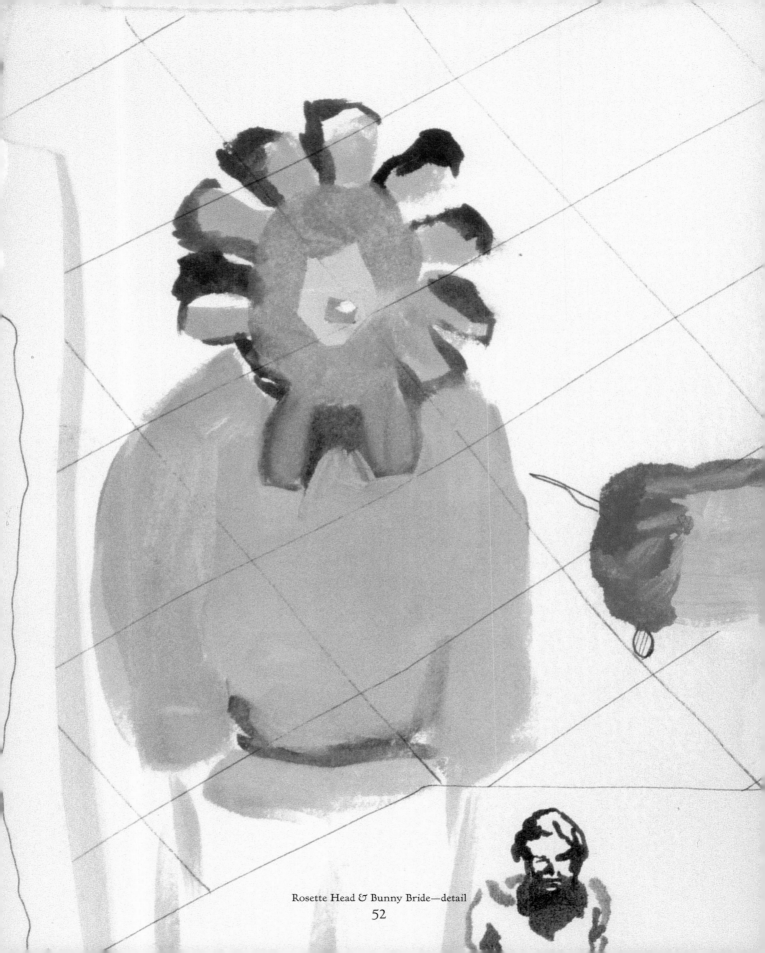

Rosette Head & Bunny Bride—detail

52

4 Doors—Ágnès b.
2004

1

2

3

4

4 Doors—Agnès b.

54

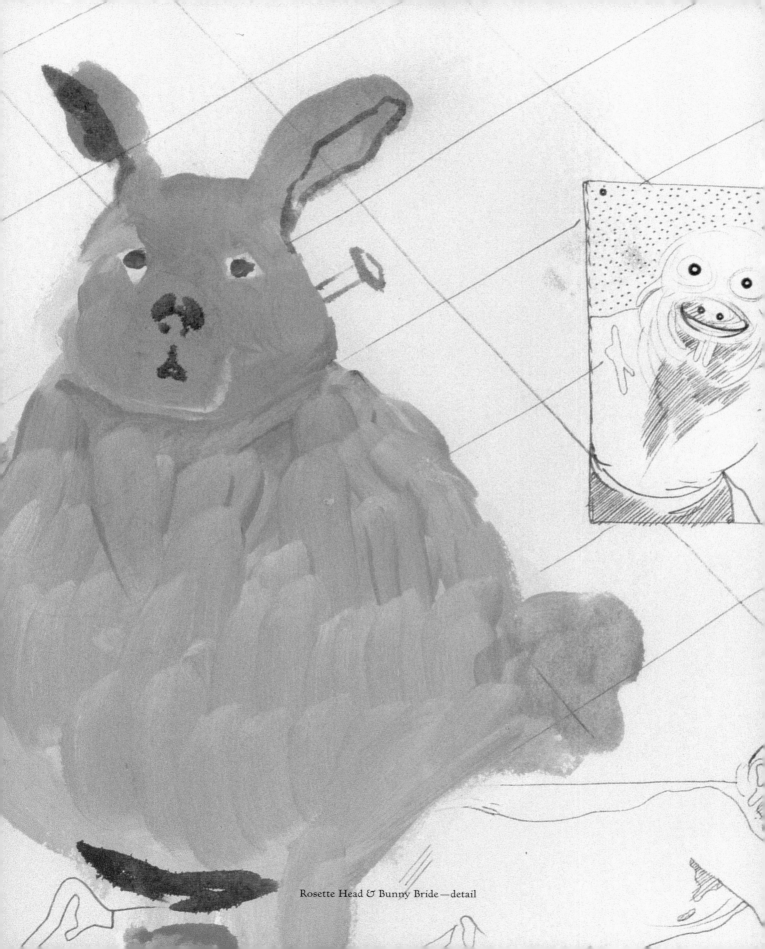

Rosette Head & Bunny Bride —detail

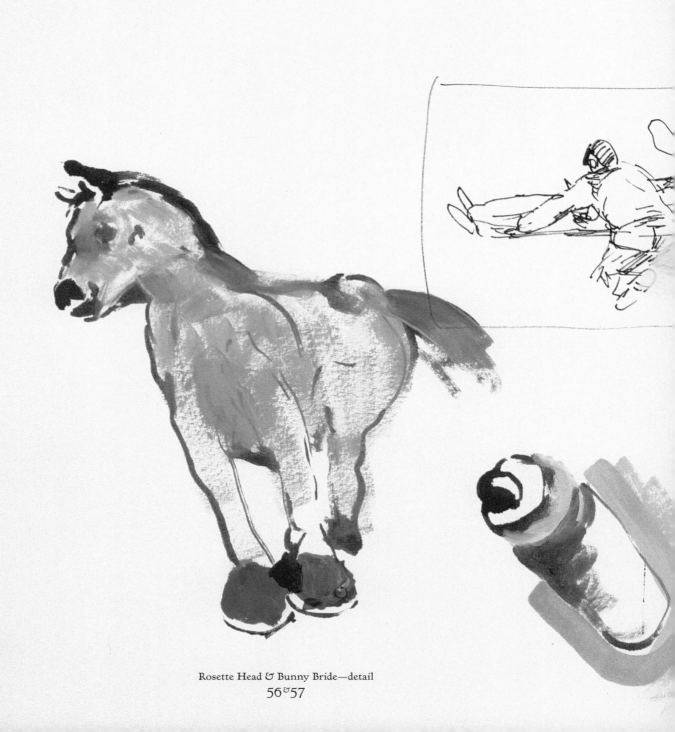

Rosette Head & Bunny Bride—detail

56&57

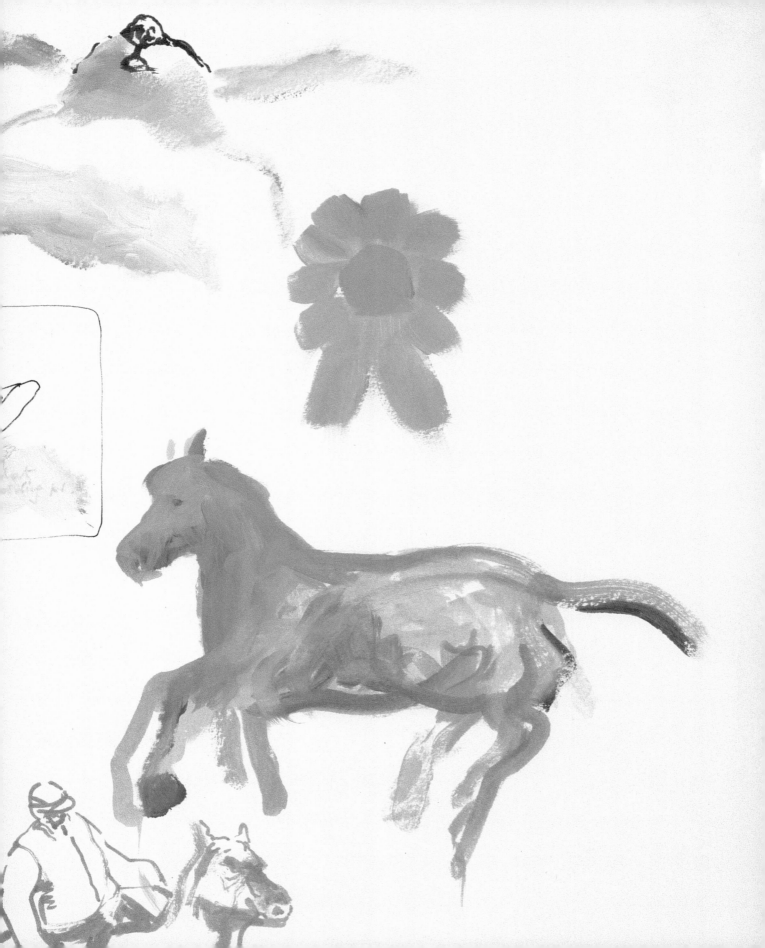

Ansuya Blum
Oil, ink, crayon, collage and print on paper
2002–2004, 210 x 188 cm

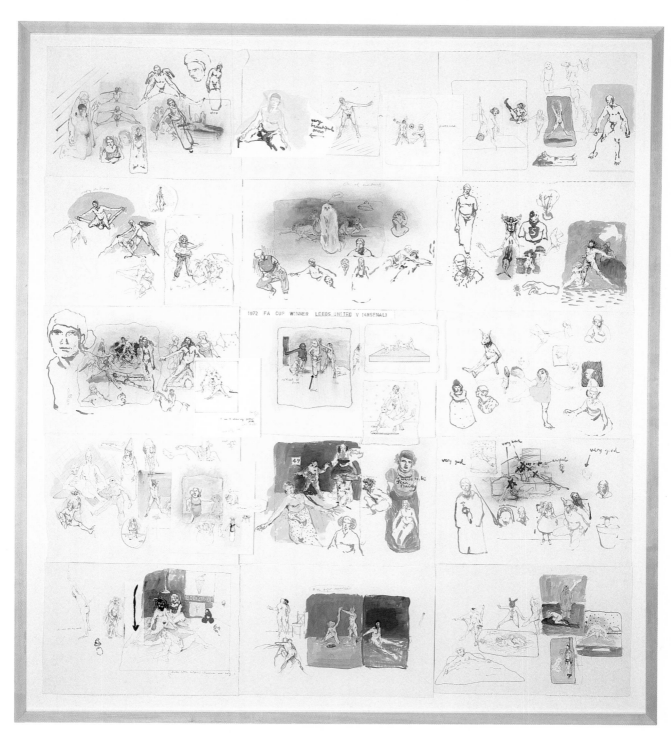

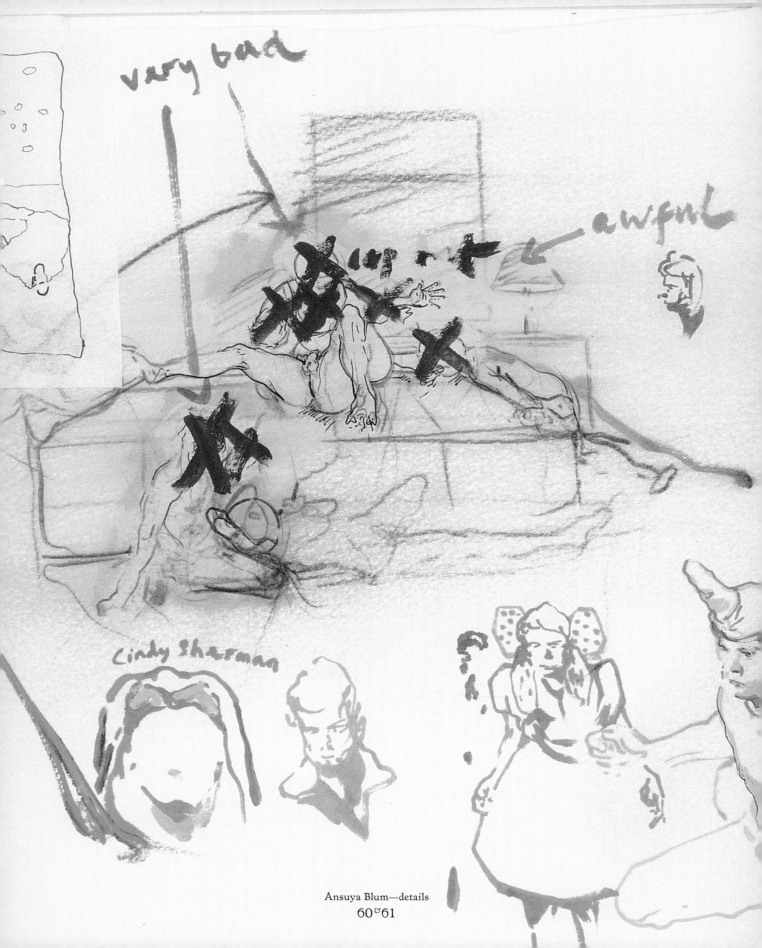

very bad

awful

Cindy Sharman

1972 FA CUP W1NNER LEEI

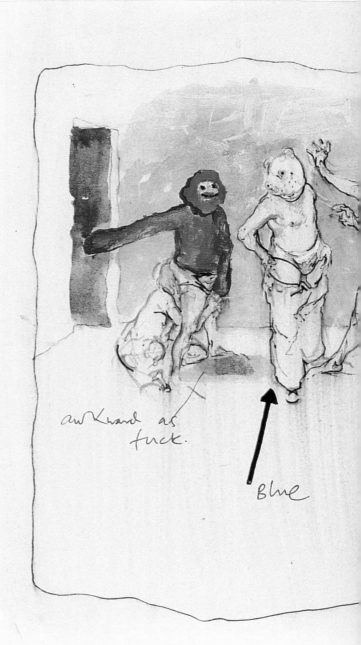

awKward as
fuck.

Blue

I was 3 when my father
was shot

1st big lie

Ansuya Blum—detail
62 & 63

very
well
painted

Bride

Oil, ink, and crayon on paper
2003–2004, 245 x 165 cm

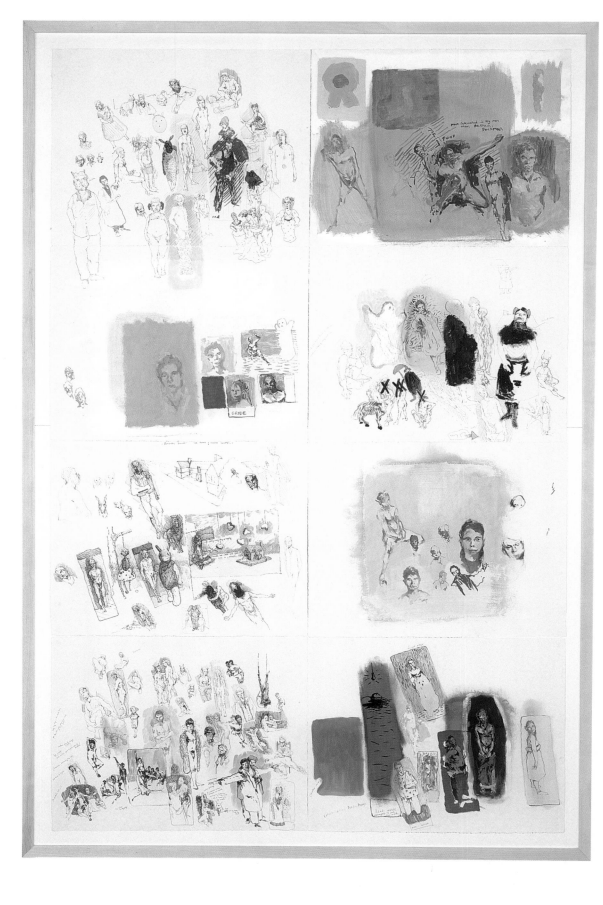

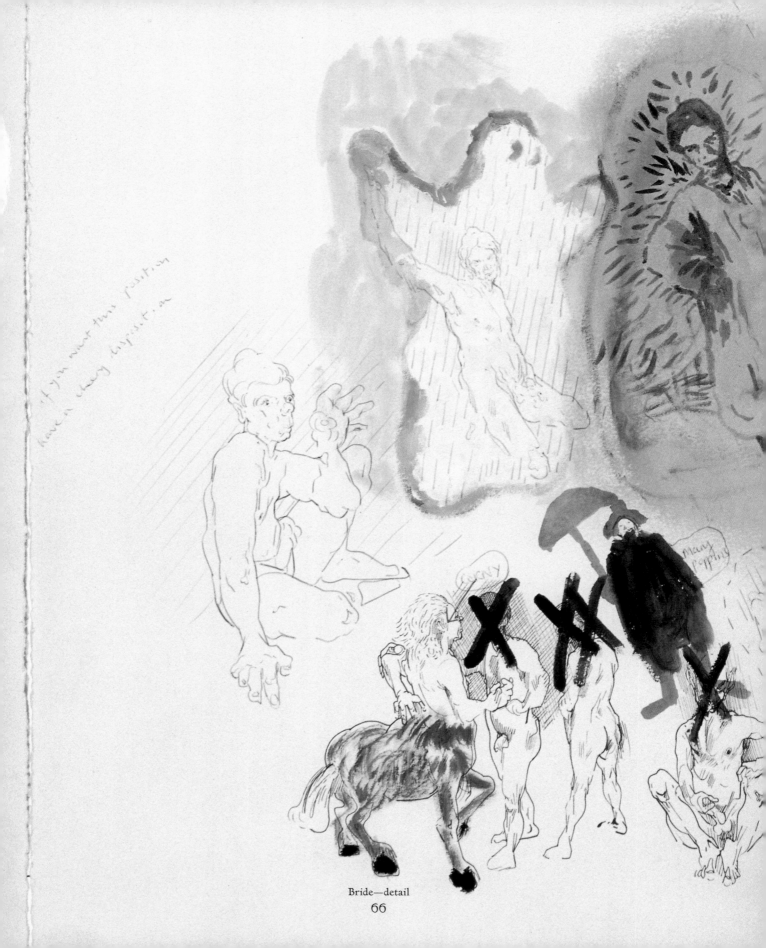

Bride—detail

6

7

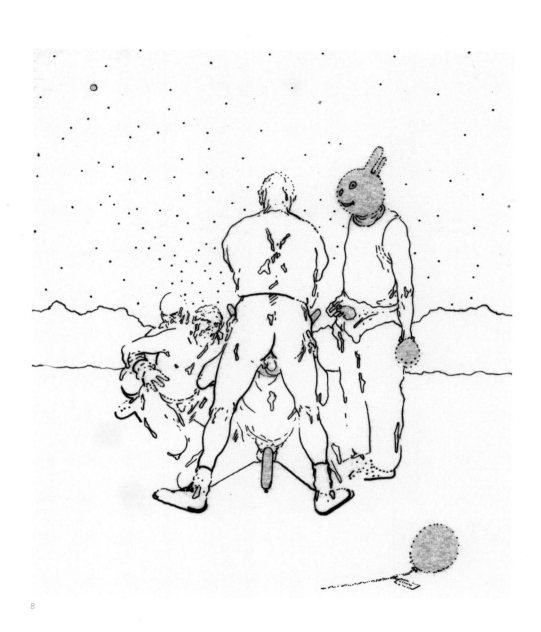

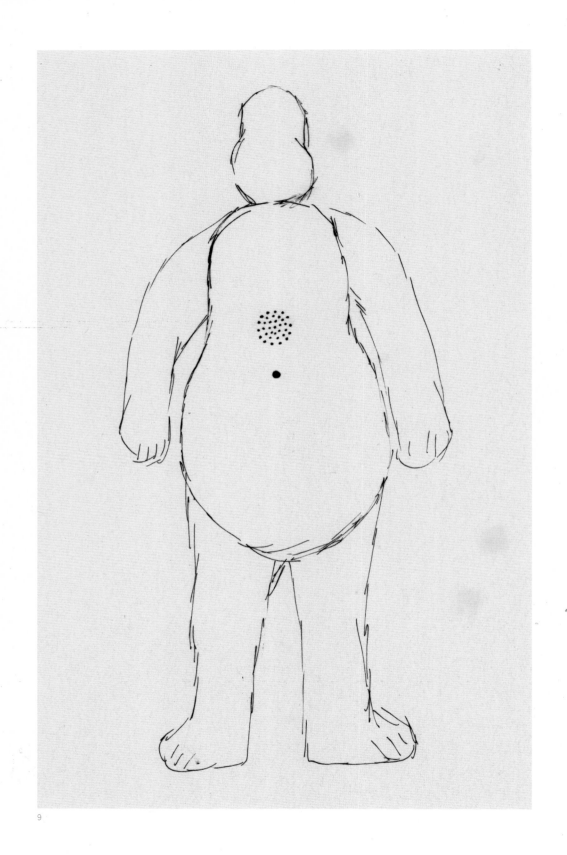

9

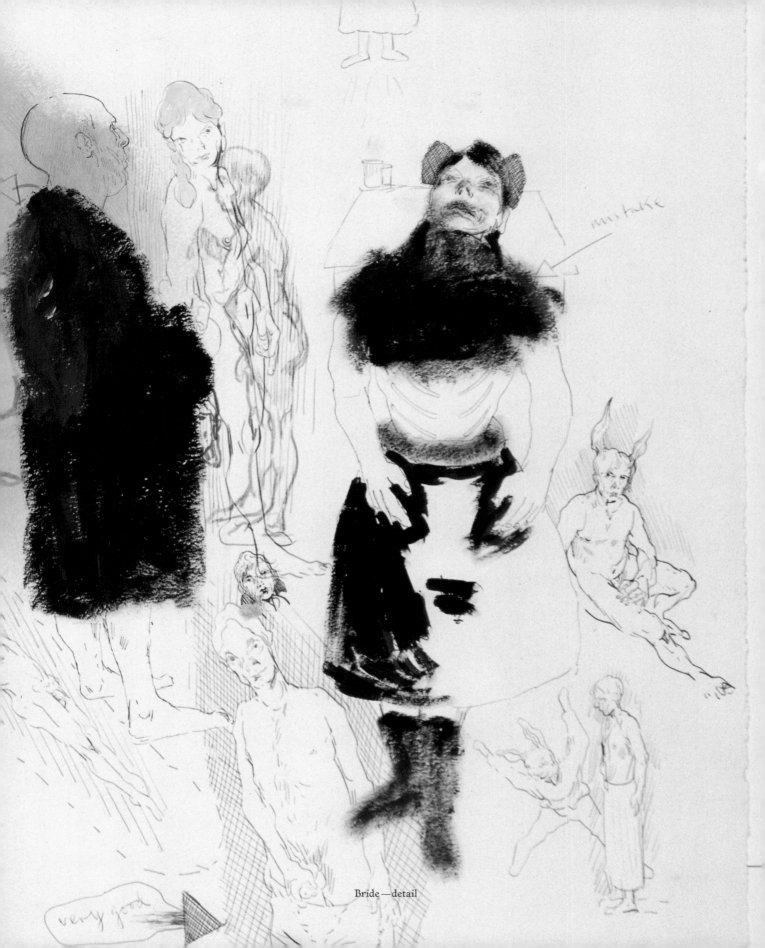

mistake

very good

Bride — detail

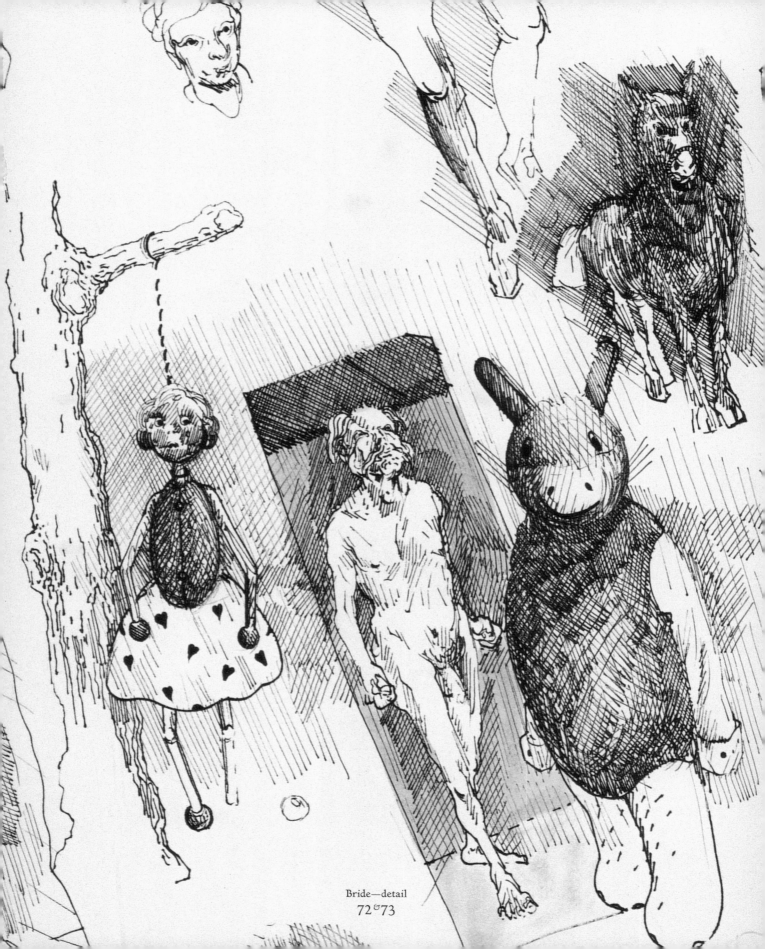

Bride—detail
72 & 73

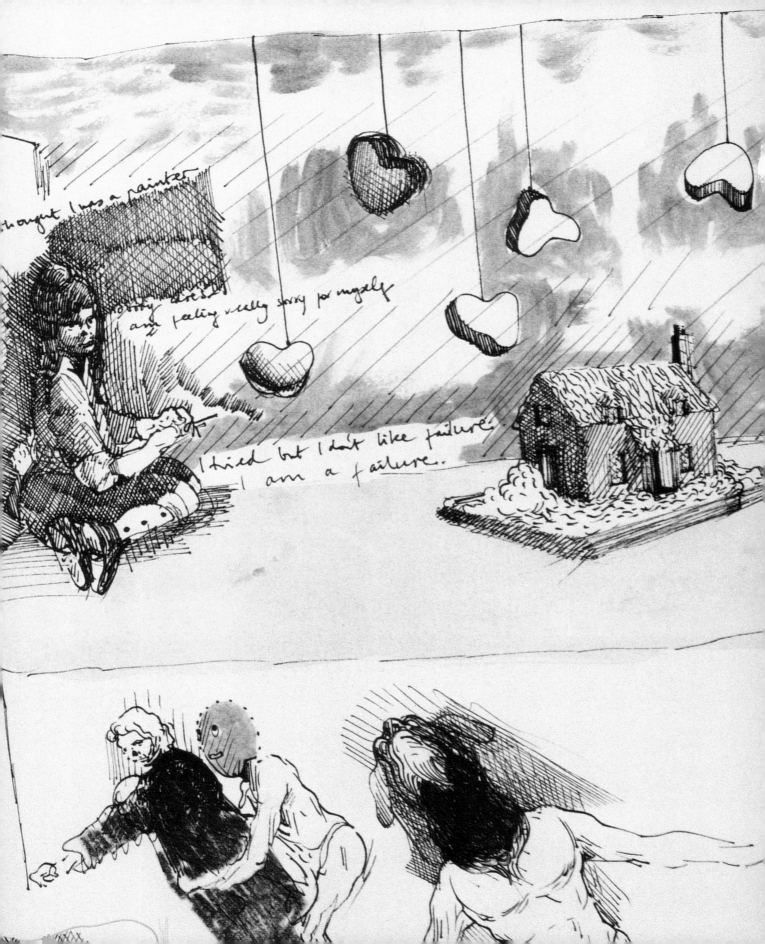

El Greco's Knees
Oil, ink, crayon and collage on paper
2002–2004, 210 x 188 cm

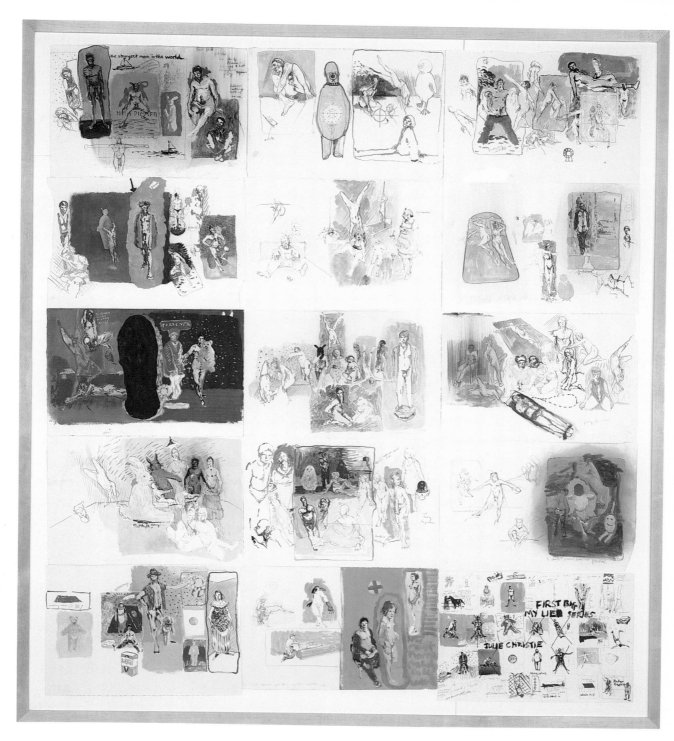

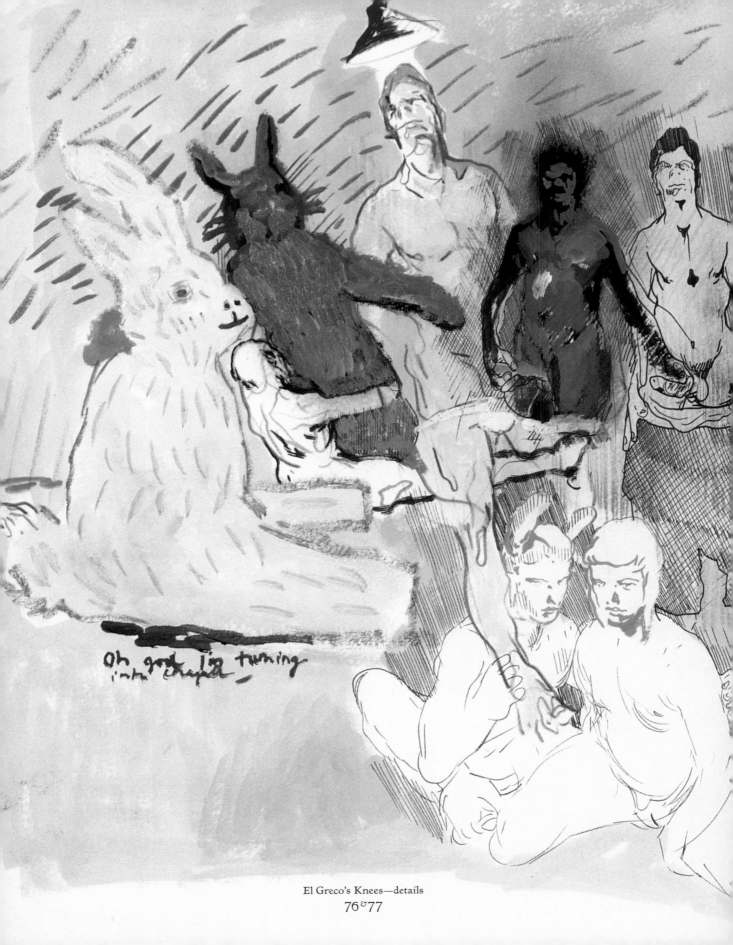

Oh god I'm turning
into chapel

El Greco's Knees—details

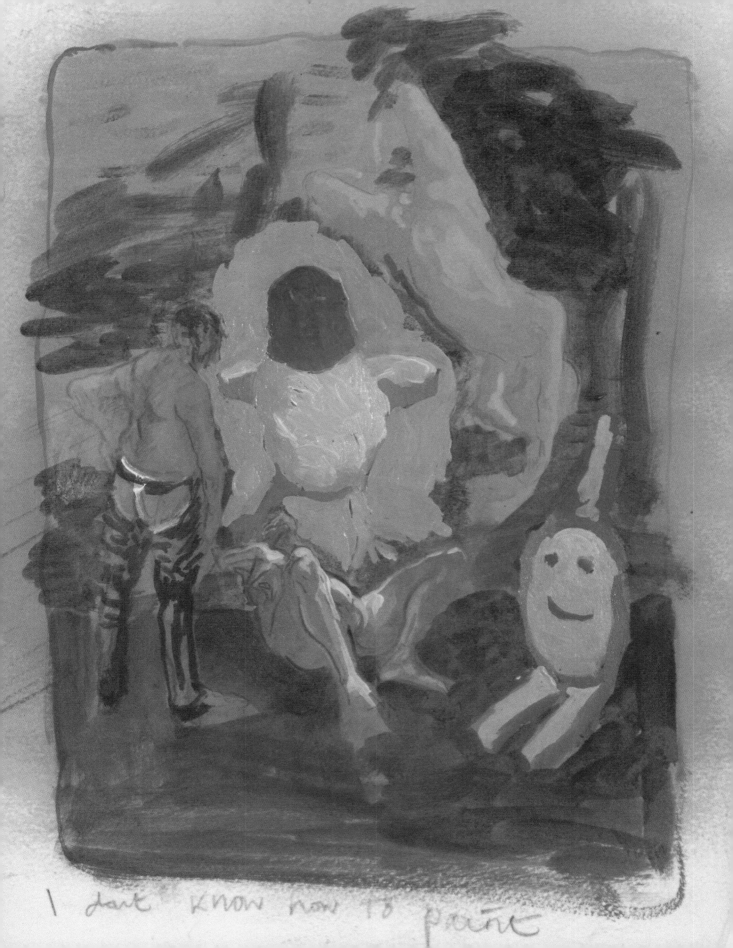

I don't know how to paint

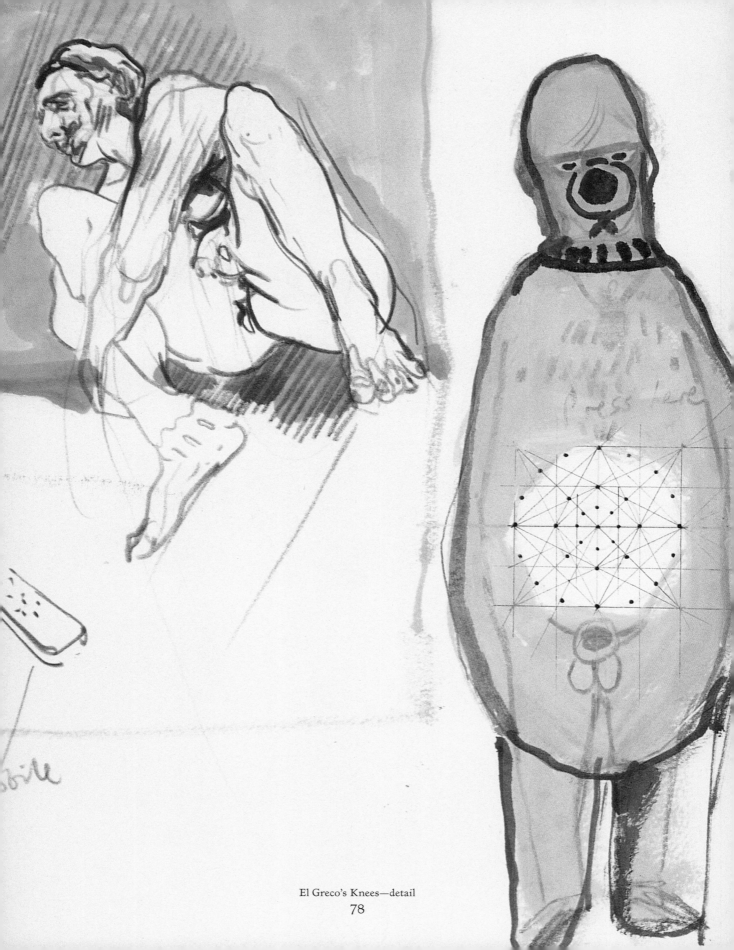

El Greco's Knees—detail

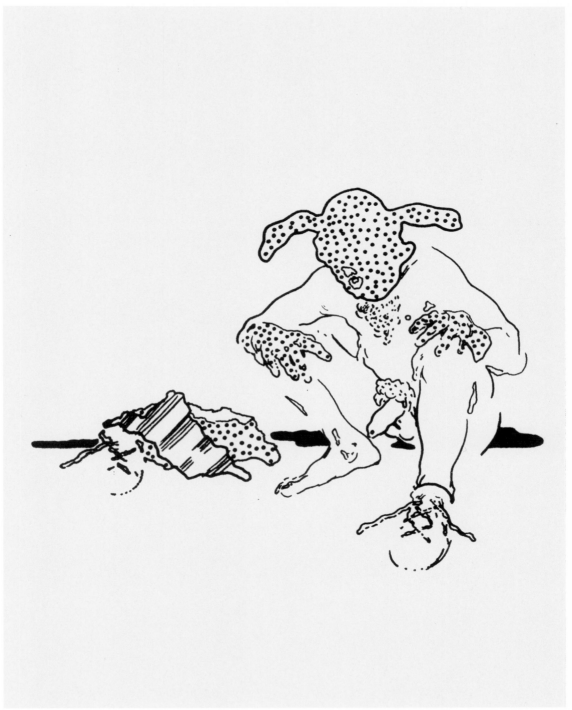

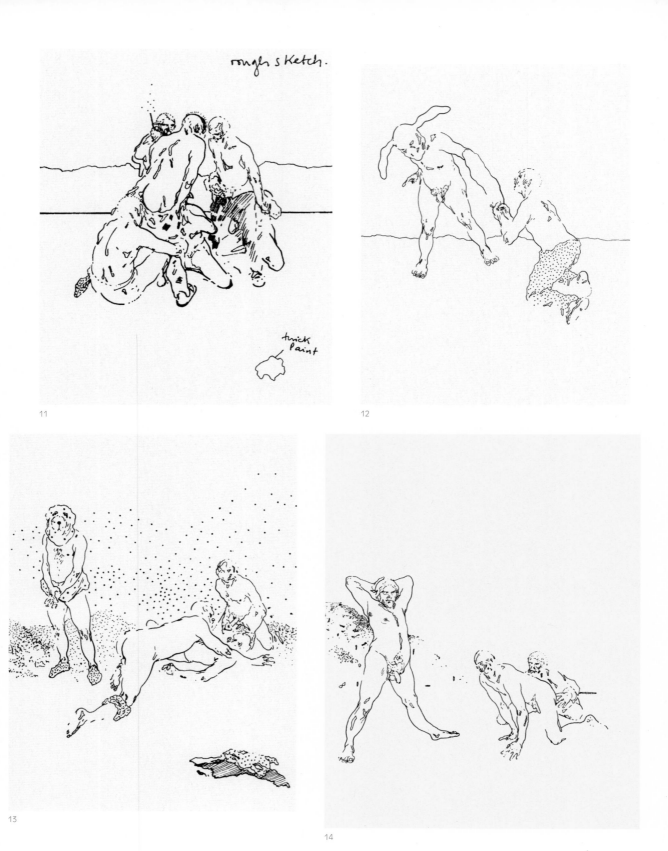

11

12

13

14

Drawing with Blu-Tack

15

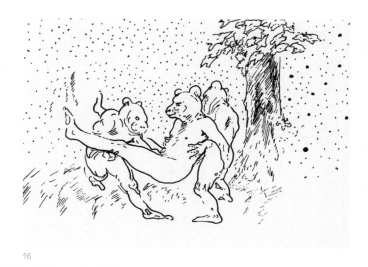

16

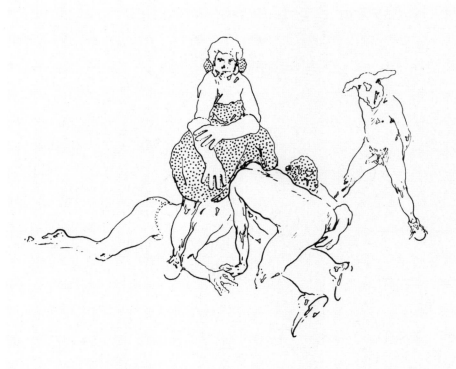

17

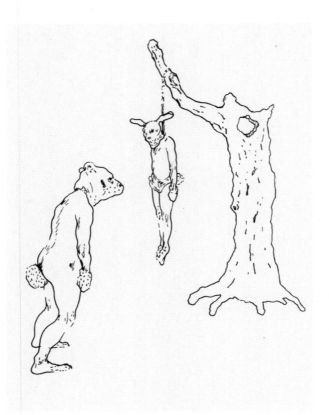

18

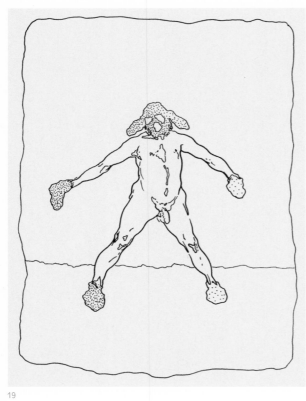

19

20

Drawing with Blu-Tack
82 & 83

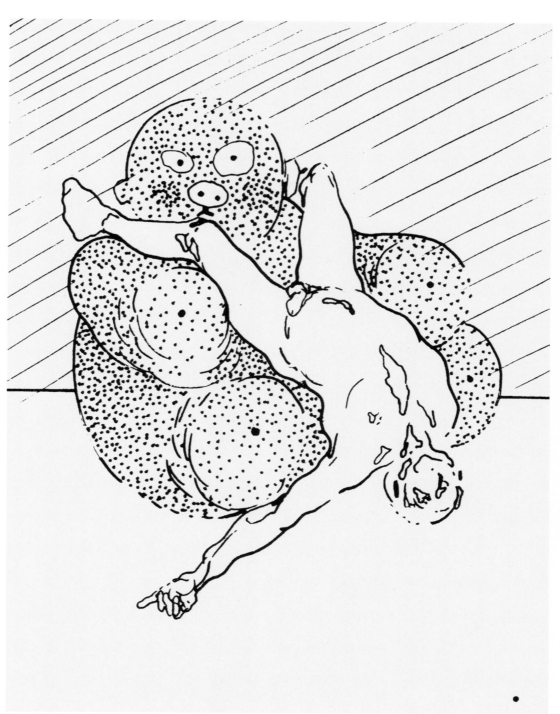

22

23

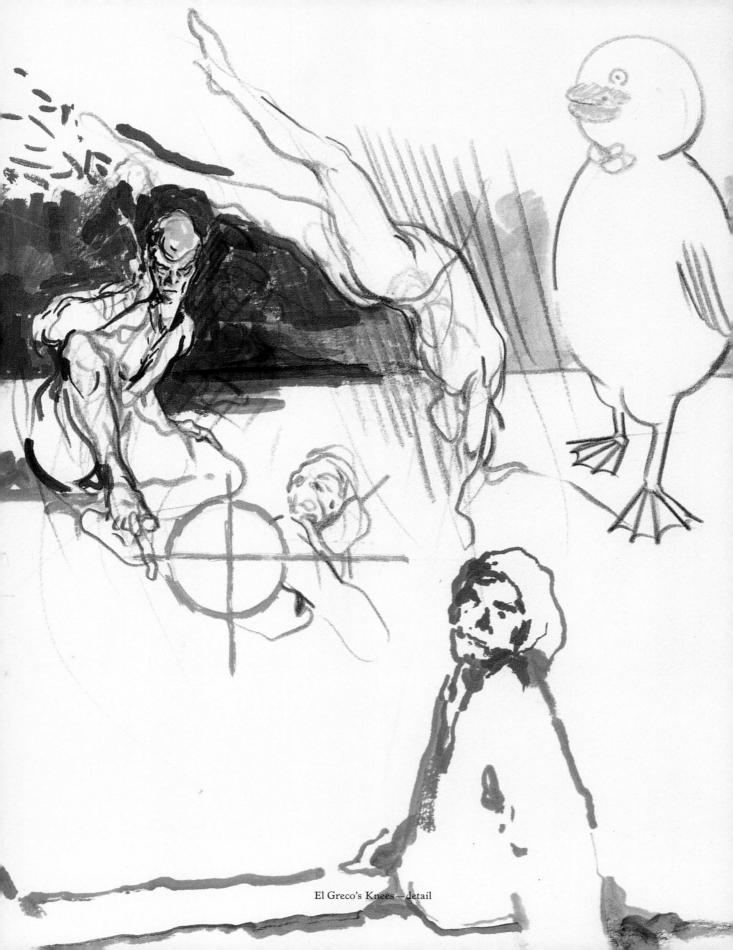

El Greco's Knees—detail

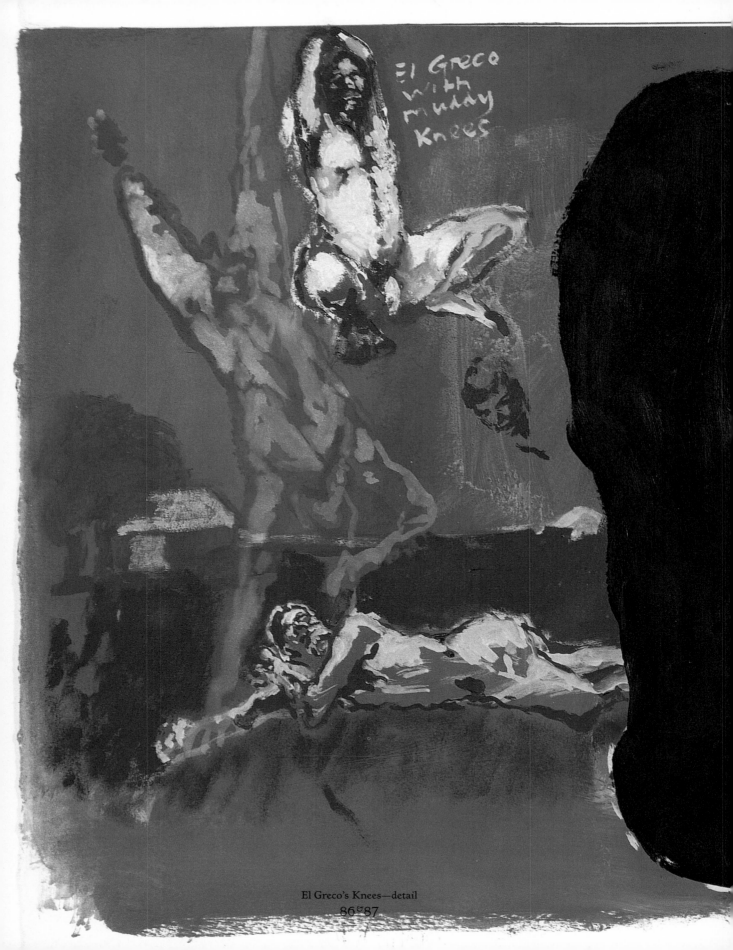

El Greco's Knees—detail

86&87

Haddock
Oil, ink, crayon and collage on paper
2002–2003, 210 x 130 cm

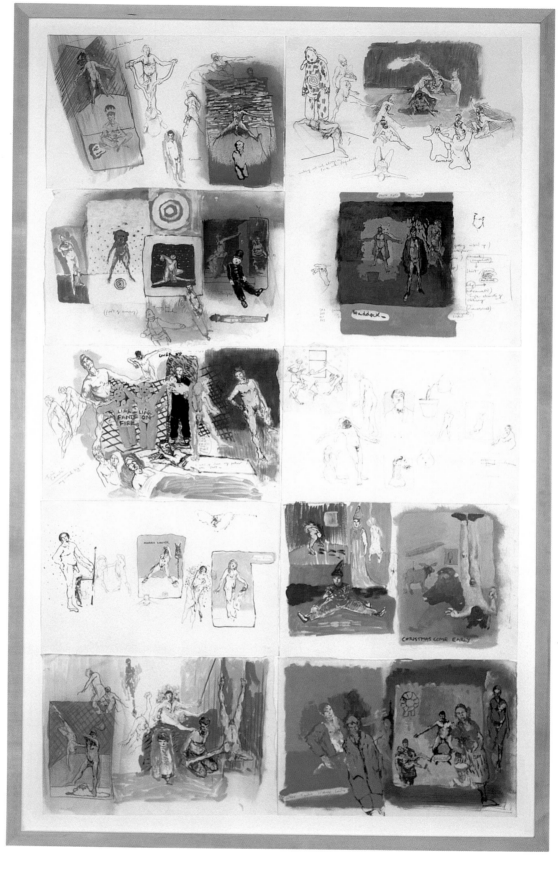

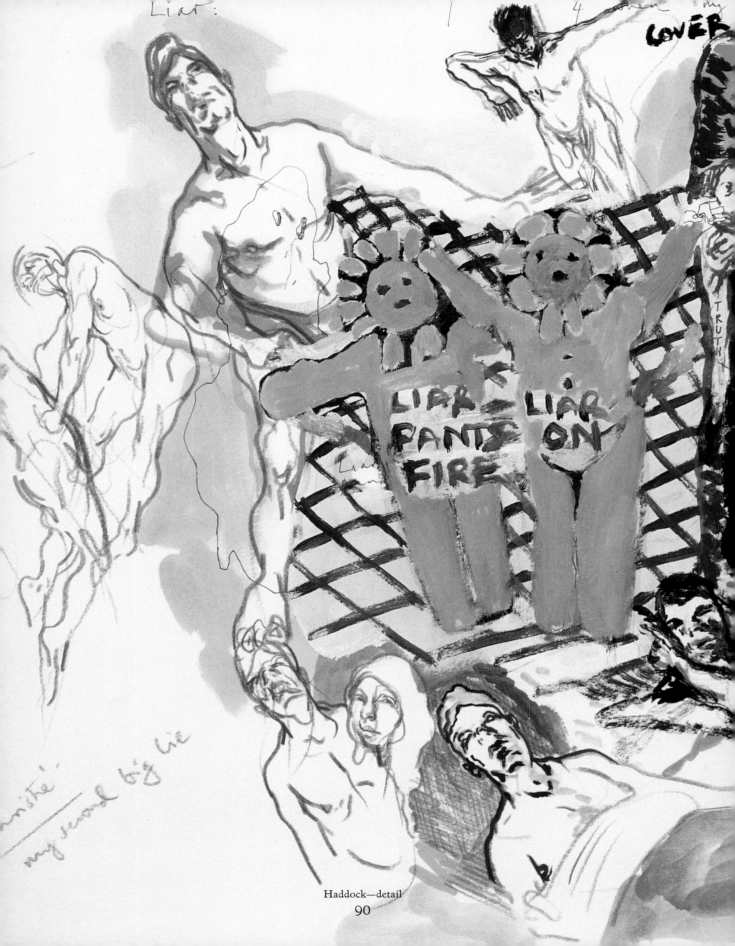

Haddock—detail
90

24

25

26

Blue-tack Rabbit

27

28

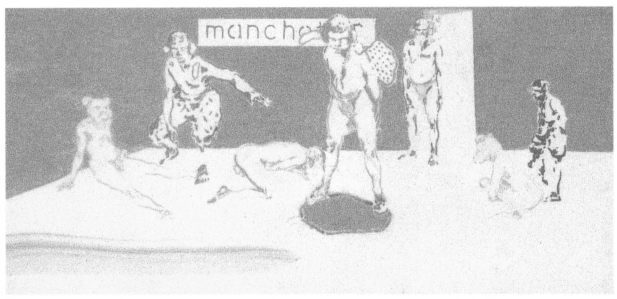

29

30

31

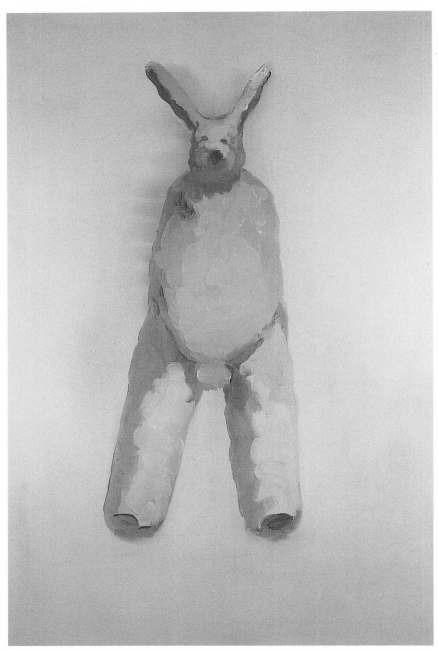

32

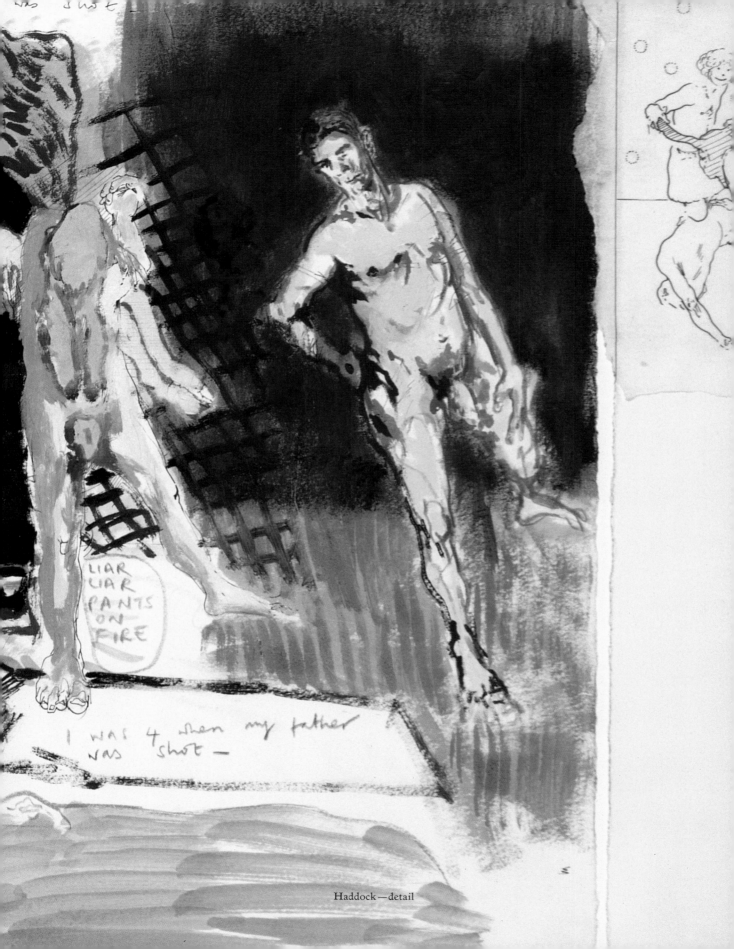

LIAR
LIAR
PANTS
ON
FIRE

I WAS 4 when my father
was shot —

Haddock —detail

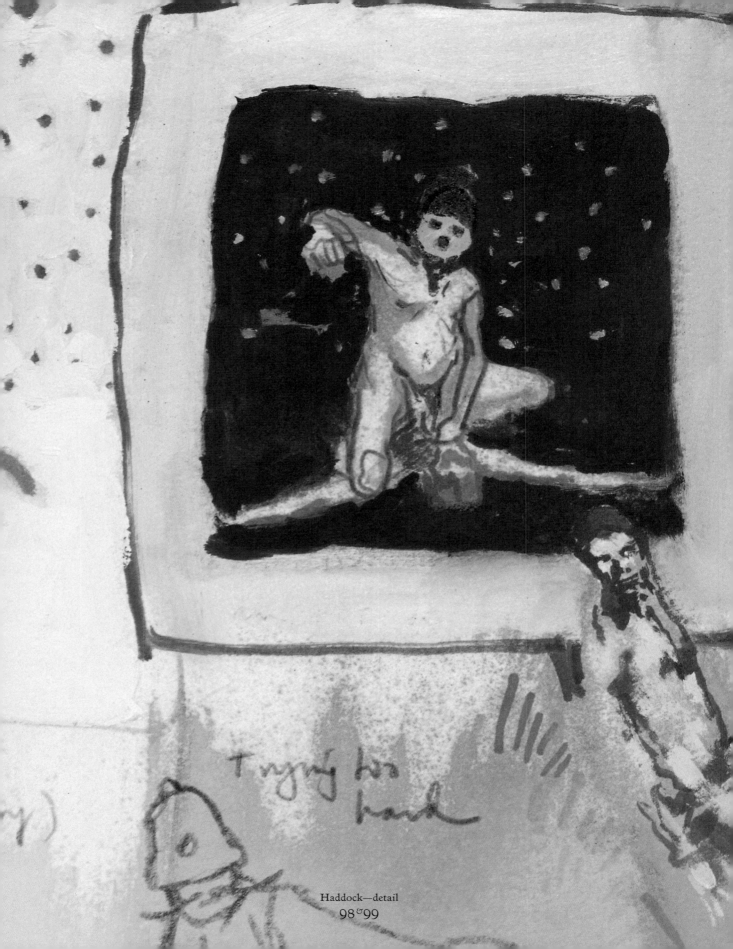

Haddock—detail
98&99

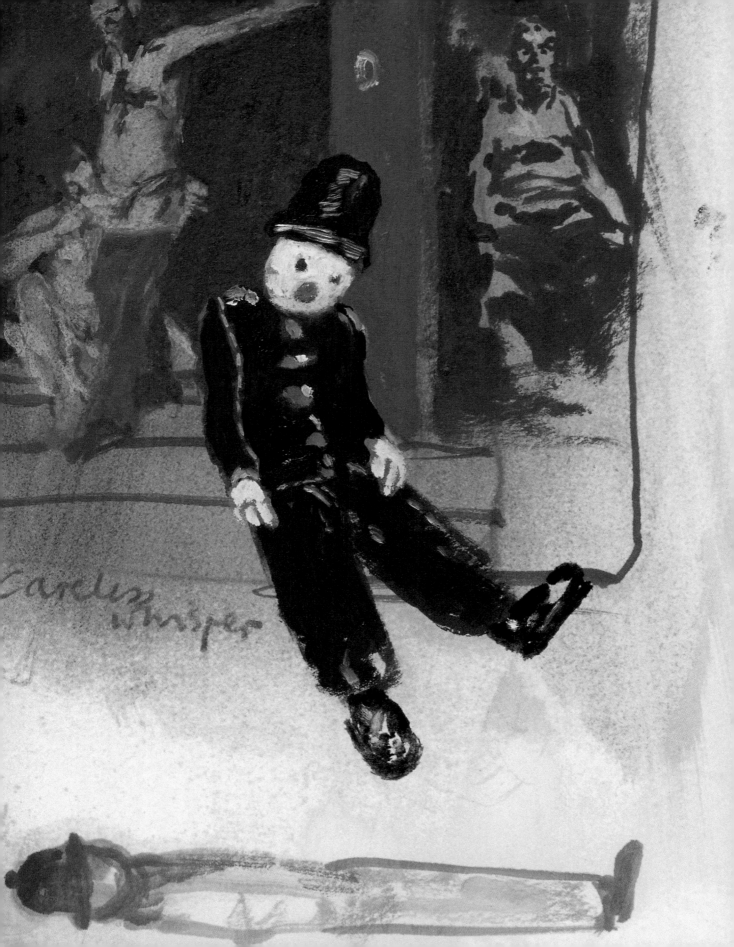

Nurse Rackham
Oil, ink, crayon and collage on paper
2003–2004, 245 x 165 cm

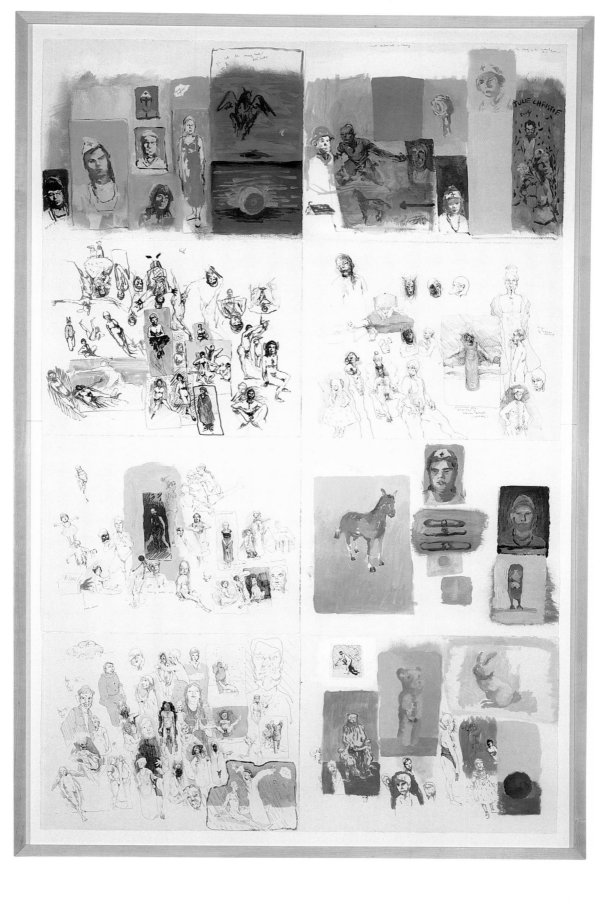

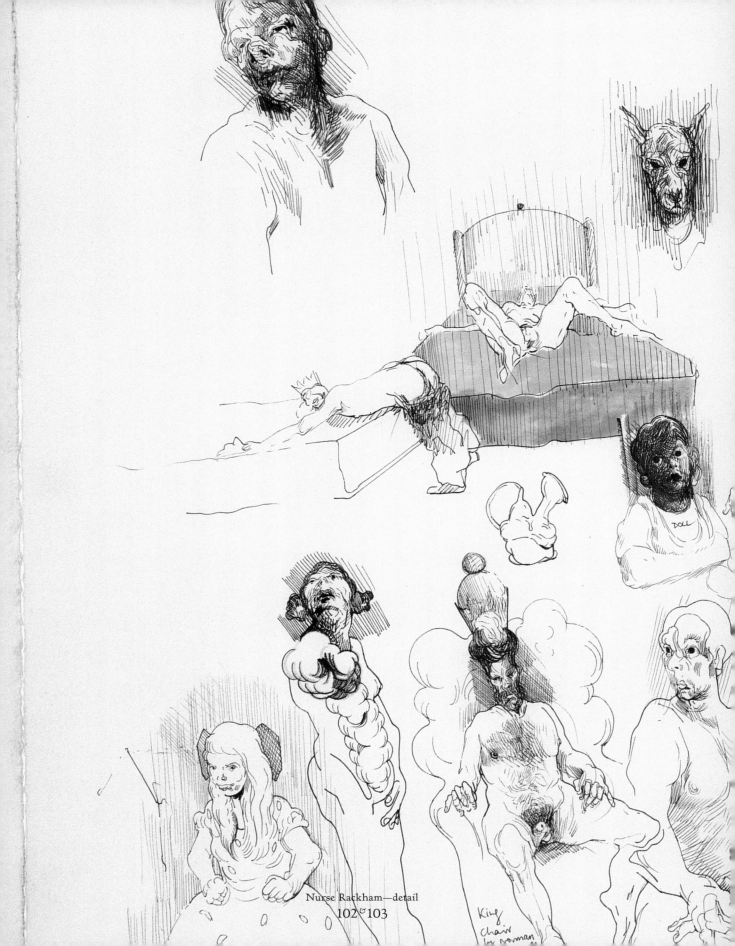

Nurse Rackham—detail
102 & 103

King
chair
by Roman

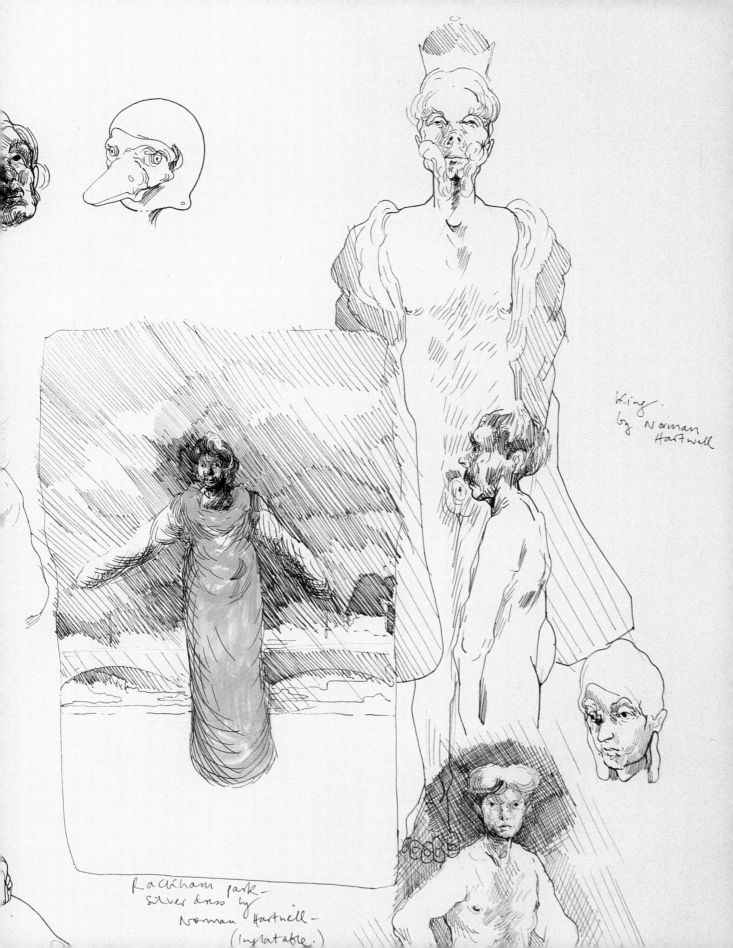

King.
by Norman
Hartnell

Rackham park—
Silver dress by
Norman Hartnell—
(Inflatable.)

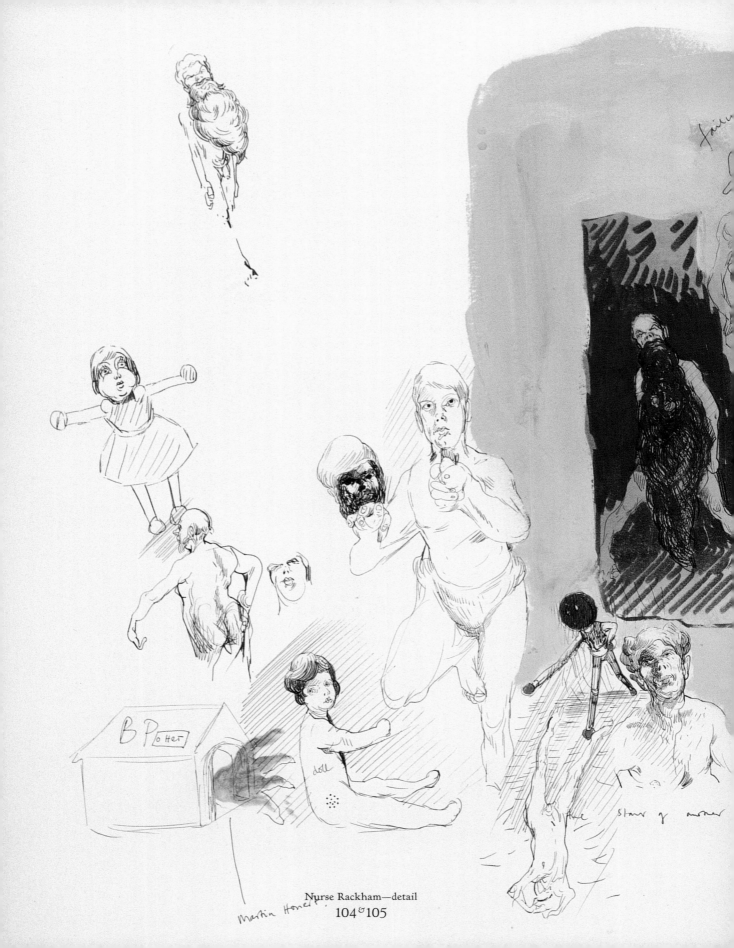

Nurse Rackham—detail
104 & 105

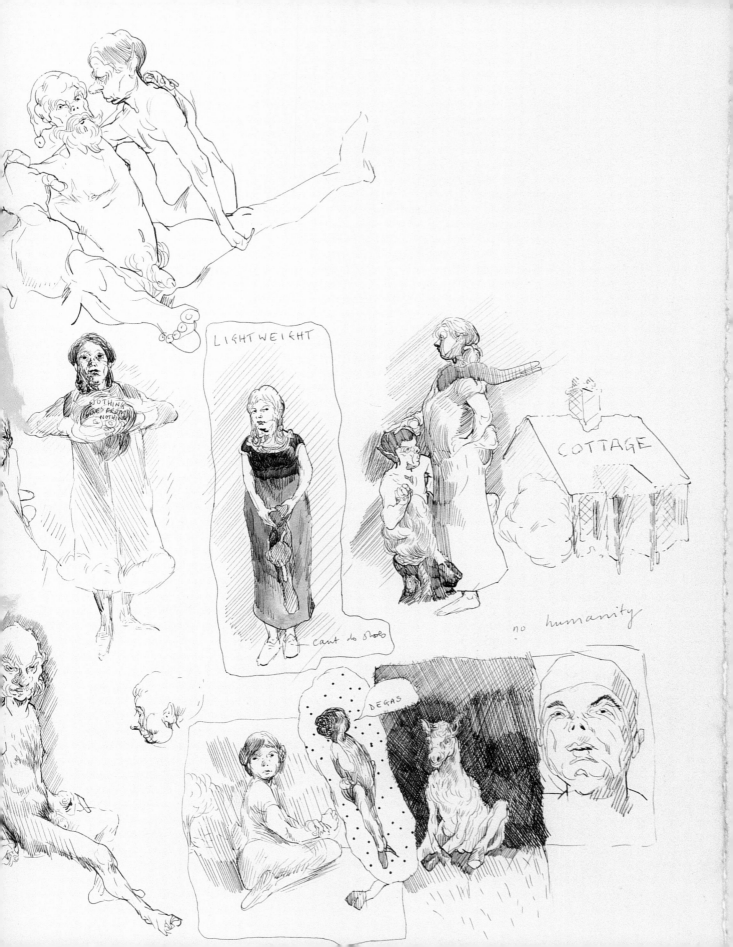

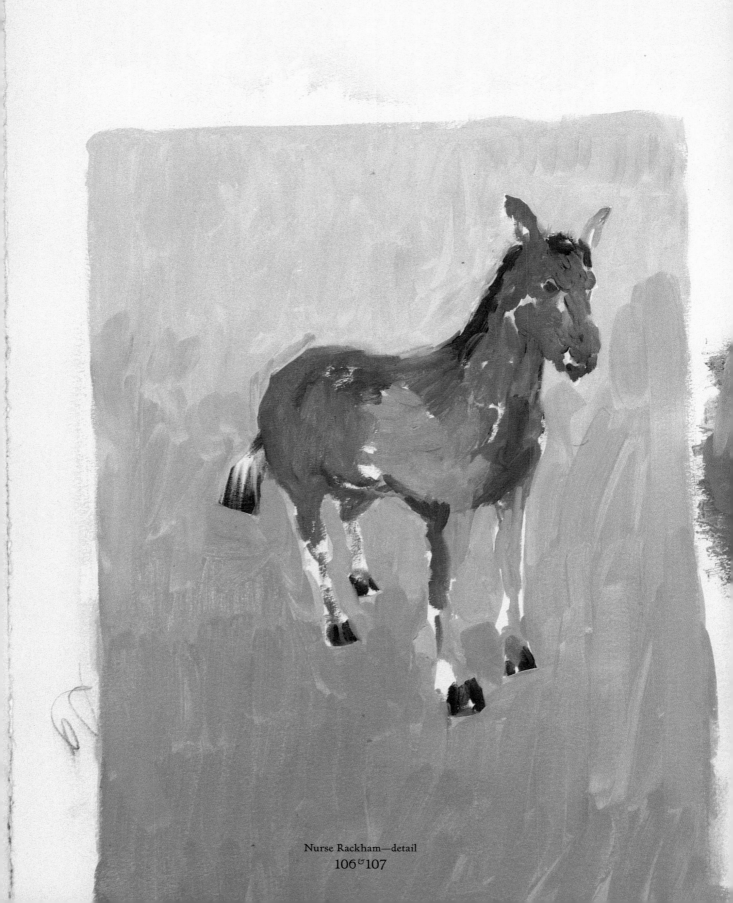

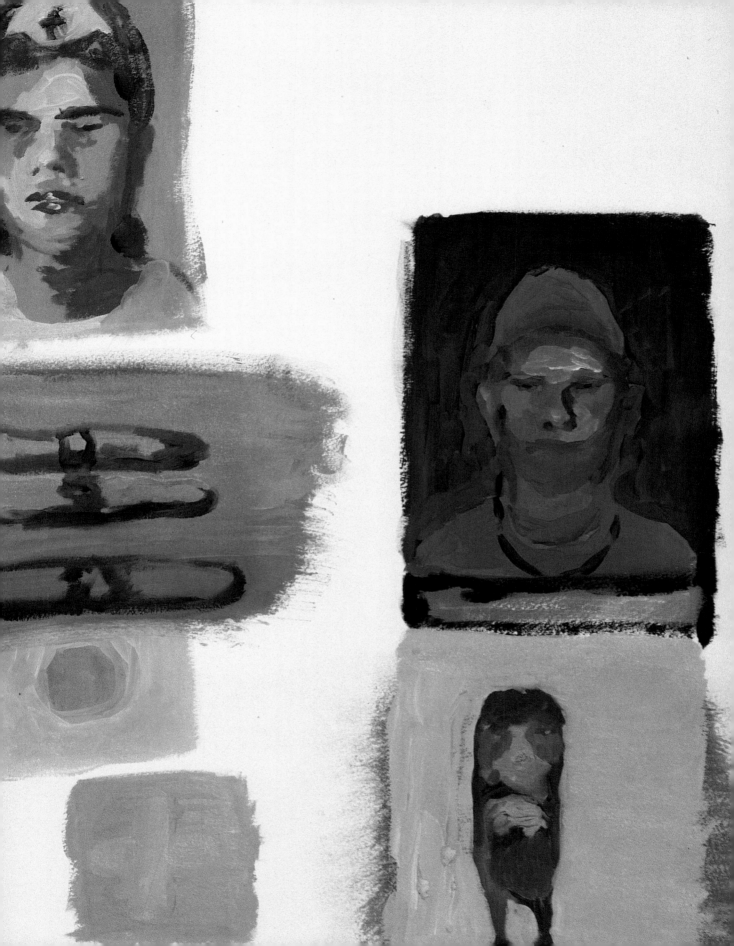

Keith Vaughn's Stable
Oil, ink, collage, gouache and crayon on paper
2002–2004, 245 x 165 cm

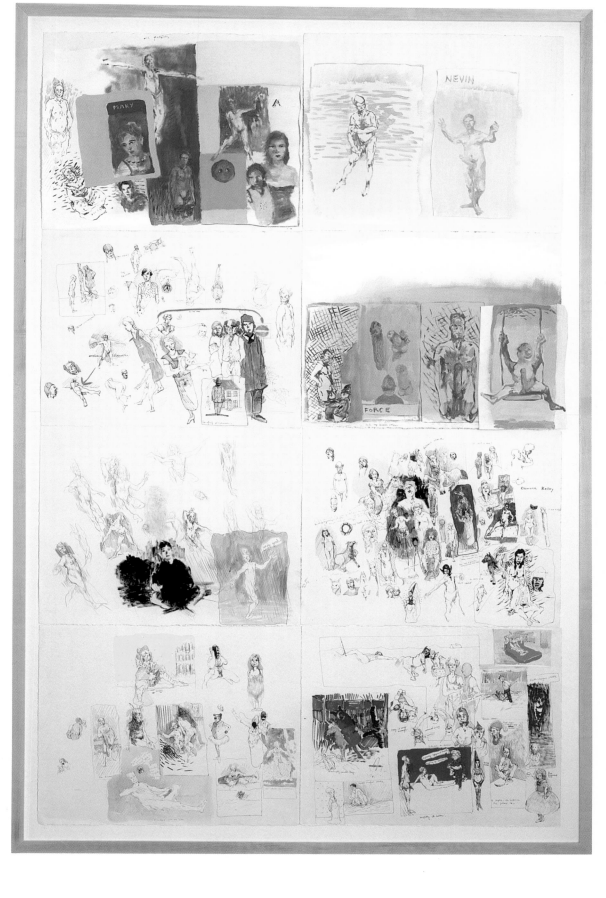

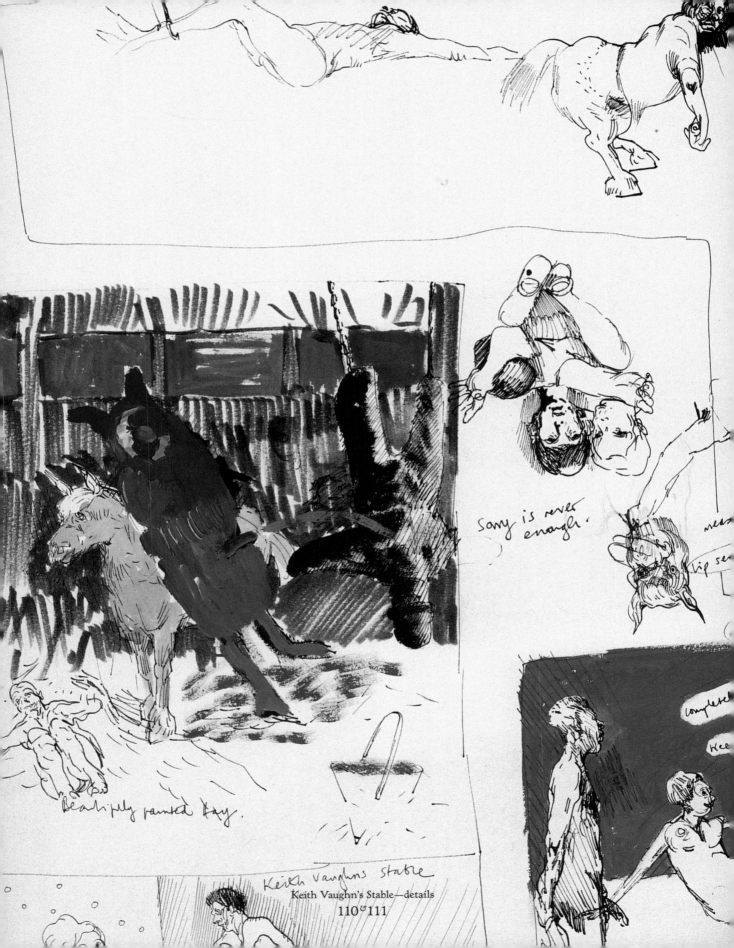

Song is never enough.

Beautifully painted bay.

laughing policeman

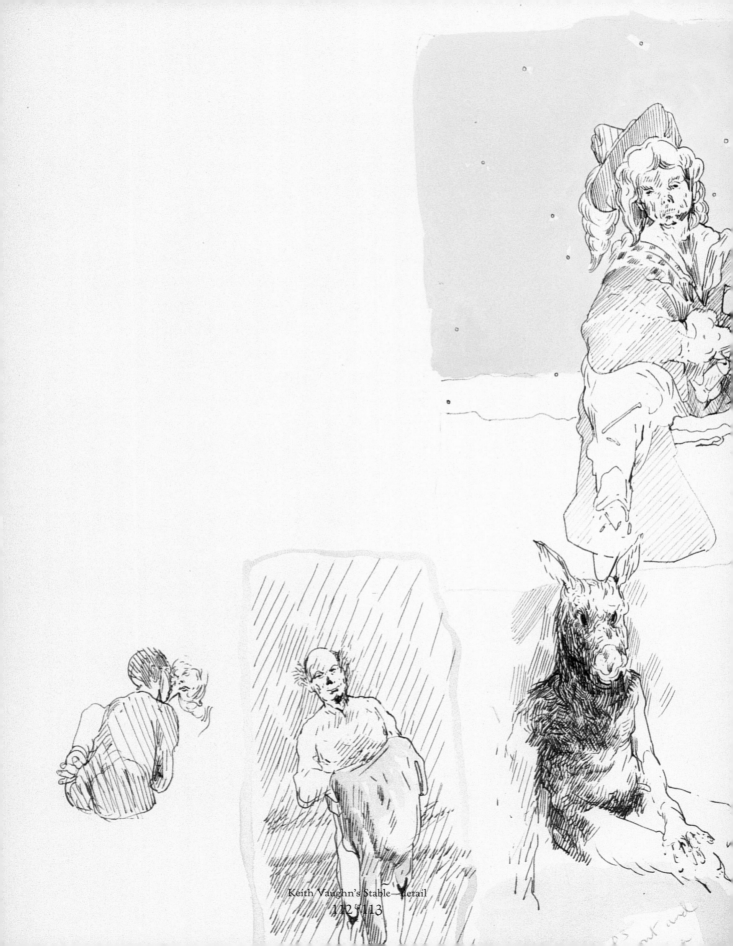

Keith Vaughn's Stable—detail
112 113

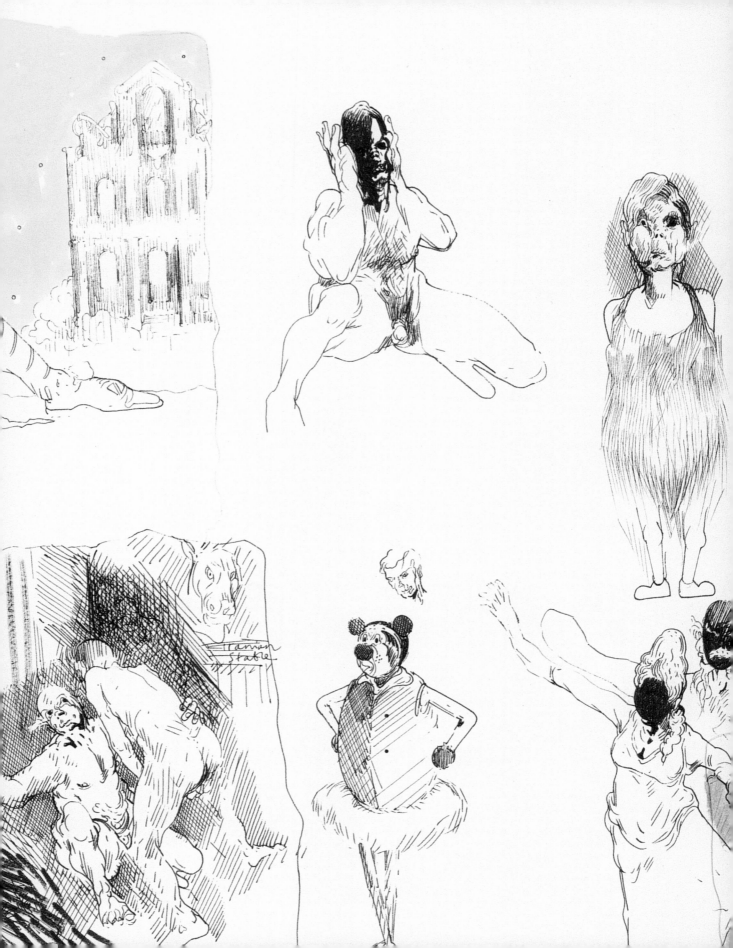

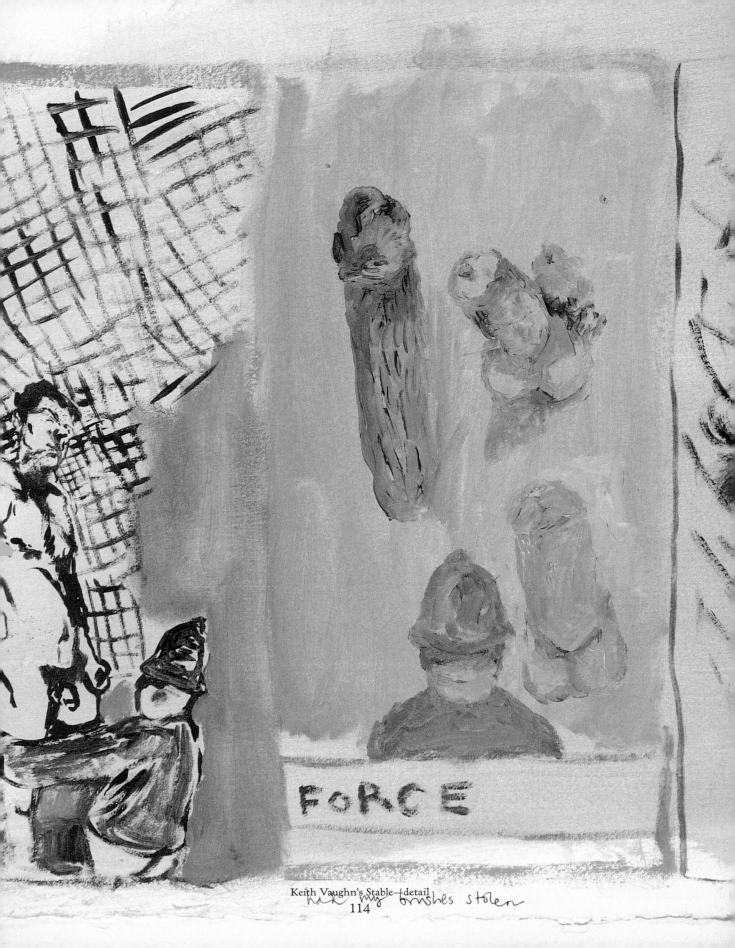

FORCE

Keith Vaughn's Stable—detail
had my brushes stolen
114

33

34, 35

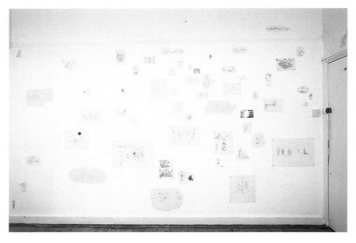

36, 37

Drawing Installation
116 & 117

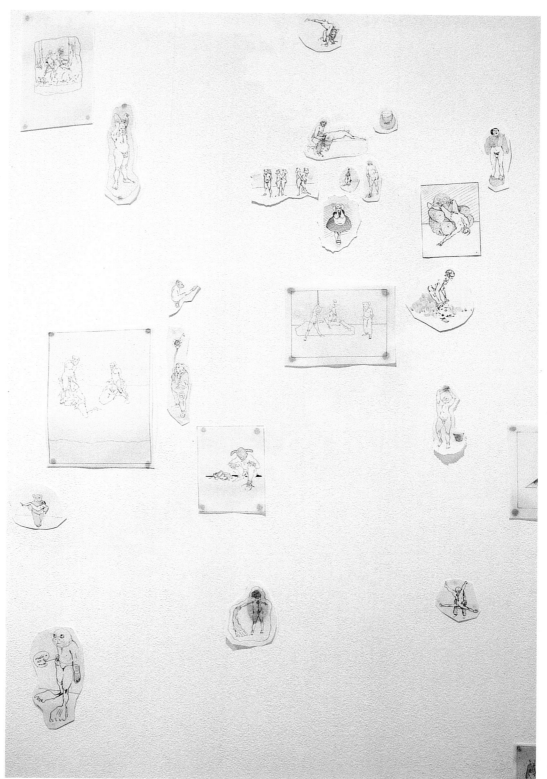

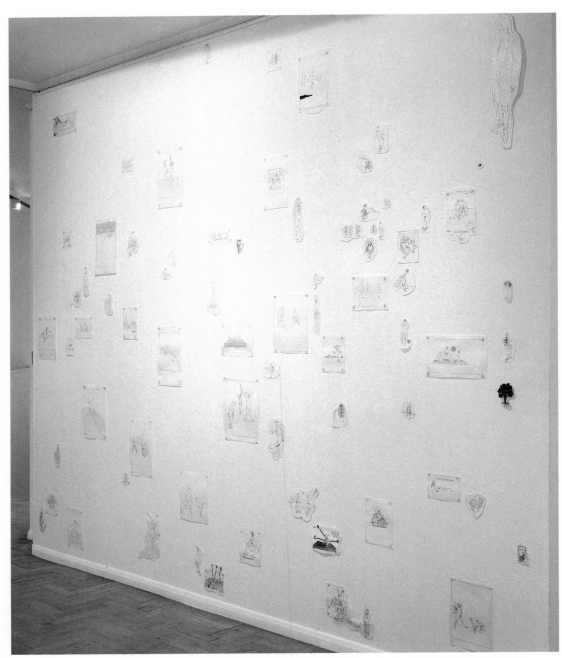

39

Drawing Installation

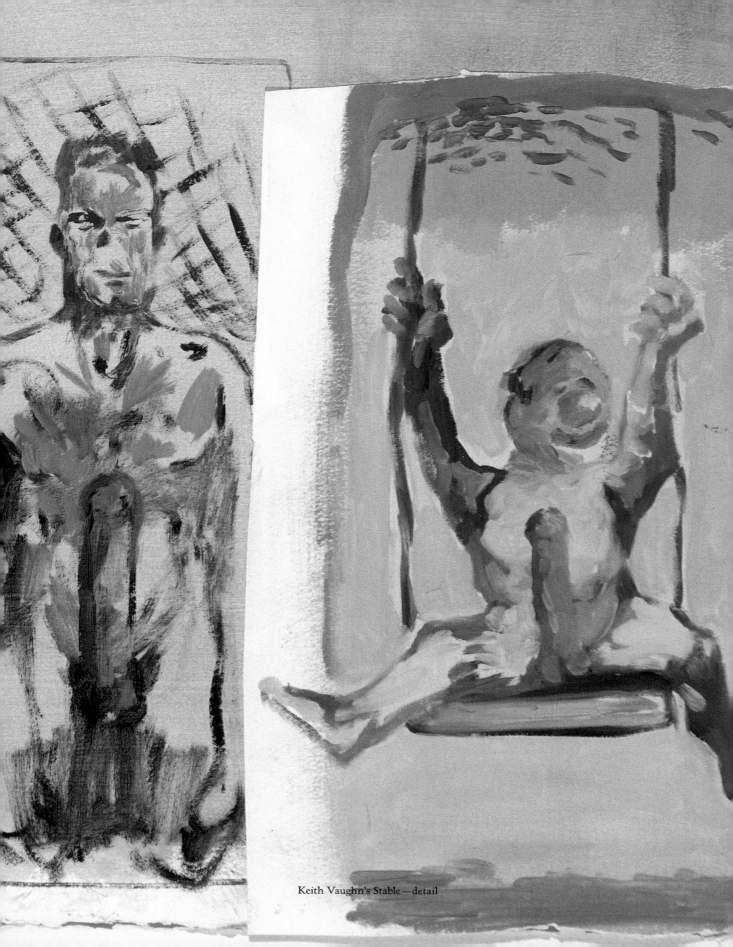

Keith Vaughn's Stable — detail

Jean Plaidy
Oil, ink, crayon and collage on paper
2002–2004, 210 x 188 cm

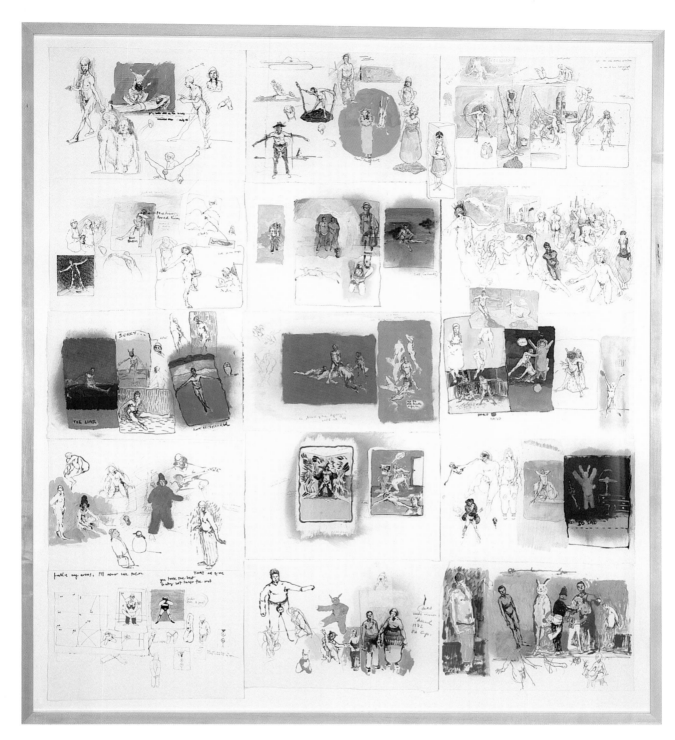

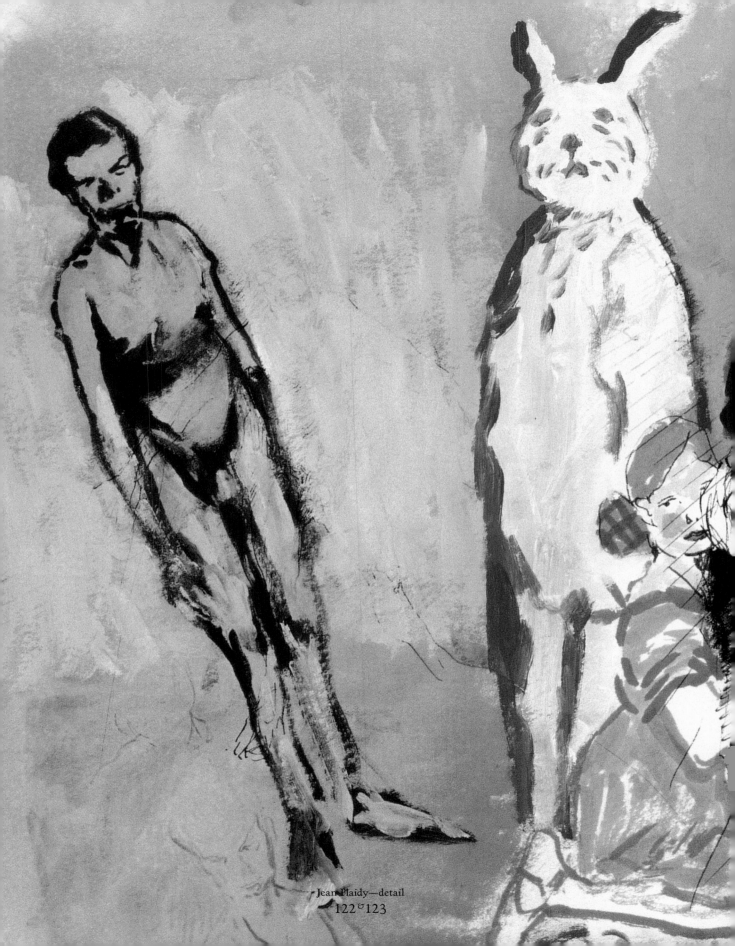

Jean Plaidy—detail
122 & 123

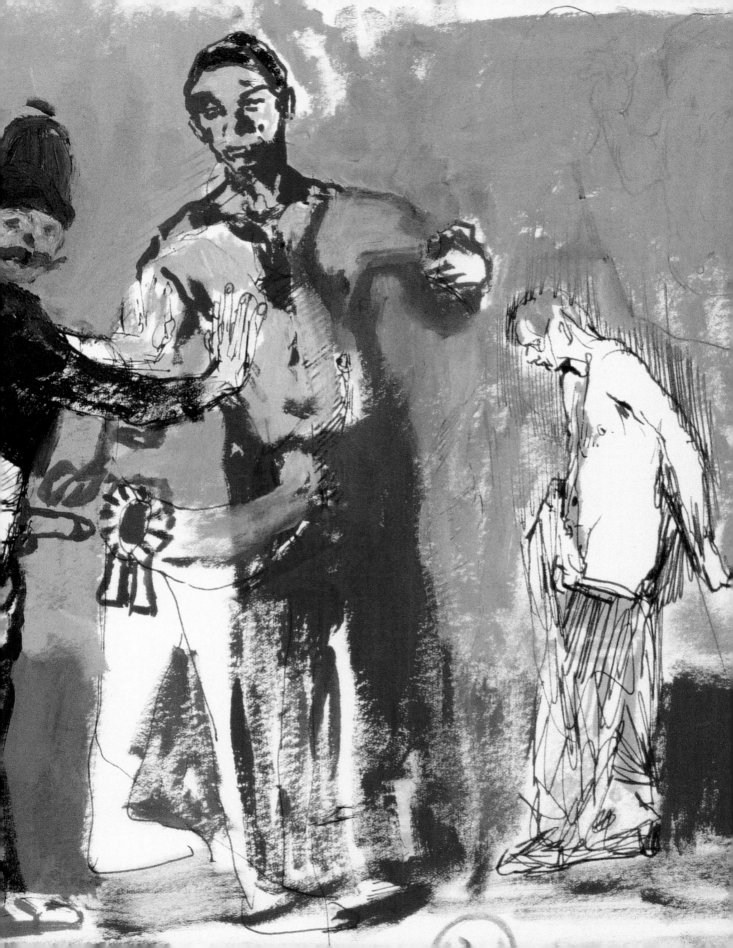

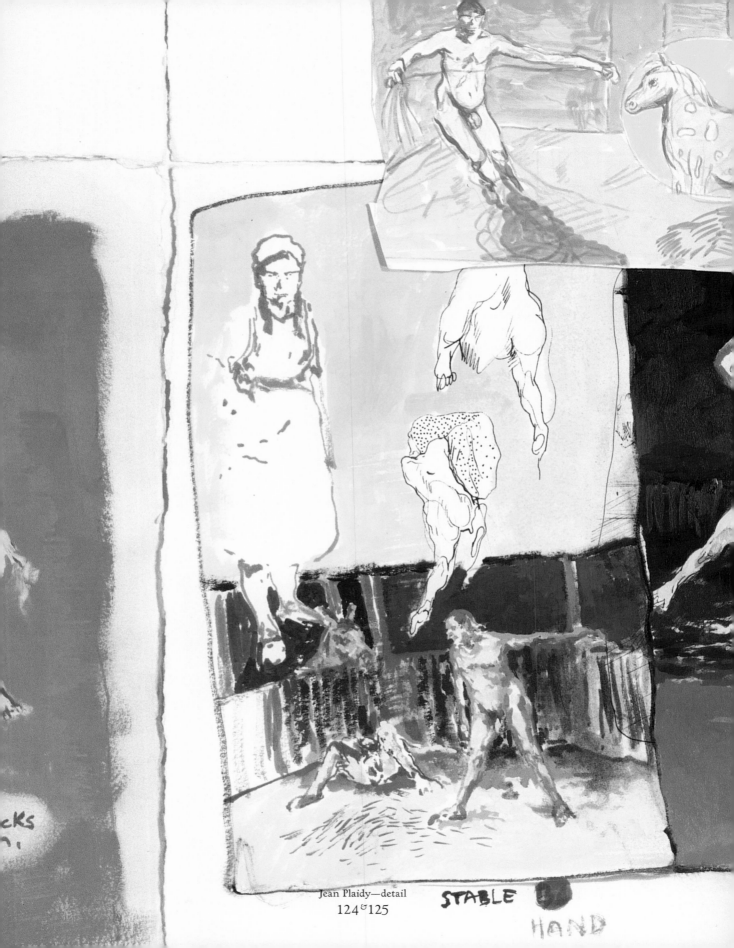

cKs

STABLE

HAND

Jean Plaidy—detail
124 & 125

Dear Simon, Thankyou so much for your letter & a long time ago. February! You said you had five friends you wanted to give my autograph to. I don't know whether you meant an autographed photo, or just an autograph, but give sent the former. As you see I'm in Switzerland at the moment, making another film. It's quite pretty, but not nearly so lovely as Dorset. Much love, Julie.

To Simon with love, Juliet Christie

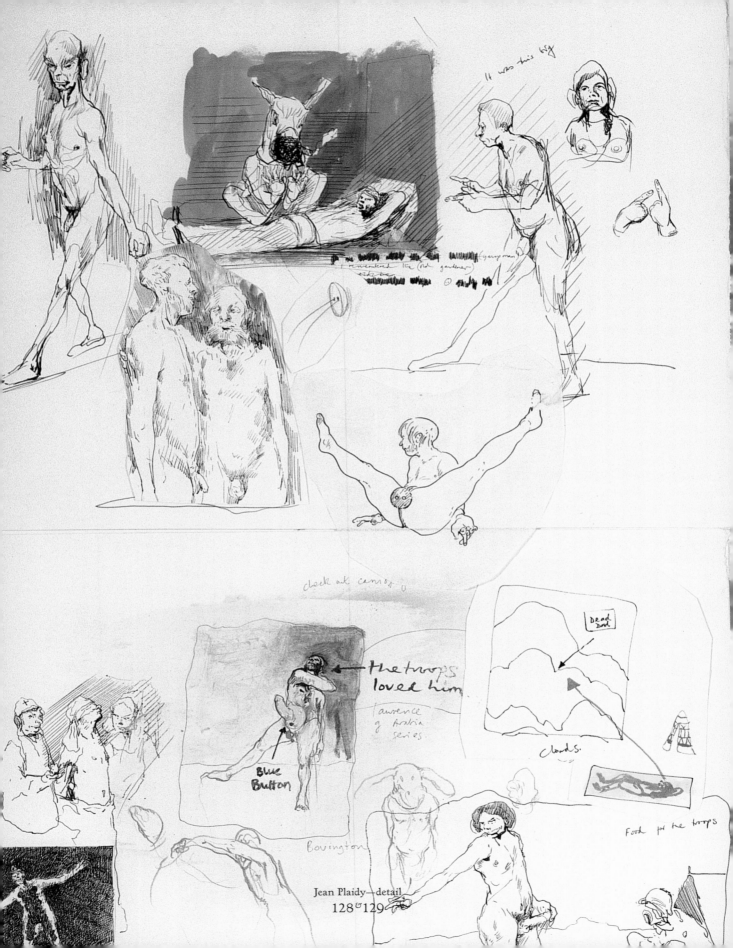

It was this big

remembered the (old gardener) (young man)

the troops loved him

Lawrence of Arabia series

Blue Button

Dead Dvl

Clouds.

check out canvas

Food for the troops

Bovington

Jean Plaidy—detail
128&129

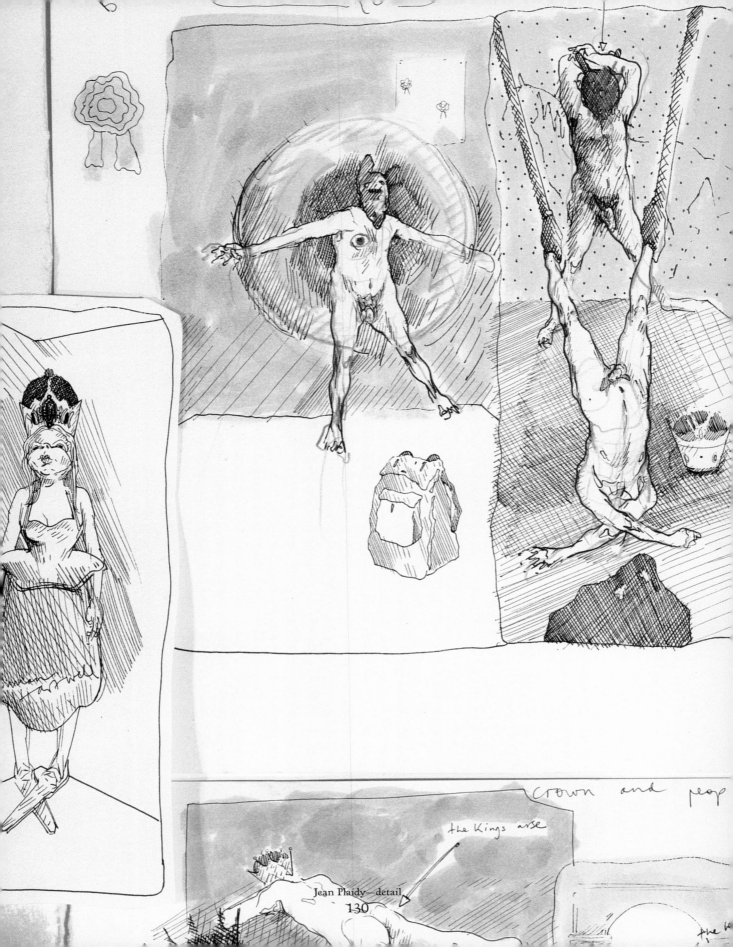

crown and peop

the Kings arse

Jean Plaidy—detail
130

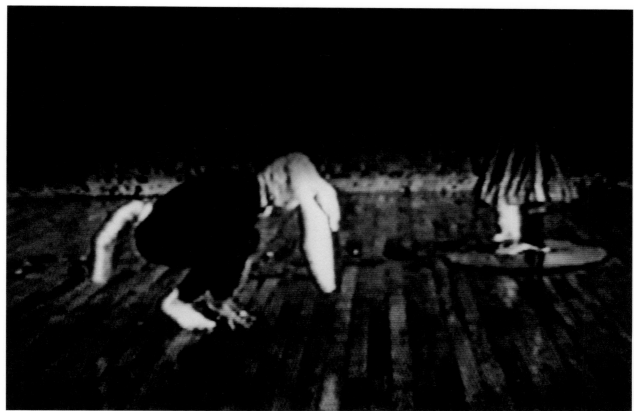

40

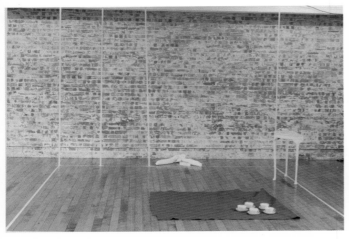 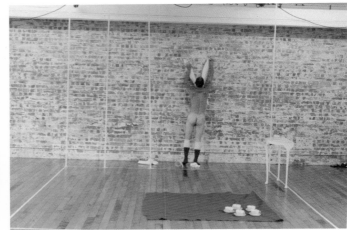

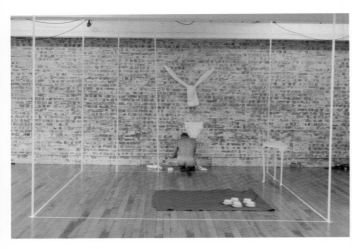 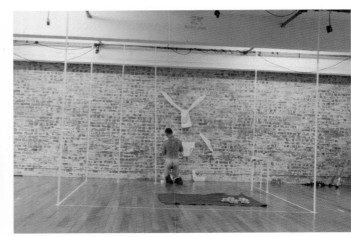

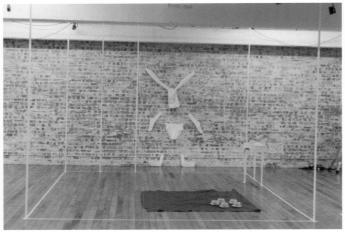

41–45

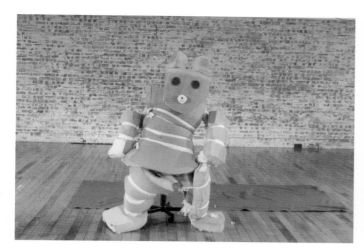 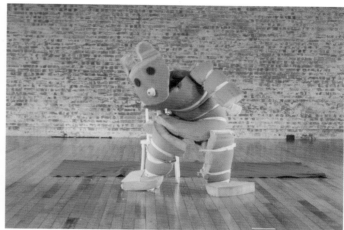

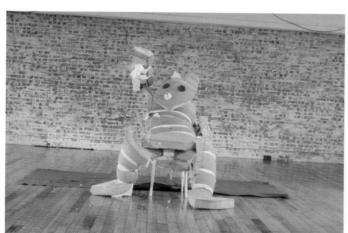 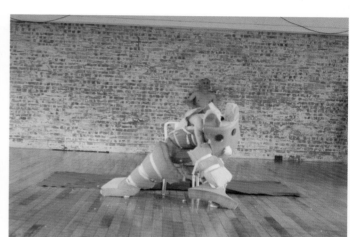

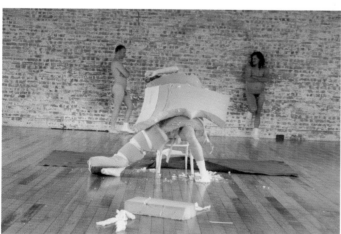 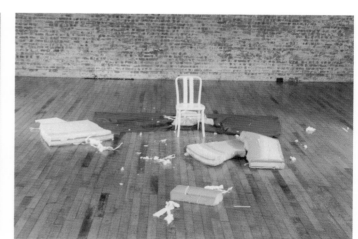

46–51

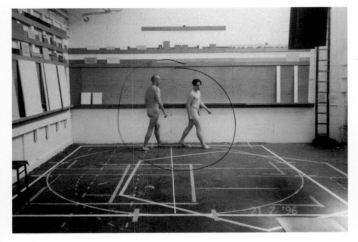

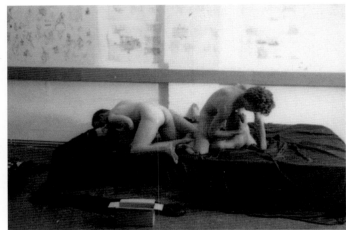

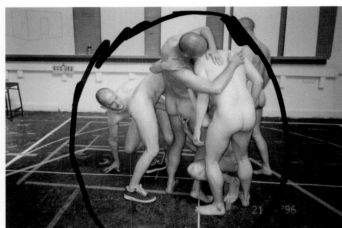

52, 53

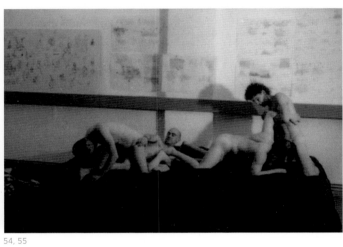

54, 55

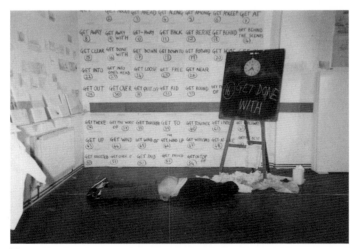

56

Performance

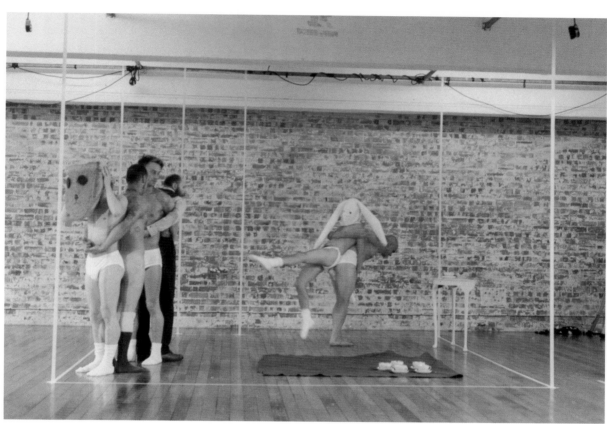

57

58–62

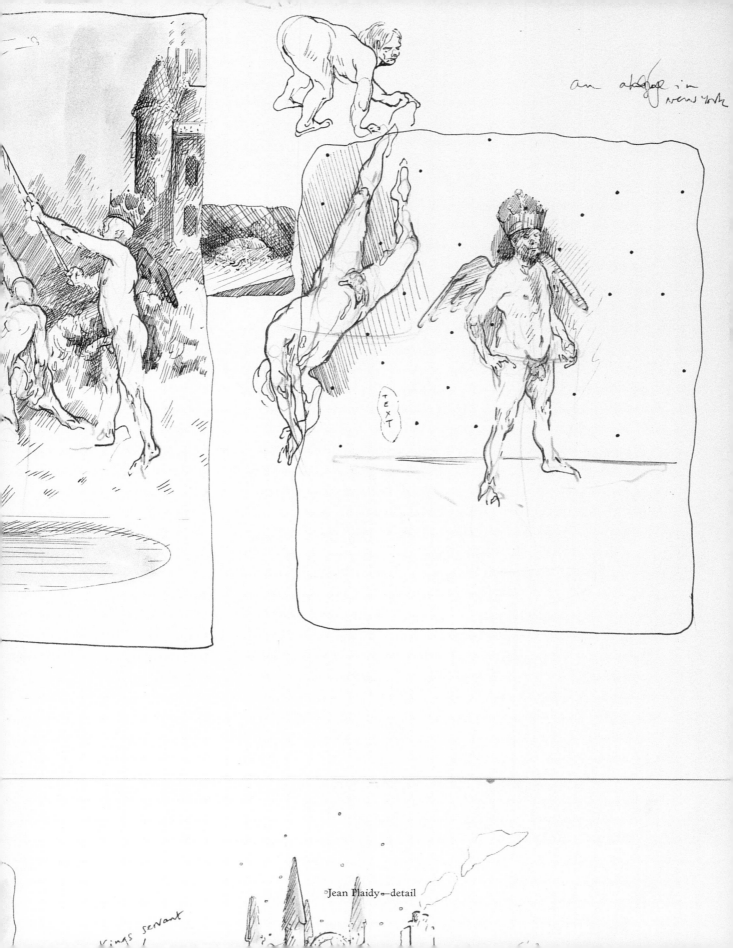

an atelier in
new york

TEXT

Jean Plaidy—detail

kings servant

Army Pink Snowman
Oil, ink, collage, acrylic and real button on paper
2002–2004, 210 x 130 cm

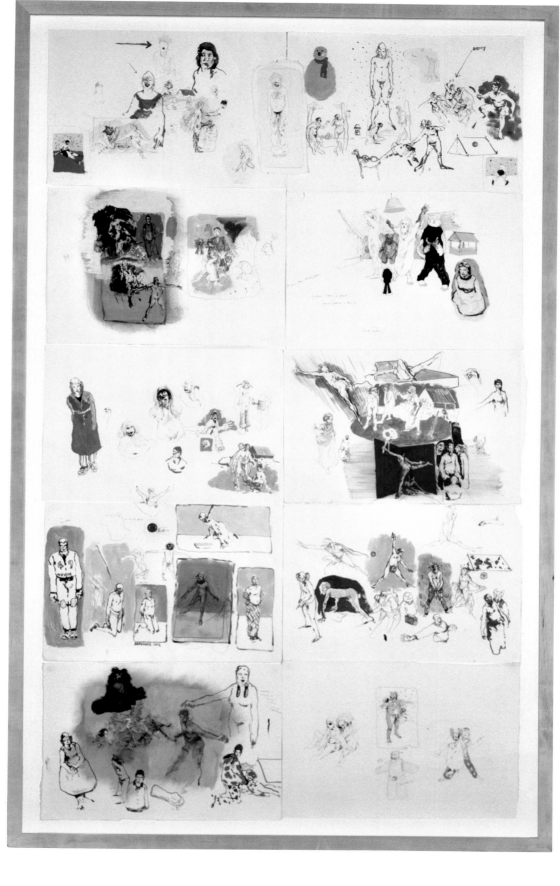

Army Pink Snowman—detail
140 & 141

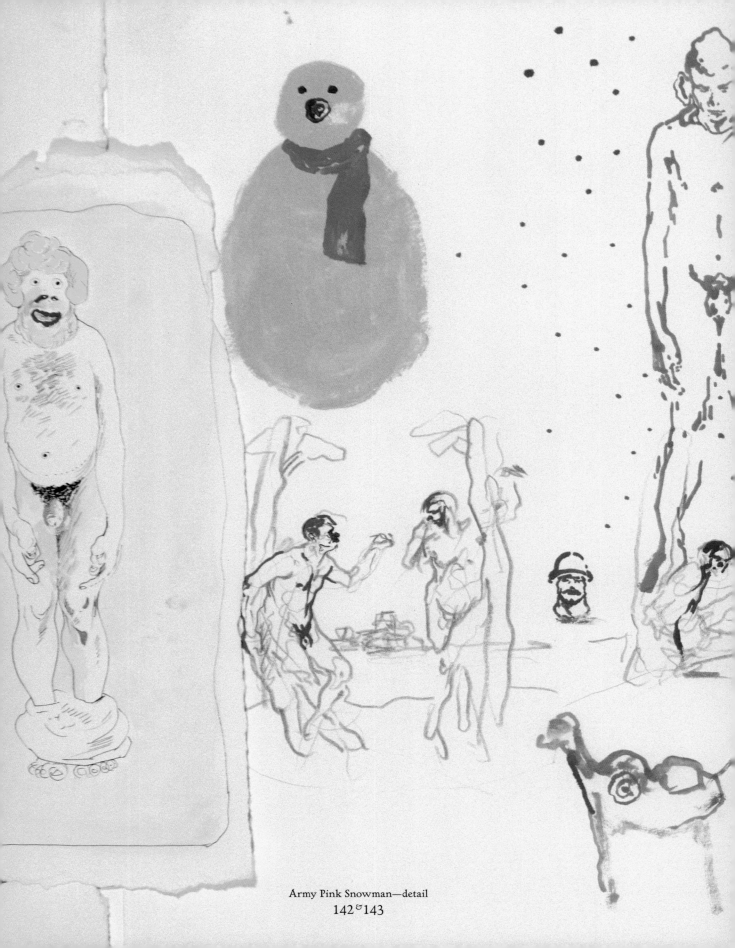

Army Pink Snowman—detail
142 & 143

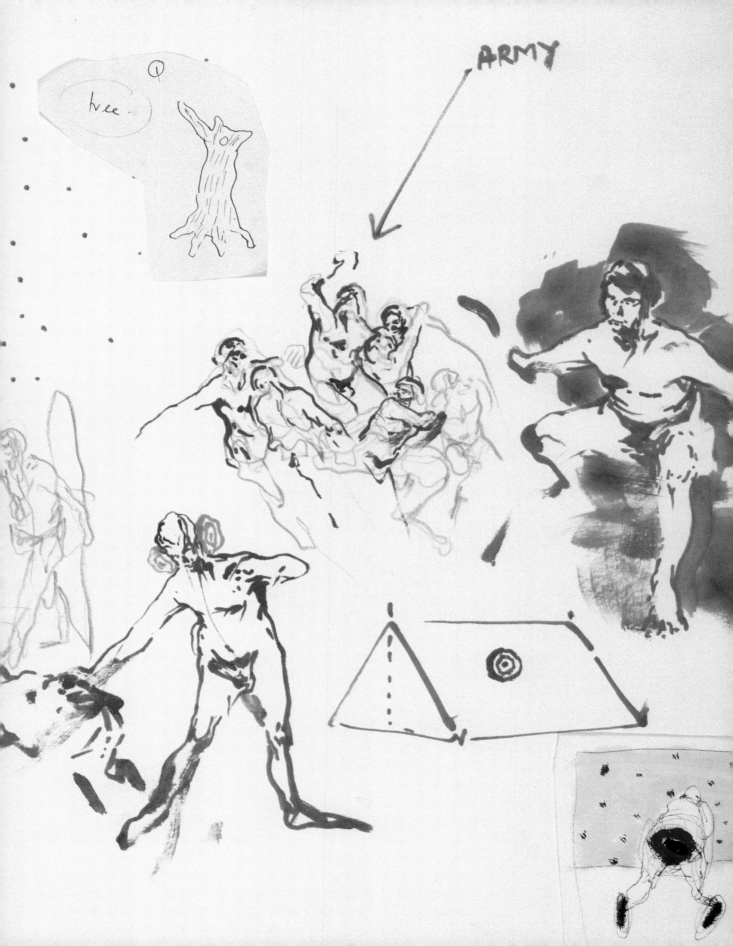

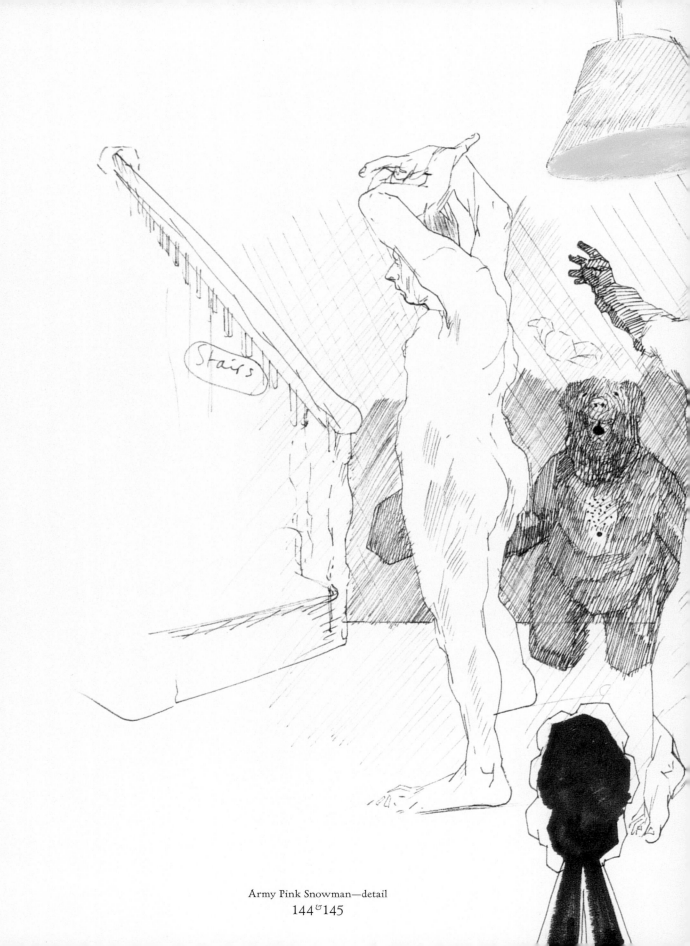

Army Pink Snowman—detail
144 & 145

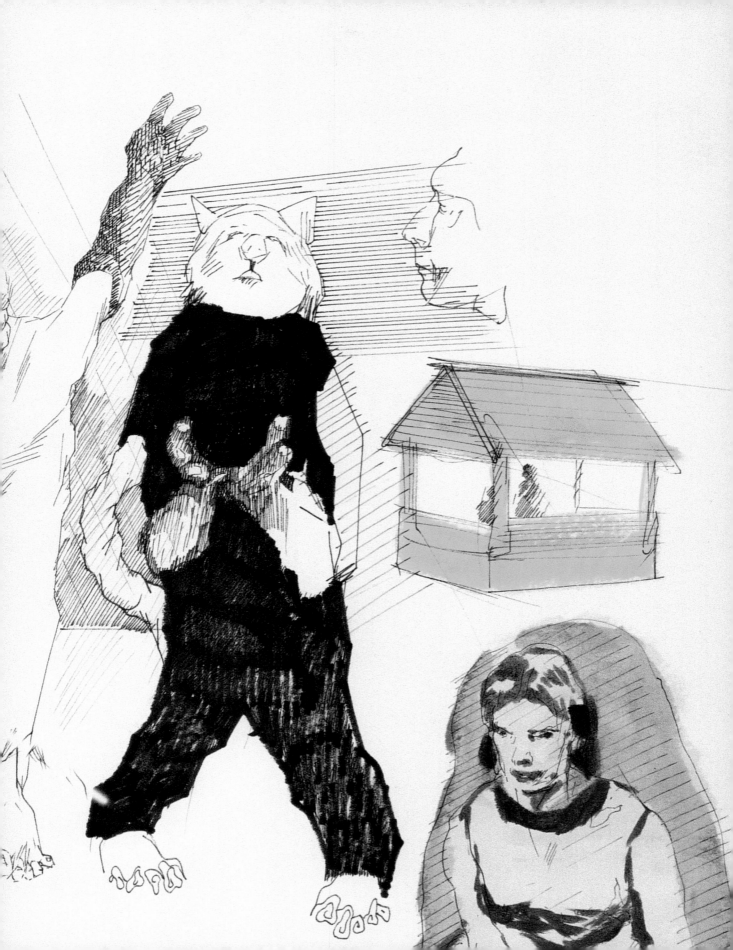

Mrs Brown
Oil, ink, collage and print on paper
2003–2004, 245 x 165 cm

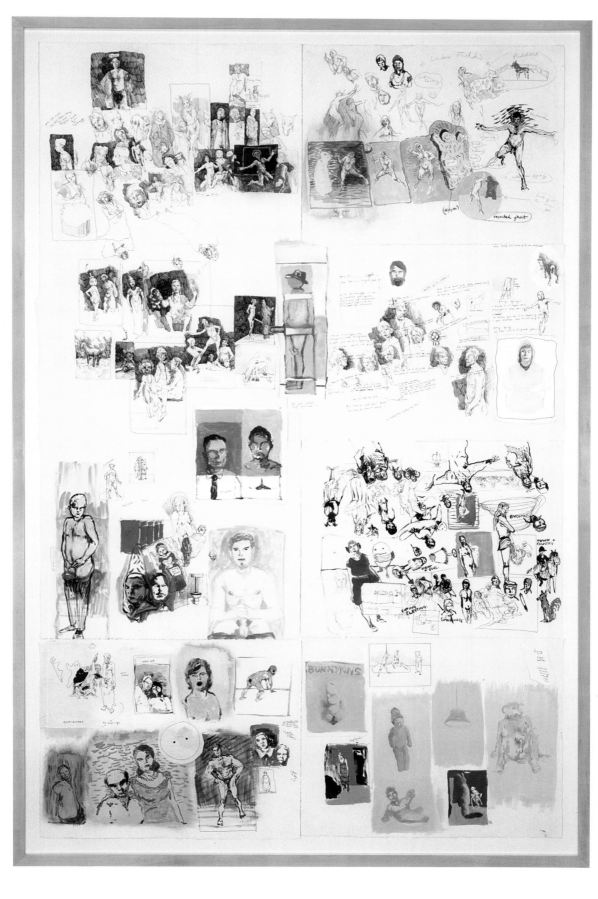

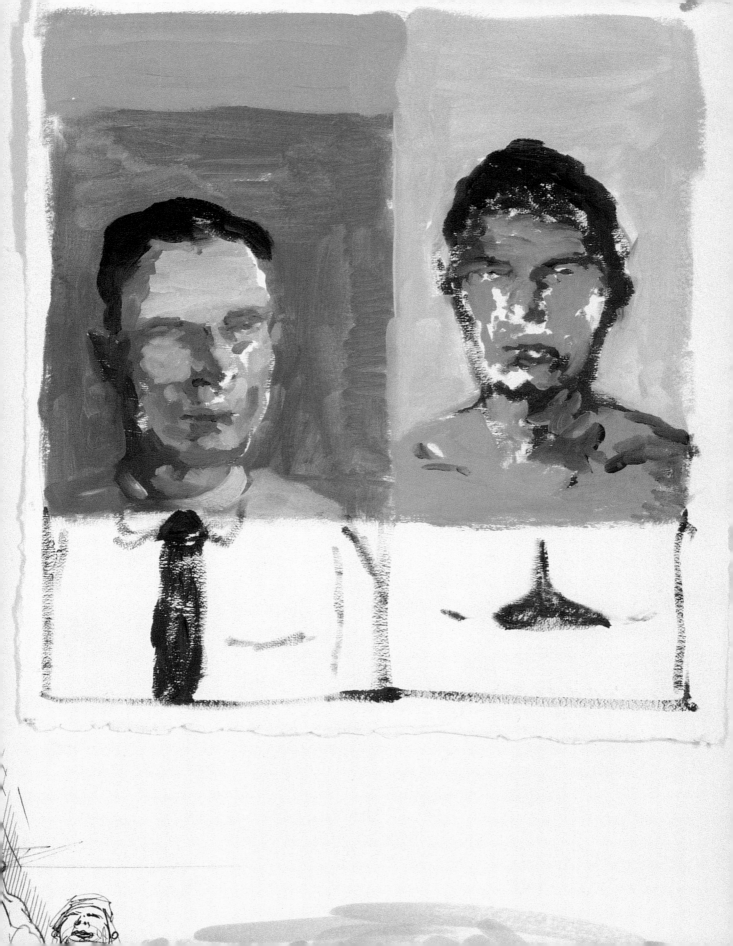

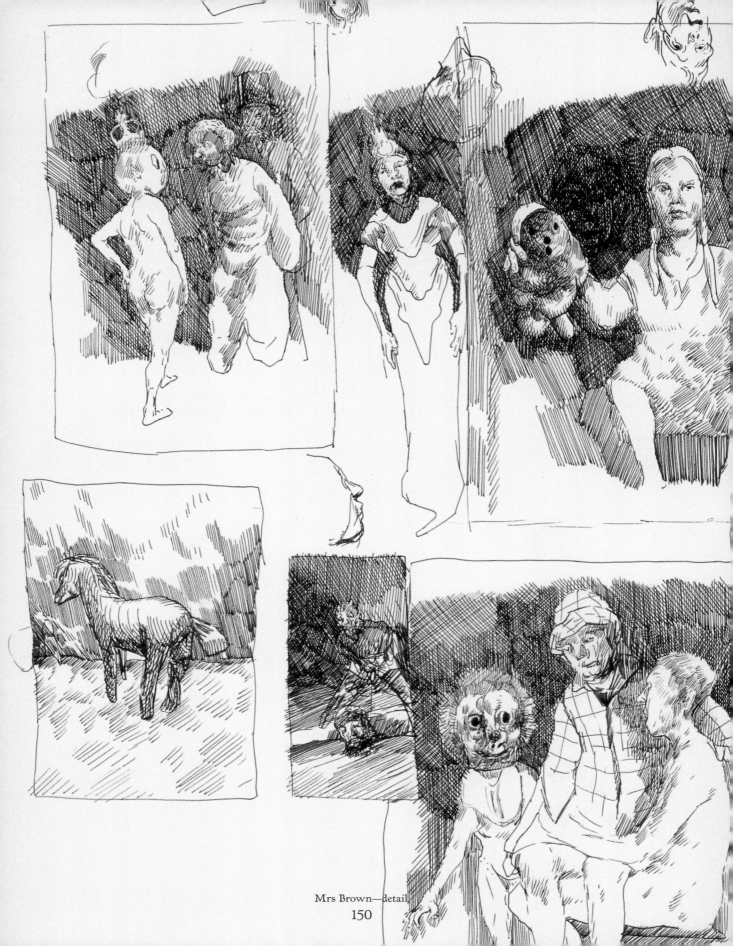

Mrs Brown—detail

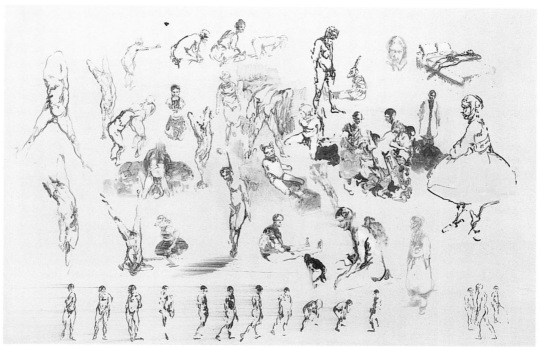

63

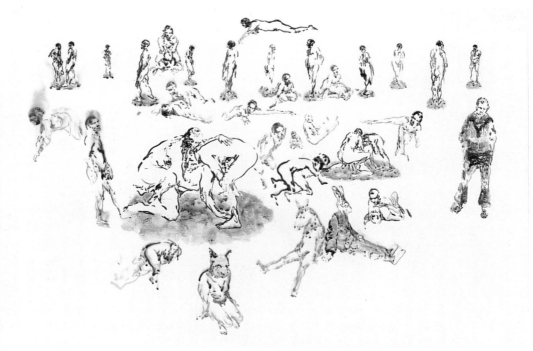

64

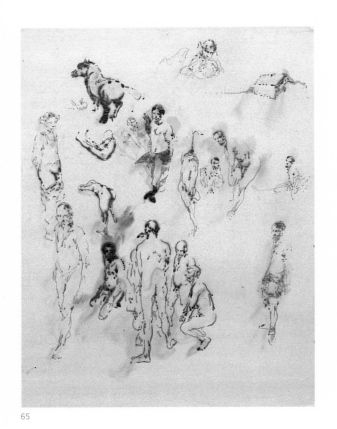

65

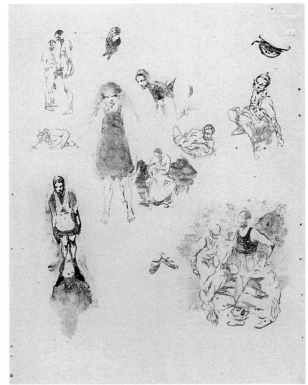

66

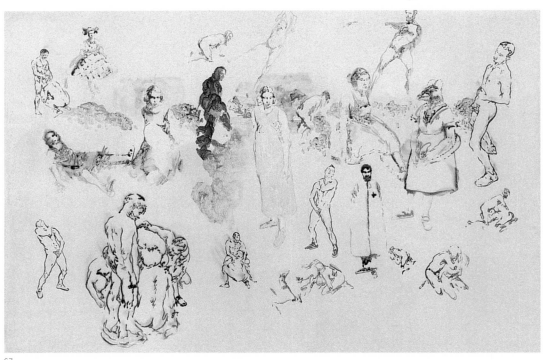

67

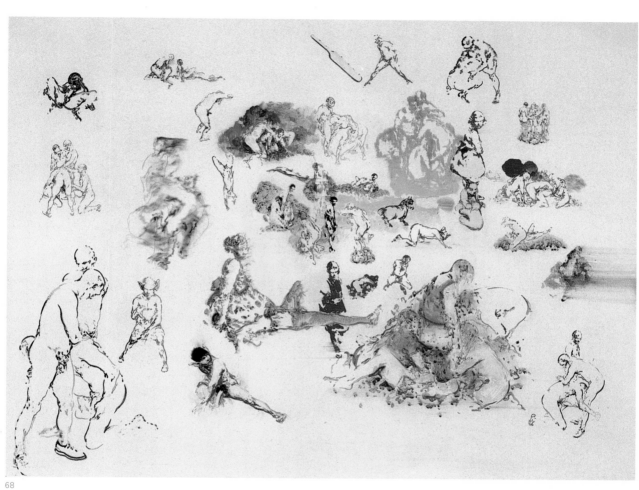

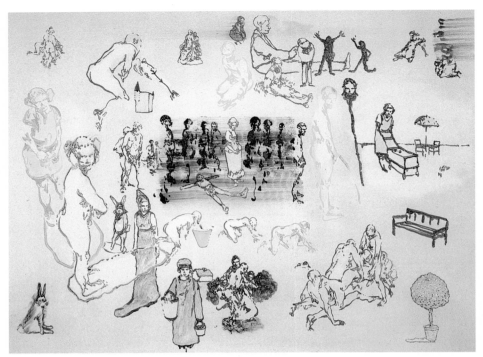

69

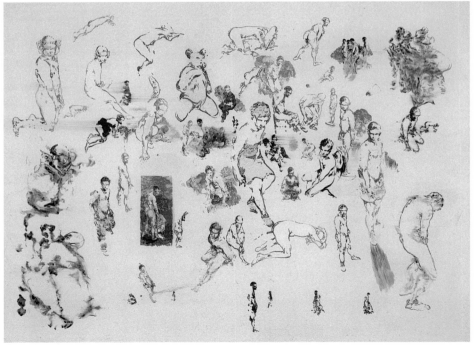

70

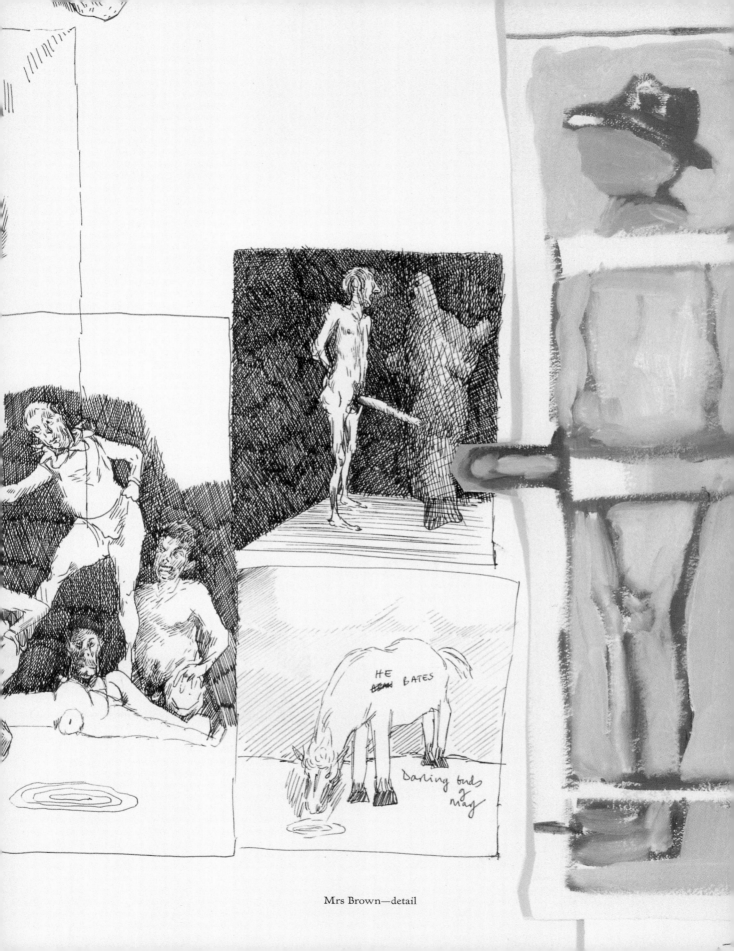

Mrs Brown—detail

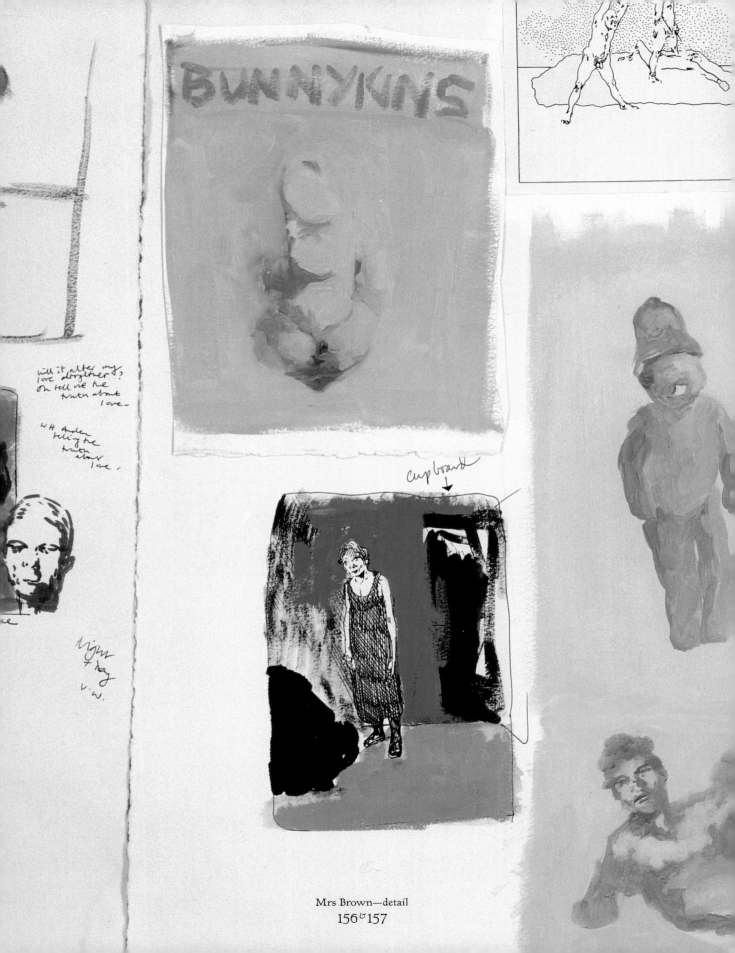

Mrs Brown—detail
156 & 157

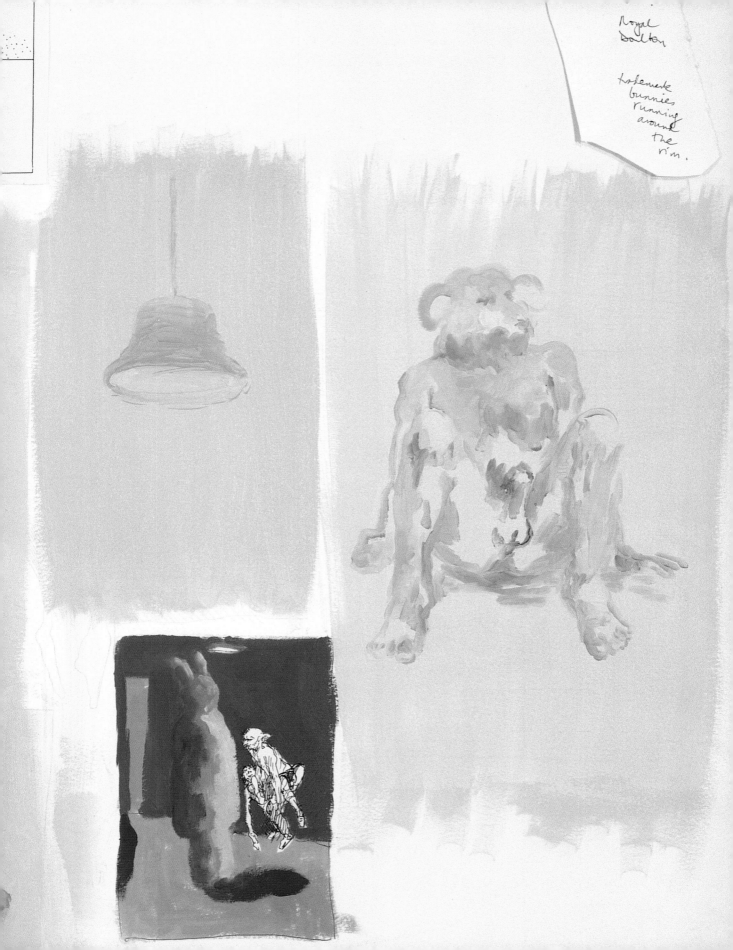

Royal
Doulton

trademark
bunnies
running
around
the
rim.

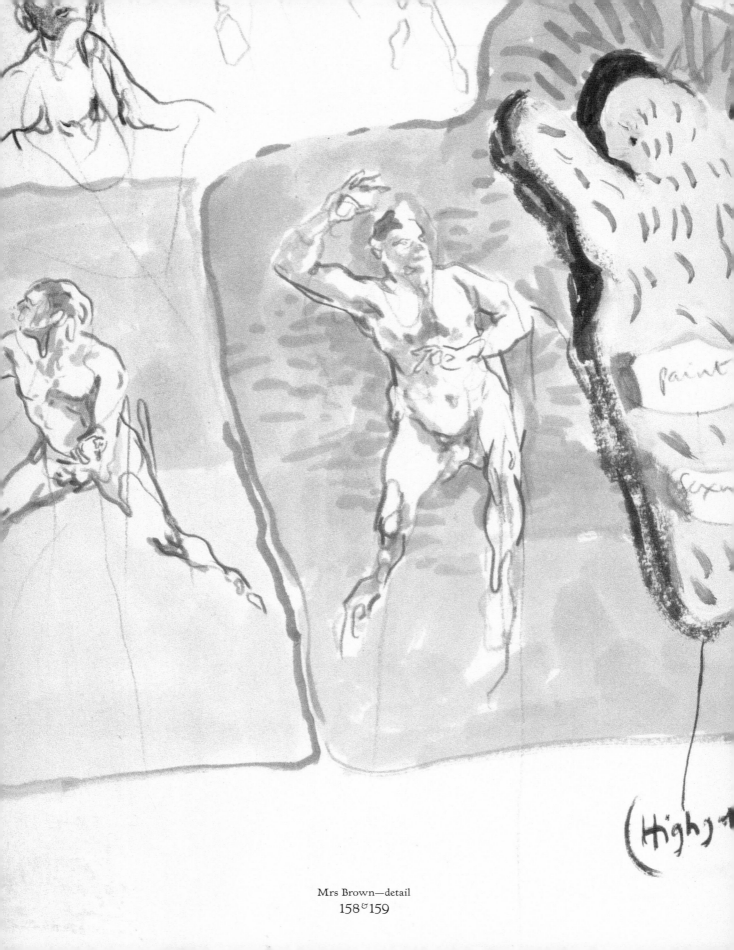

Mrs Brown—detail
158 & 159

Classical

Dumb →

↓

Dexterous)

↓

touch

↓

no agent ——— anti agent

2 nude men tight

B
the

rejected ghost

Real Rosette
Oil, ink, collage, print, crayon and real rosette on paper
2002–2004, 210 x 130 cm

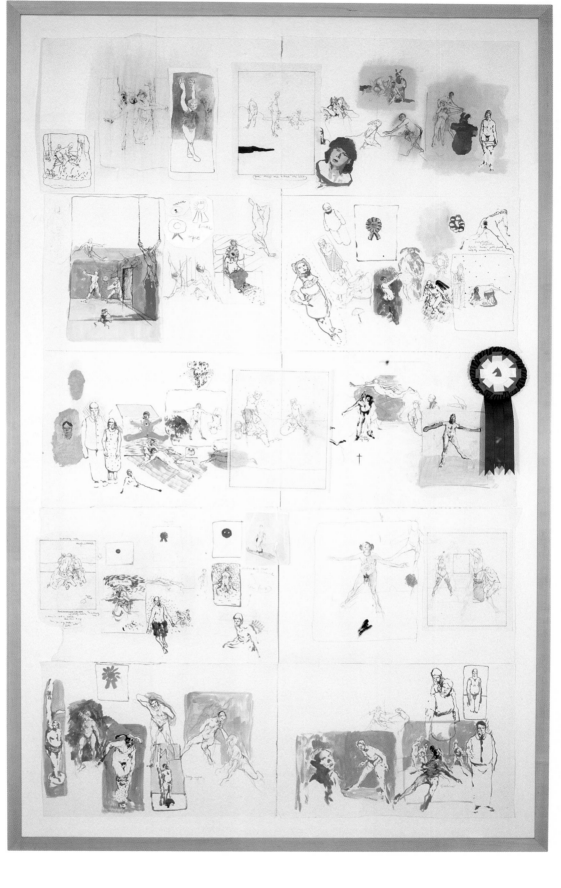

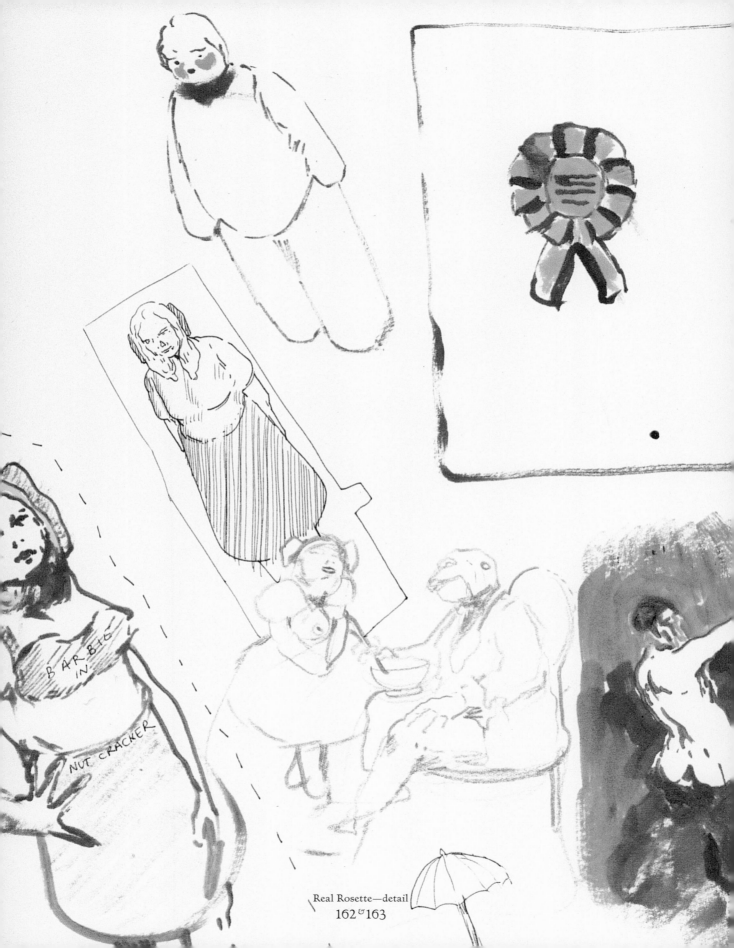

BAR BIG
IN

NUT CRACKER

Real Rosette—detail
162 & 163

71–75

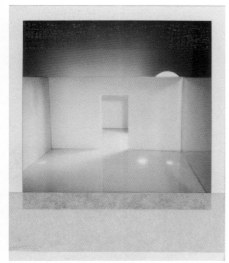

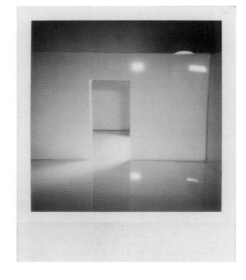

76–80

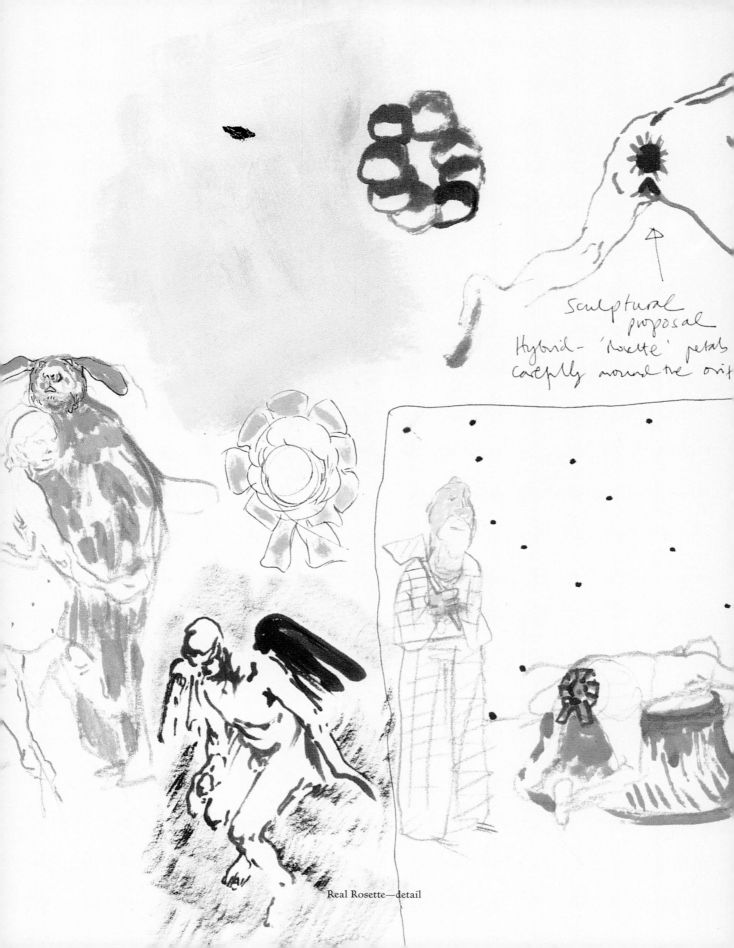

Sculptural
proposal
Hybrid— 'Rosette' petals
carefully around the orifice

Real Rosette—detail

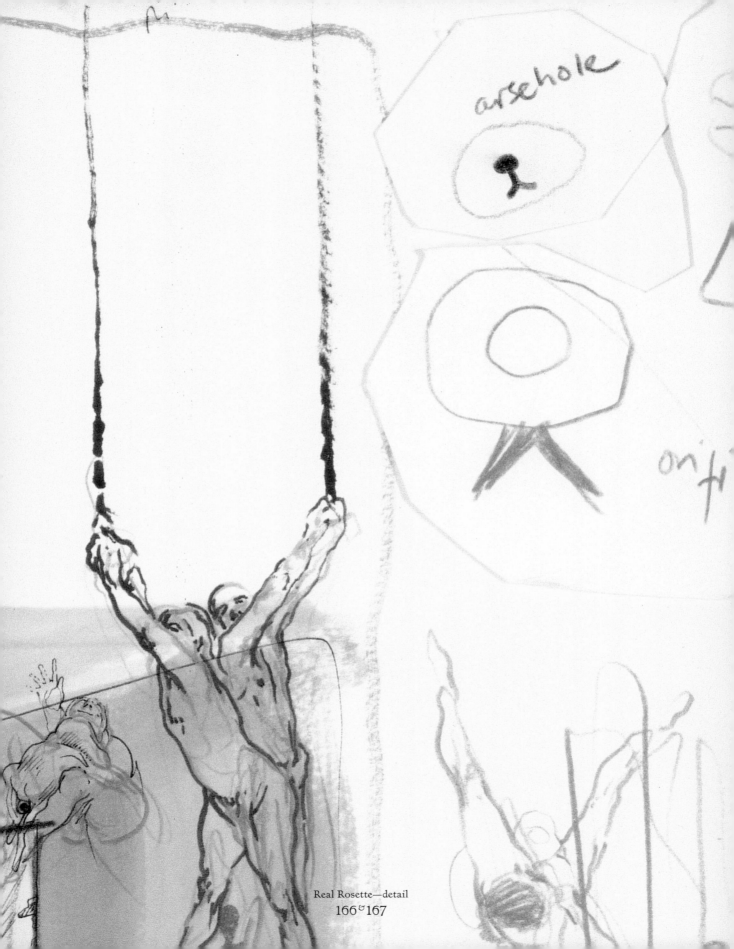

arsehole

ori
fi

Real Rosette—detail
166 & 167

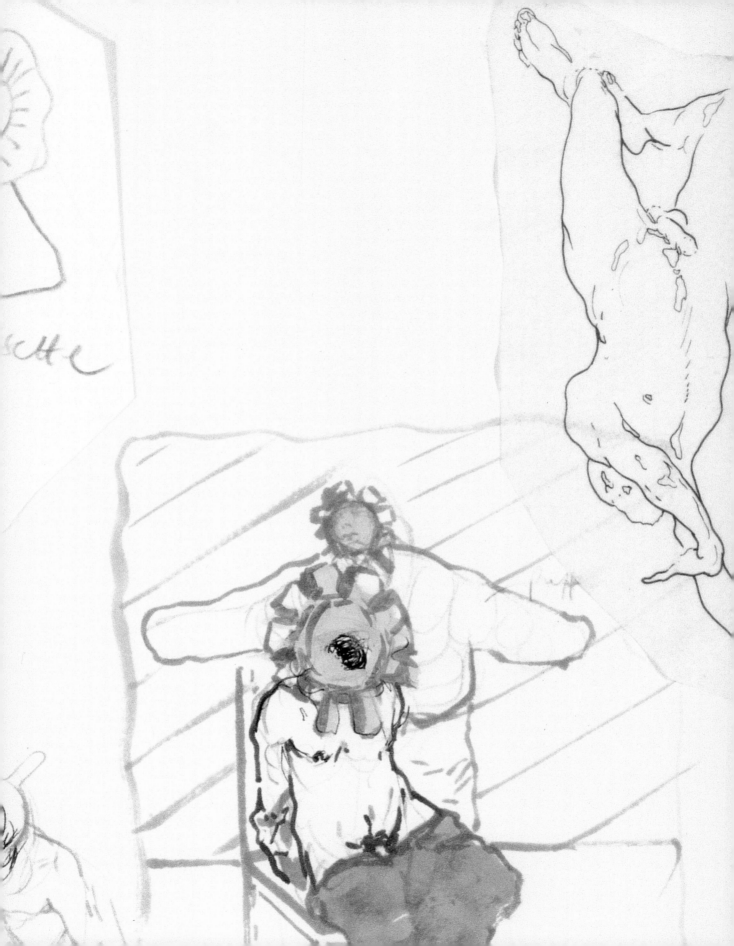

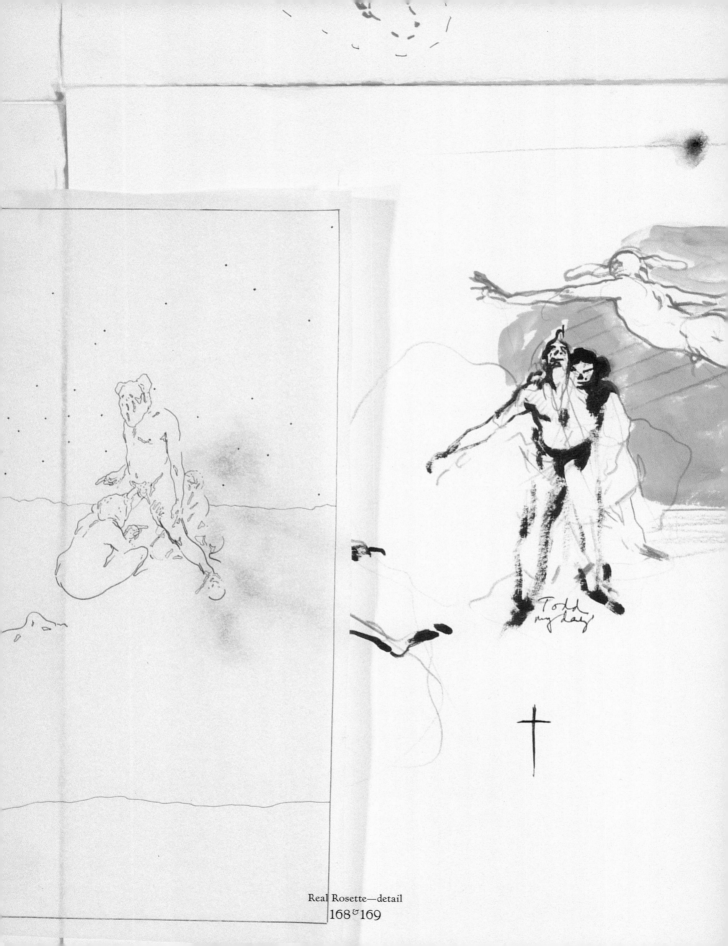

Real Rosette—detail
168 & 169

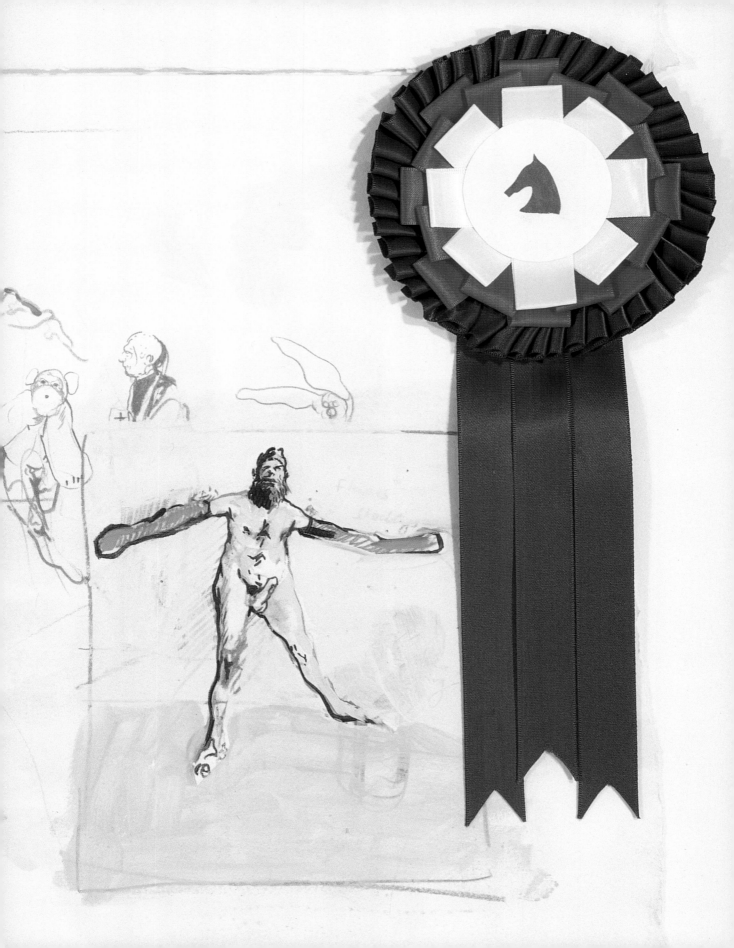

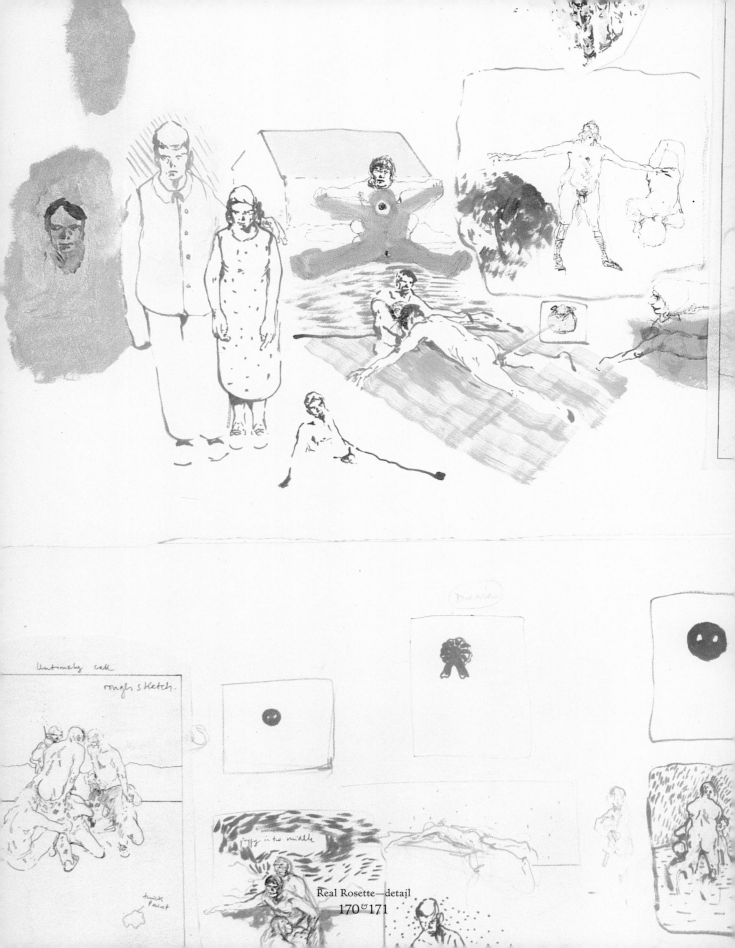

Real Rosette—detail
170 & 171

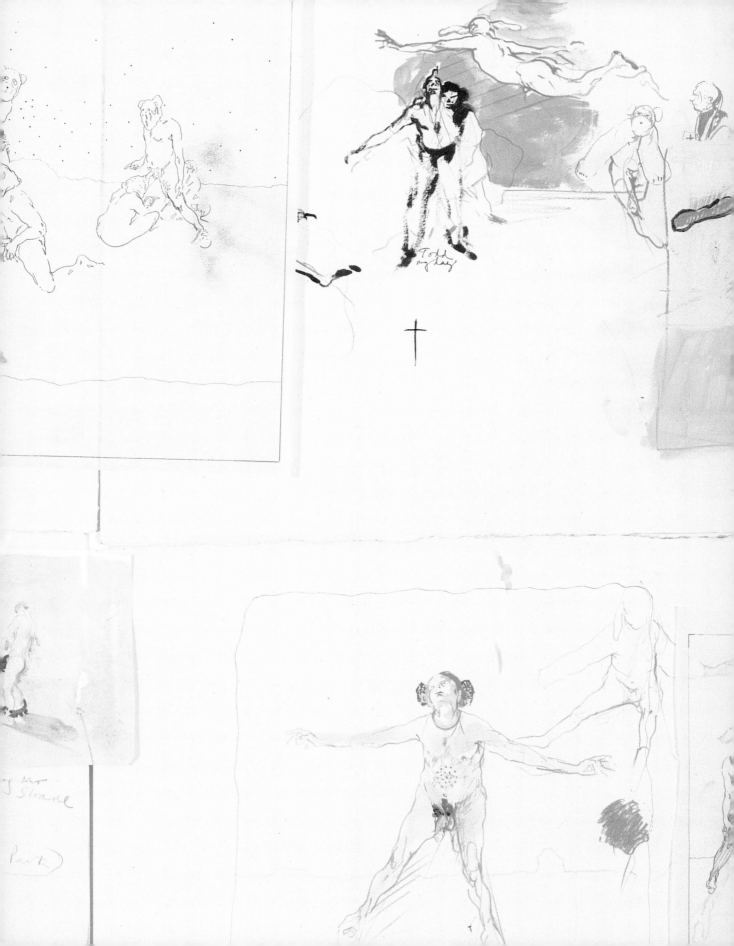

Lawrence Gober-Munch
Oil, ink, collage, crayon and gouache on paper
2002–2004, 210 x 188 cm

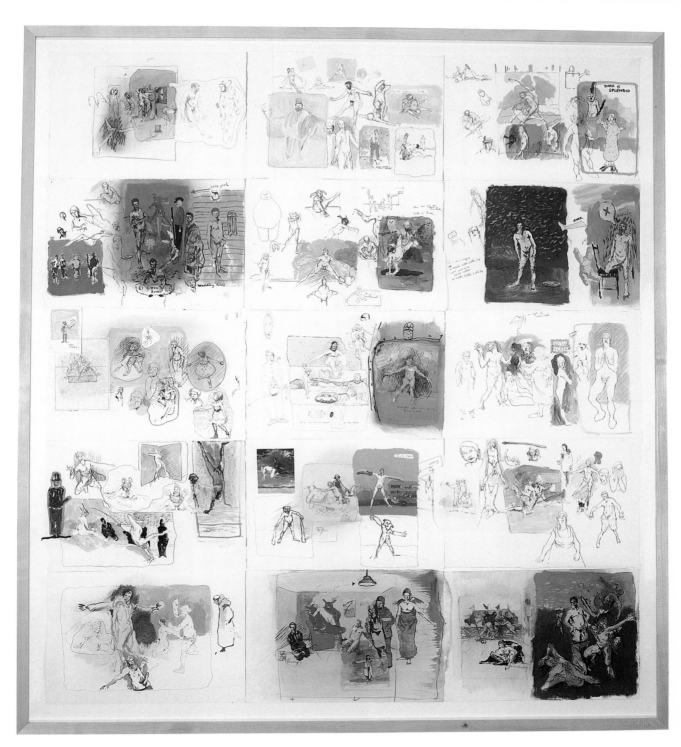

If I was a sculptor
de diddle diddle diddle dee
I would want to be
Robert Gober
de diddle diddle diddle dee

Lawrence Gober-Munch—detail
174 & 175

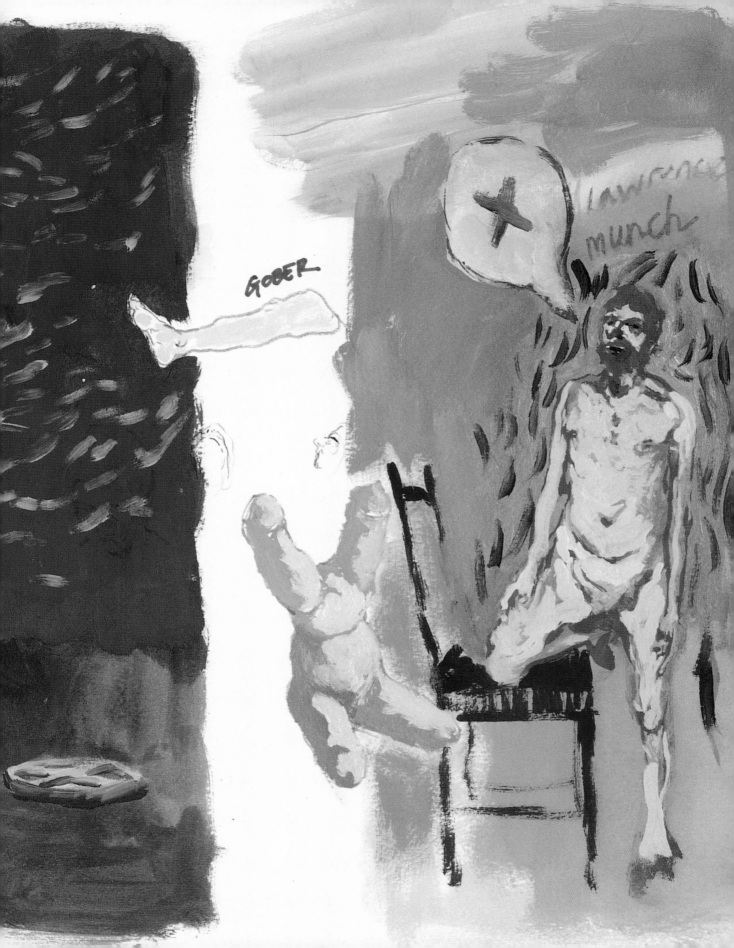

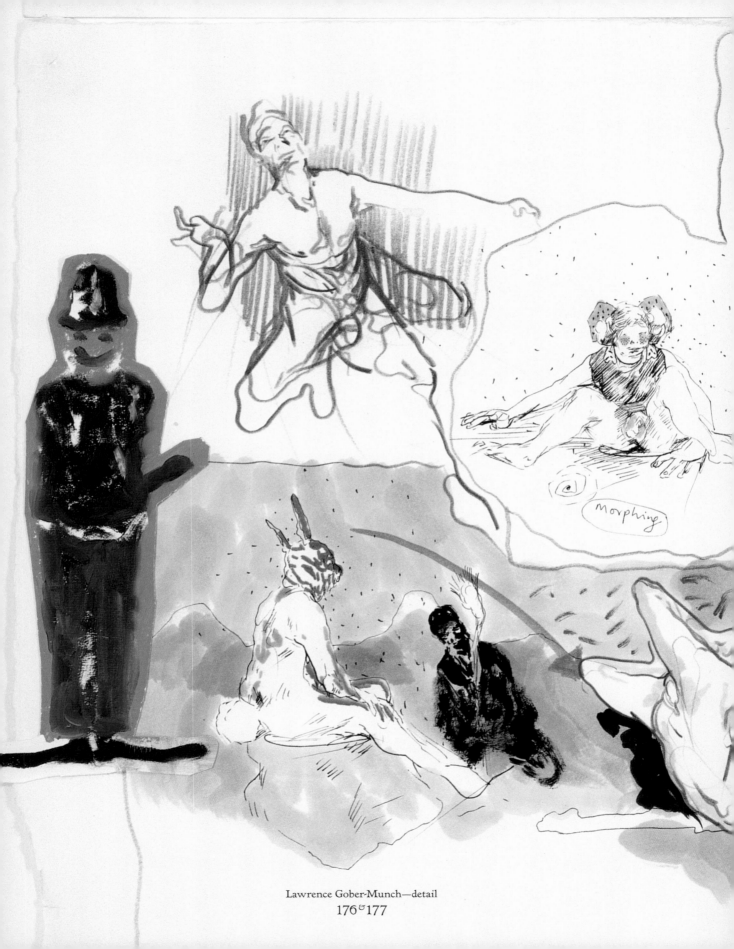

Lawrence Gober-Munch—detail
176 & 177

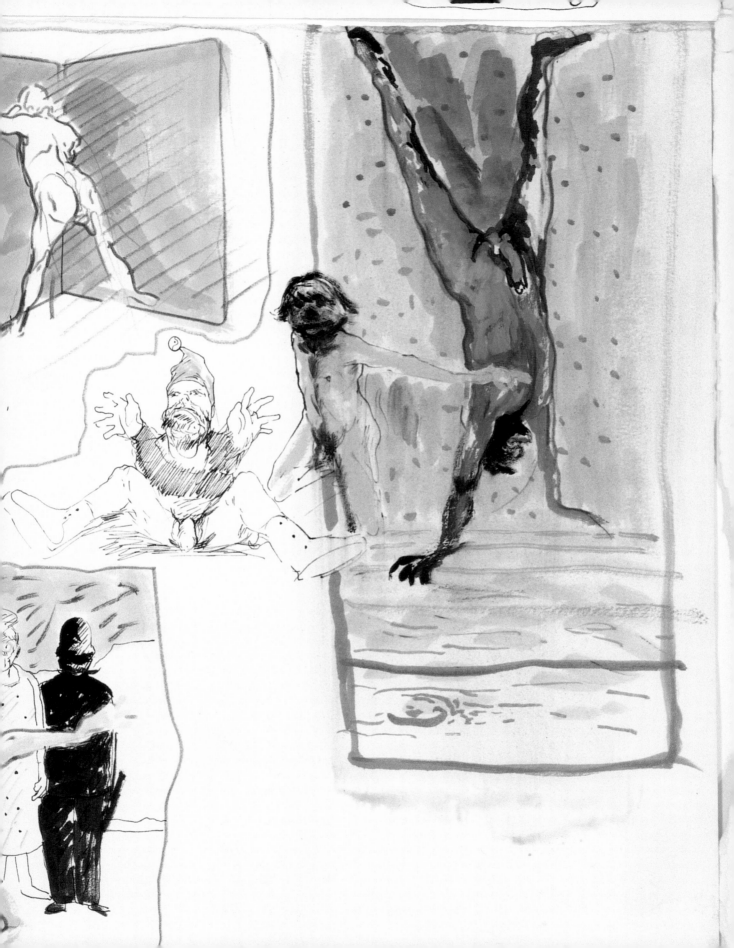

81

82, 83

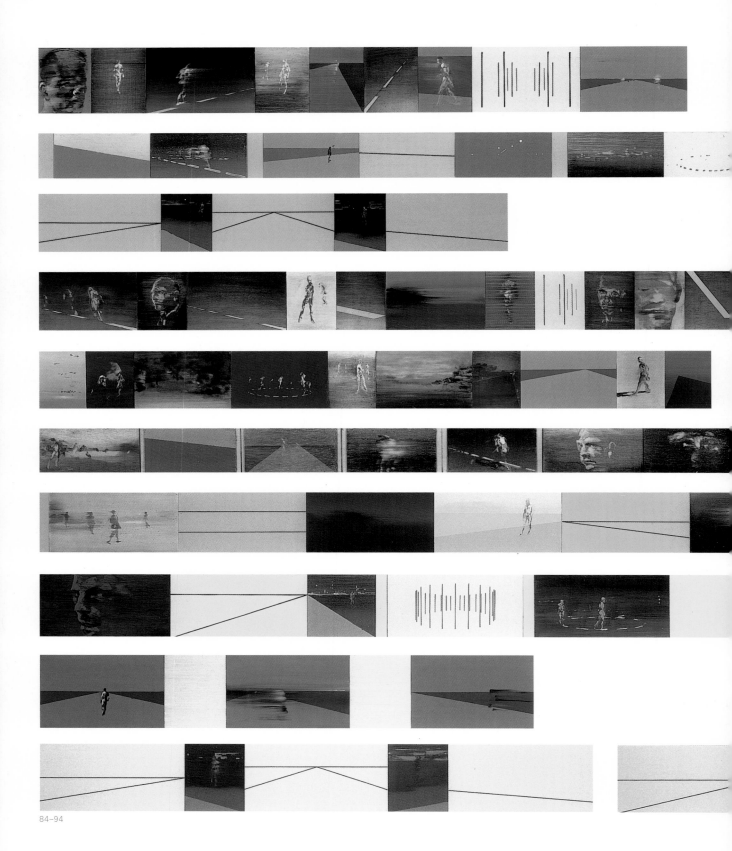

84–94

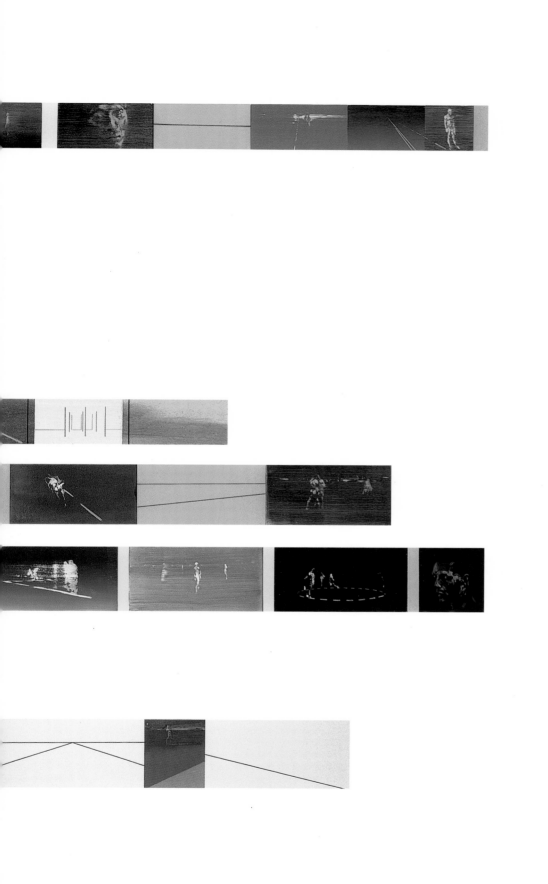

95–99

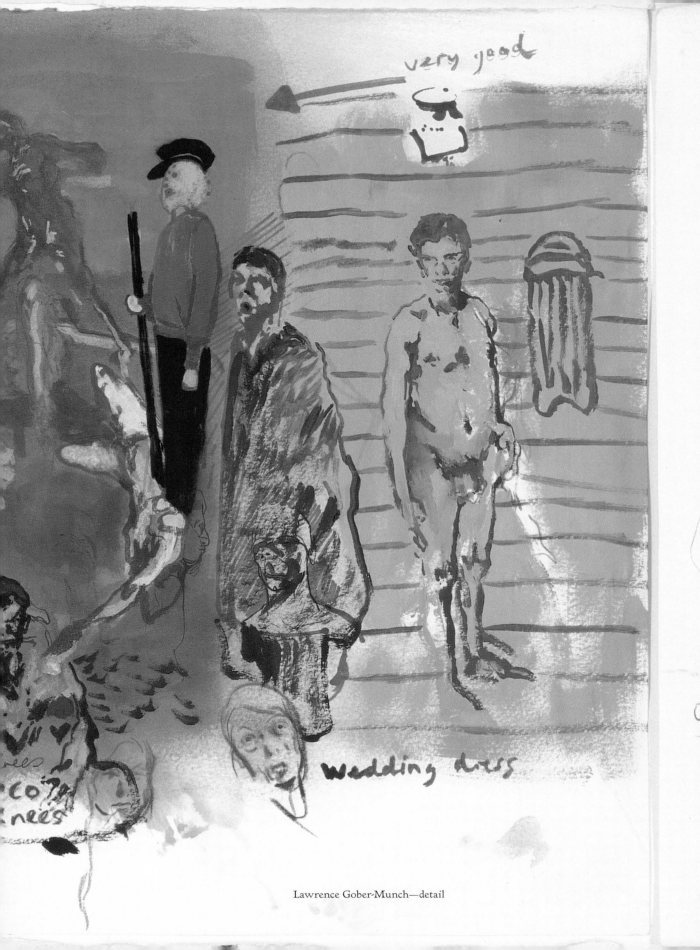

Lawrence Gober-Munch—detail

The 7.42 From Worthing
Oil, ink, collage, crayon and print on paper
2004, 228 x 223 cm

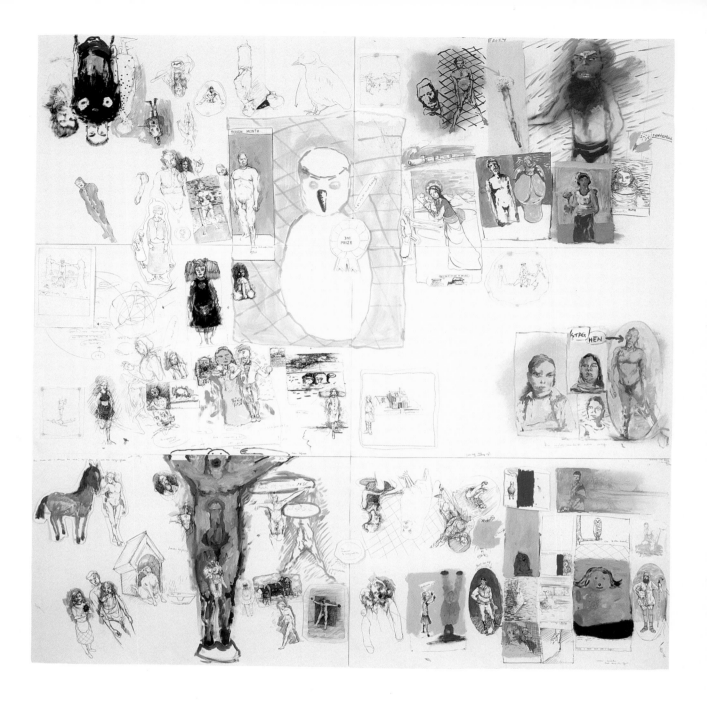

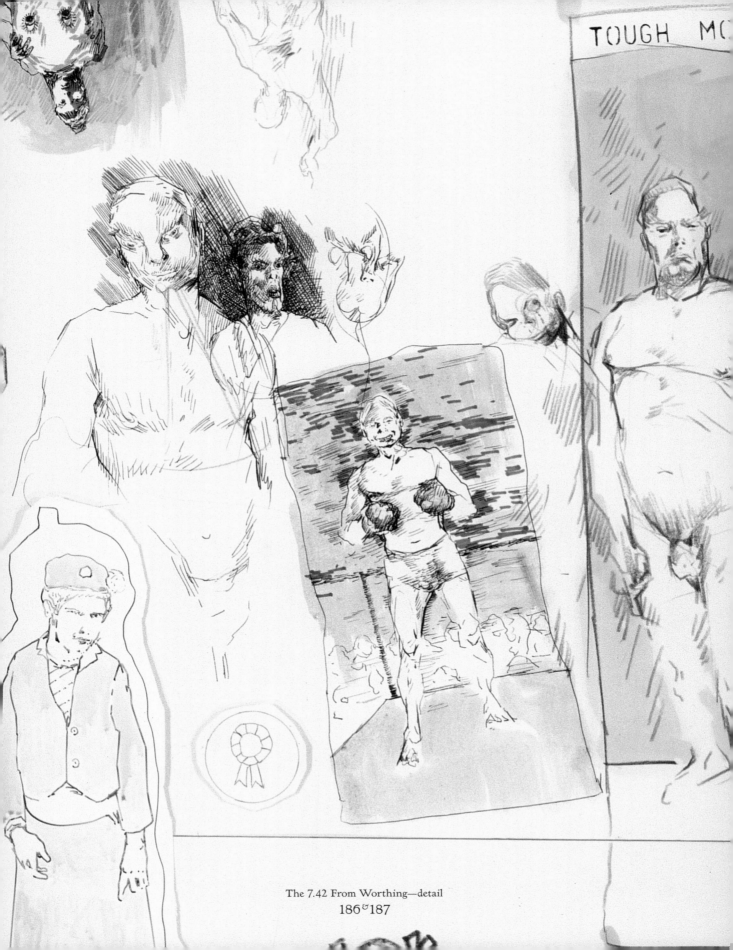

TOUGH MO

The 7.42 From Worthing—detail
186&187

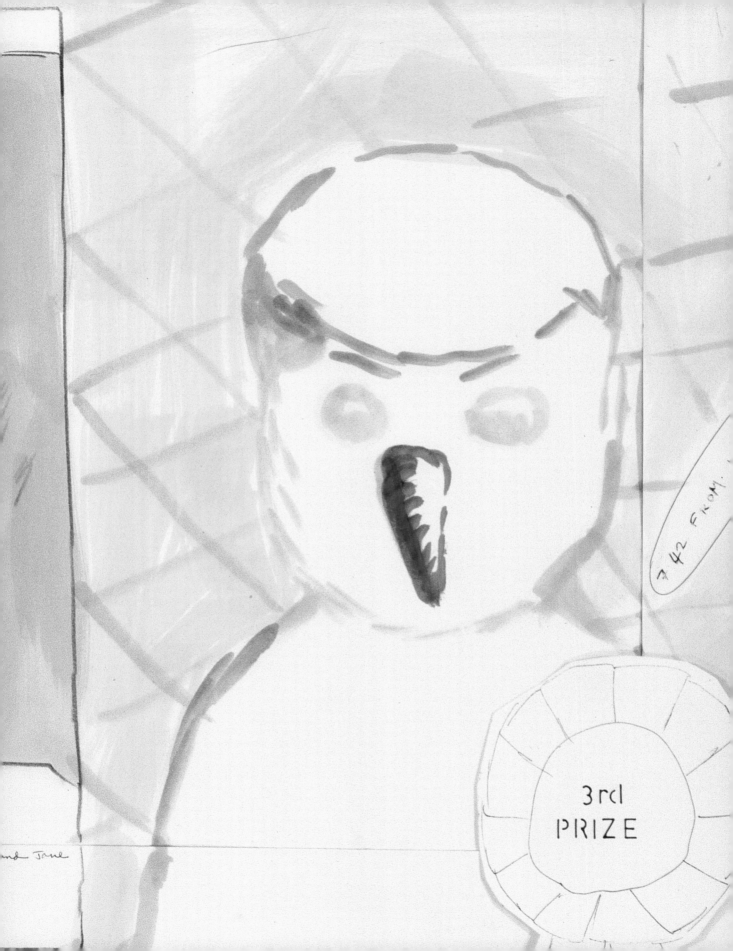

The 7.42 From Worthing—detail
188-189

rutherlan

love

Dorelia RUTH

3rd
PRIZE

try to save me will make me feel alive

The 7.42 From Worthing—detail
190 & 191

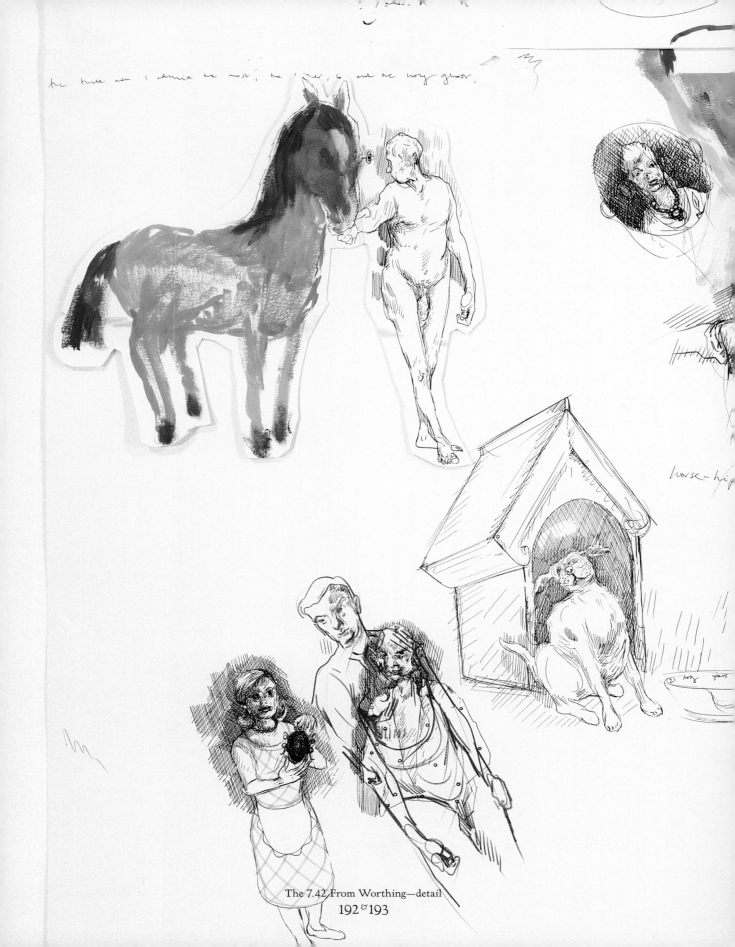

The 7.42 From Worthing—detail

192 & 193

Farmer Humpty

Oil, ink, collage, acrylic and crayon on paper
2003–2004, 245 x 165 cm

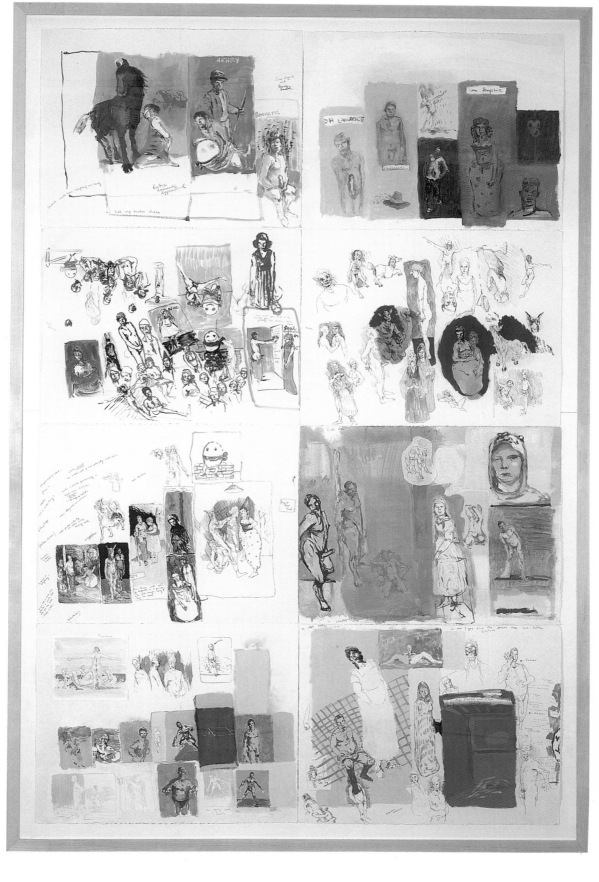

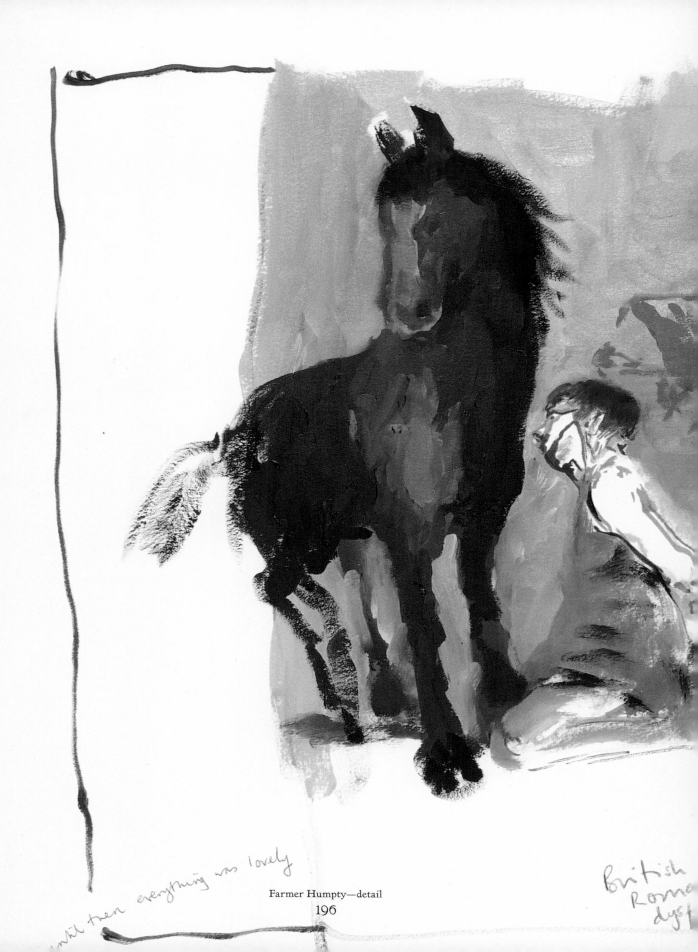

until then everything was lovely

Farmer Humpty—detail

British
Roma
dys

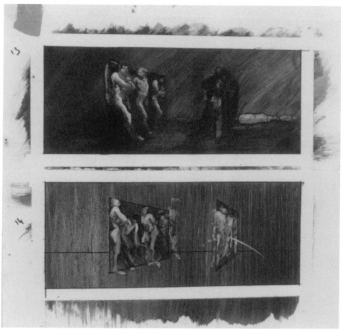

100

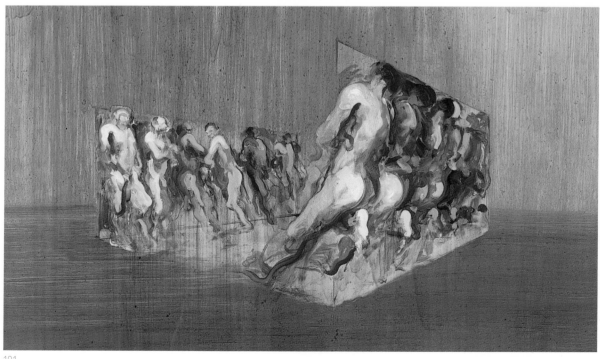

101

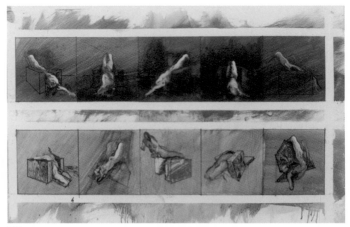

102

103

104

HENRY

Simon English
and
Henry
Bonnard

Bonnard

Farmer Humpty—detail

Simon English
and
Henry
Barnard

DH LAWRENCE

D'Artagnan—

Farmer Humpty—detail
200 & 201

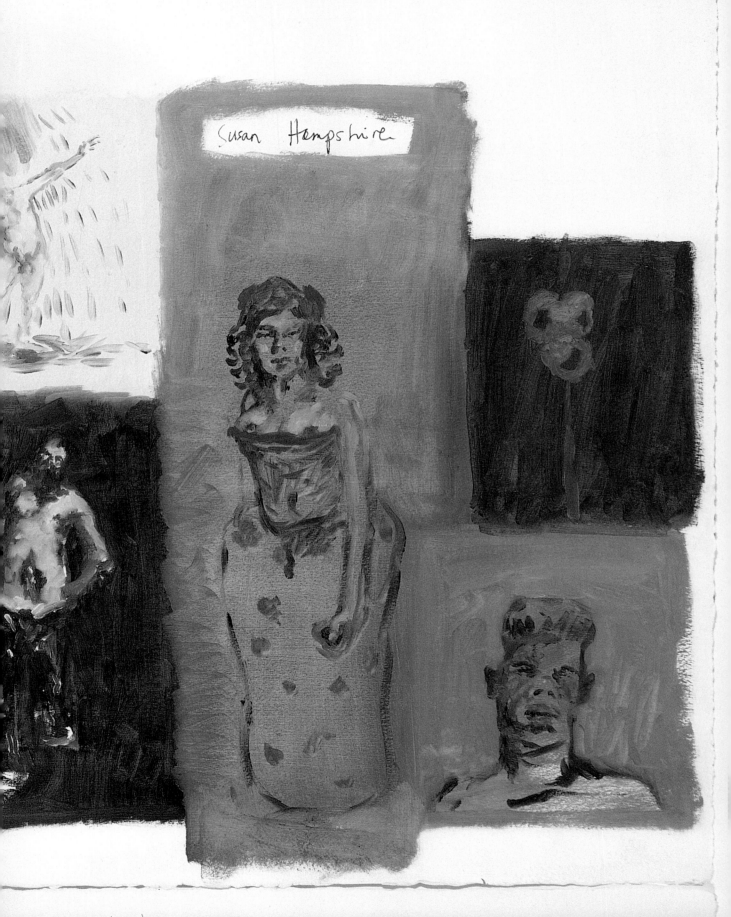

Farmer Humpty—detail
202

List of Illustrations, Selected Bibliography & Biography

List of Illustrations

4 Doors—Agnès b.

Illus. N°

1–4 *4 Doors*, Drawing Installation for Agnès b., Rue De Rivoli, 2004, Oil, ink, crayon and print on paper, photography: Etienne Clement

Drawings for The Breeder No. 5

5–9 *Drawings for The Breeder No. 5*, 2000–2002, Ink on paper, dimensions variable

Drawing with Blu-Tack

10–23 *Drawing With Blu-Tack*, 1999–2001, Ink on paper, dimensions variable

Nobody Loves Me

24 *Diana Ross*, 2000, Oil on polyester on canvas, 20 x 15

25 *Bogey-man*, 2001, Ink on canvas, 264 x 160

26 *Intervention in Grey and Green*, 2000, Oil on polyester on board, 30 x 45.8

27 *Blu-Tack Rabbit*, 2000, Oil on board, 23 x 23

28 *Bear With Red Mouth*, 2000, Oil on polyester on board, 30 x 45.8

29 *Manchester*, 2000, Polyester on oil on board, 15.5 x 30

30 *We Take Our Work Very Seriously*, 2000, Ink on polyester on oil on canvas, 20 x 15

31 *Snooker Room*, 2000, Oil on polyester on board, 15.5 x 30

32 *Blu-Tack Rabbit in Painterly Pink*, 2001, Oil on canvas, 160.2 x 106.5

24–32 photography: David Grandorge

Drawing Installation

33 Drawing installation from *In Your Dreams*, FA1 Contemporary Art, London, 2000 (detail)

34, 35 *Studio Installation*, 1999–2000

36, 37 *Drawing Installation*, FA1 Contemporary Art, London, 2000

38, 39 Drawing Installation: *Drawings With Blu-Tack*, from *Mommy Dearest*, Gimpel Fils, London, 2000 (detail) 38/39 photography: Sue Barr

Performance

40 *Performance: Drawing Out Loud*, Chisenhale Dance Space, London, Chisenhale Live Arts Award 1999

41–45 *Chisenhale*, 1999

46–51 *Chisenhale*, 1999

52, 53 *Studio Performance*, 1996

54, 55 *Delacroix Bed—Studio Performance*, 1999

56 *Get Series—Studio Tableaux*, 1999

57 *Chisenhale*, 1999

58–62 *Performance Installation: Drawing Out Loud*, in collaboration with Simon Moretti, Chisenhale Dance Space, London, Chisenhale Live Arts Award, 1999

Double & Twist

63 *Double & Twist 5*, 1997, Oil on board, 30.5 x 45.7

64 *Double & Twist 6*, 1997, Oil on board, 30.5 x 45.7

65 *Double & Twist 10*, 1997, Oil on board, 30.5 x 22.8

66 *Double & Twist 1*, 1997, Oil on board, 30.5 x 22.8

67 *Double & Twist 7*, 1997, Oil on board, 30.5 x 45.7

68 *One on One 9*, 1998, Oil on board, 69 x 92

69 *Sauce for the Gander*, 1998, Oil on board, 69 x 92

70 *One on One 7*, 1998, Oil on board, 69 x 92 63–70 photography: Edward Woodman

Artist's Gaze

71–80 *Artist's Gaze*, 1995–1996, photographs, various dimensions

R & W Series

81 *R Series*, 1994, Studio Installation

82, 83 *9 and 10 R*, 1995, Studio Installation

84 *5W*, 1994, Oil on board 19.6 x 182.7

85 *5R*, 1995, Oil on board 16.5 x 207

86 *6R*, 1995, Oil on board 24 x 126

87 *4W*, 1994, Oil on board 19.6 x 213

88 *2W*, 1994, Oil on board 19.6 x 213

89 *1W*, 1994, Oil on board 10.2 x 200.7

90 *7R*, 1995, Oil on board 24 x 289.6

91 *1R*, 1995, Oil on board 24 x 297

92 *7W*, 1994, Oil on board 19.6 x 91.3

93 *9R*, 1995, Oil on board 24 x 126

94 *10R*, 1995, Oil on board 24 x 126

95–99 *R & W Series*, 1994–1996, Studio Installation

Walls & Chairs

100 *Wall 2 & 3*, 1992, Studio shot

101 *Wall 1*, 1992, Oil on PVC rigid, 39 x 65 Saatchi Collection

102 *Chairs 1*, 1992, Studio shot, Saatchi Collection

103 *Chair preparations*, 1993, Ink and acrylic on canvas, 150 x 300

104 *Chair preparations*, 1993, Ink and acrylic on canvas, 150 x 300

Figure Series

Page N°

46 *Rosette Head & Bunny Bride**

58 *Ansuya Blum**

64 *Bride*

74 *El Greco's Knees*

88 *Haddock*

100 *Nurse Rackham*

108 *Keith Vaughn's Stable*

120 *Jean Plaidy**

138 *Army Pink Snowman*

146 *Mrs Brown*

160 *Real Rosette**

172 *Lawrence Gober-Munch**

184 *The 7.42 from Worthing**

194 *Farmer Humpty*

All Figures pieces photographed by Hugo Glendinning

*Courtesy of FRED (London) Ltd.

Page 127 Julie Christie autograph c. 1960, and postcard from Switzerland

Endpapers (front & back) *Studio View*, 2005, photography: Anne Hardy

All Works—Private collection unless stated otherwise

All dimensions given in centimetres, height x width x depth

Selected Biography & Bibliography

Solo Exhibitions

2006
Simon English,
FRED (London) Ltd., London

2005
Simon English,
Galerie Volker Diehl, Berlin
Clouds Hill,
Galerie Römerapotheke,
Zurich

2004
4 Doors—Agnès b.,
Drawing installation
Rue de Rivoli, Paris
Simon English Figures,
Rhodes + Mann, London

2001
Nobody Loves Me,
Galleri Christian Dam
Oslo, Norway

1999
*Performance: Drawing Out
Loud,* Chisenhale Dance
Space, London, Chisenhale
Live Arts Award

1998
Project Room,
Milch, London
Double & Twist,
Laurent Delaye, London

1995
Entwistle Gallery and
Laurent Delaye, London

1992
Laurent Delaye, London

Group Exhibitions

2005
Group Show: *Look. Look
Again,* Aldrich Contemporary
Art Museum and touring USA,
curated by Stuart Horodner

2004
Je m'installer aux abattoirs!,
Agnès b, her private
collection, Les Abattoirs,
Toulouse, France

2002
The Green Room,
Percy Miller Gallery, London,
curated by Simon Moretti

2000
In Your Dreams,
FA1 contemporary art,
London
Mommy Dearest,
Gimpel Fils, London

1999
Sampling, Ronald Feldman
Fine Arts New York
Il luogo degli Angeli,
Ex Manufactura Tabaschi
Citta Sant'Angelo, touring
to Villa Bottini, Lucca, Italy,
curated by Renato Bianchini

1998
Body Double,
Winston Wachter Fine Art,
New York, curated by
Bruce Ferguson
Leisure,
Glassbox, Paris

1997
*29eme Festival International
de la Peinture,*
Musée de Cagnes-sur-Mer,
selected and with catalogue
essay by Mark Gisbourne
Afternoon in the Park,
Laurent Delaye Gallery,
London

1994
Laurent Delaye at
The Fete Worse Than Death,
organised by Factual
Nonsense, London
Young British Artists III,
Saatchi Collection, London

Collections

Arts Council of England
Saatchi Collection
Paisley Museum, Scotland
British Museum & numerous
public and private

Selected Bibliography
Further Reading

1999
Il Luogo degli Angeli,
exhibition catalogue, curated
by Renato Bianchini

1997
*29eme Festival International
de la Peinture,* Musée de
Cagnes-sur-Mer, text by Mark
Gisbourne

1994
Young British Artists III,
Saatchi Collection, text by
Sarah Kent, London

Books

2005
Clouds Hill,
Galerie Römerapotheke,
Zurich, text by Pablo
Lafuente: "Just look,
don't read"

2000
The Saatchi Gift,
Arts Council Collections

1999
*Young British Art:
The Saatchi Decade,*
Richard Cork, Booth-Clibborn
Editions, London

1994
Shark Infested Waters,
The Saatchi Collection, Sarah
Kent, Zwemmer, London

Acknowledgements

Simon English wishes to thank Arts Council England, Anna Soares and Pierfranco Grosso, Agnès b., Volker Diehl, Phillipe Rey, Rhodes + Mann, FRED (London) Ltd, Galerie Volker Diehl Berlin, Galerie Römerapotheke Zurich, Galerie Lelong New York, Duncan McCorquodale, Stella Santacatterina, Bill Arning, Fred Mann, Benjamin Rhodes, Jaime Ritchie, Robert Gober, Raymond Pettibon, Jeffrey Peabody at Matthew Marks Gallery, Sadie Coles, Value and Service, Hazel Rattigan and Sean Murphy, Stuart Horodner, Sarah Wayson, Charlotte Nourse, Peter Cross, Phillip Doyle, Françoise Testory, Ian Johnstone, Andrew Kean-Hammerson, Ernst Fischer, Joshua Sofaer, Adrian George, Andrew Mottishead, Neal Walters and Phil Jones, Matthew Bartlett, Steven Whinnery, Christian S Tate, Gary Dove, Stefan Reekie, Robin Whitmore, Simon Moretti, Rut Blees Luxemburg, Michael Petry, Hugo Glendinning, Ansuya Blom, Silvia Lorenz, Mary Sabbatino, Mark Hughes, Laurent Delaye, Rebecca Reinhart, Michelle Woo, Richard Hall, Emilia Gomez Lopez, Catherine Grant, Oriana Fox, Tahani Nadim, Amy Sackville, Harpreet Kalsi, The Breeder Magazine, Nick Baker and Zöe Foster, Reneé Gimple and Jackie Halliday, Christian Dam, Lance and Roberta Entwistle, Charles Saatchi, Jenny Blythe, Anne English, Fiona Banner and Nick Rosen, Richard Bucht, Melanie Manchot, Joe Ewart, Ebi, Magadelen Rubalcava, Mark Gisbourne, Pablo Lafuente, Goswin Schwendinger, Jeremy and Christina Martin, Christopher Truman, Leigh Gardiner, Alistair and Susie Sinclair-Till, Phillipa Devas, Geraldine Kenway, Pierre Del Fondo, Julie Christie, Edward Woodman, Sue Barr, Eivind Lentz, Etienne Clement, Tim Burke, Mark Dodds.

Designed by
Value and Service

Written by Fred Mann,
Stella Santacatterina
& Bill Arning

Black Dog Publishing Limited
Unit 4.4 Tea Building,
56 Shoreditch High Street,
London E1 6JJ

Telephone
+44 (0)20 7613 1922
Fax +44 (0)20 7613 1944
Email info@bdp.demon.co.uk
Web www.bdpworld.com

All opinions expressed within this publication are those of the authors and not necessarily of the publisher.

British Library Cataloguing-in-Publication Data.

A CIP record for this book is available from the British Library.

Printed in the European Union

ISBN 1 904772 18 8

Supported by
The Arts Council England
Pierfranco Grosso &
 Anna Soares
Agnès b.
Galerie Volker Diehl
Galerie Römerapotheke
Rhodes + Mann
FRED (London) Ltd.

GALERIE VOLKER DIEHL

Galerie RÖMERAPOTHEKE

All works by Simon English are courtesy of FRED (London) Ltd.
www.fred-london.com

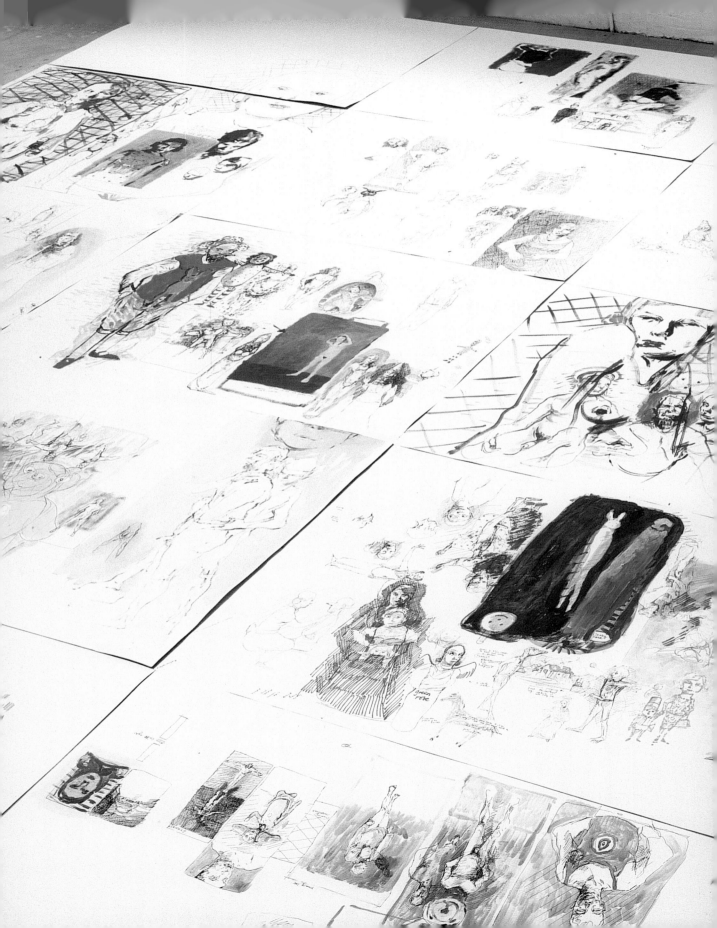